A Complete Guide to

Special Effects Makeup 2

Introduction to Dark Fantasy and Zombie Makeups

Gallery 004

A COMPLETE GUIDE TO SPECIAL EFFECTS MAKEUP

Chapter01

Conceptual Beauty Makeup 036

Chapter02 Zombie Makeup Primer 042

Chapter03 Masks 069

Chapter04

Mold Making – Producing Special Effects Makeup Appliances 082

Chapter05 Step-by-Step Application 094

TOPICS3 MV: Halloween Party

CONTENTS

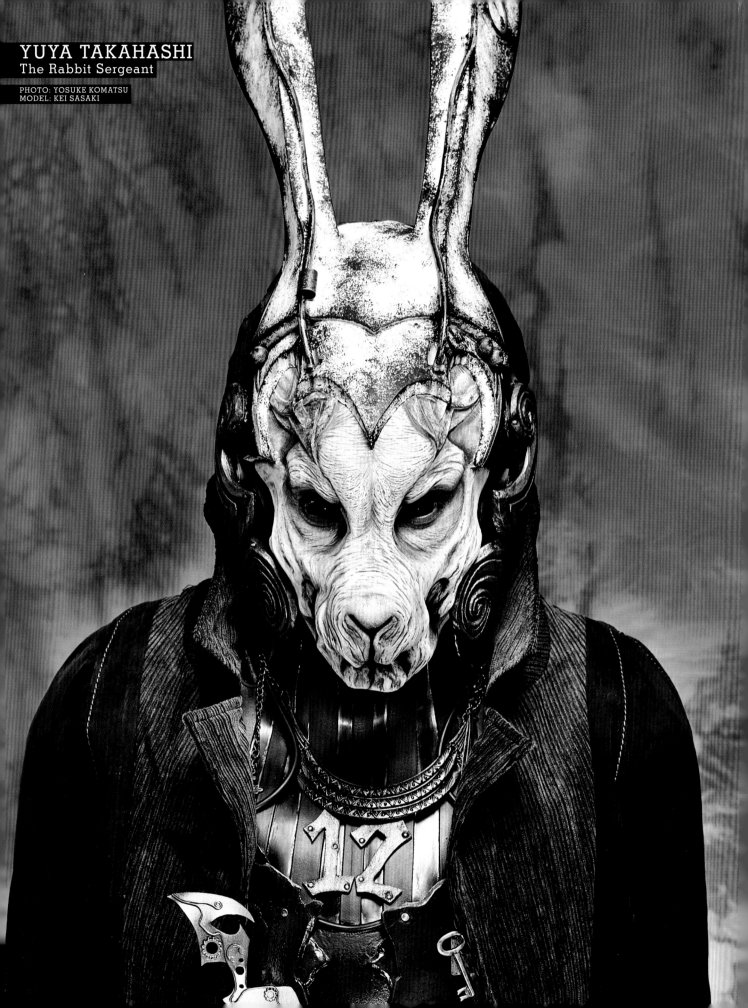

YUYA TAKAHASHI
The Rabbit Sergeant

PHOTO: YOSUKE KOMATSU
MODEL: KEI SASAKI

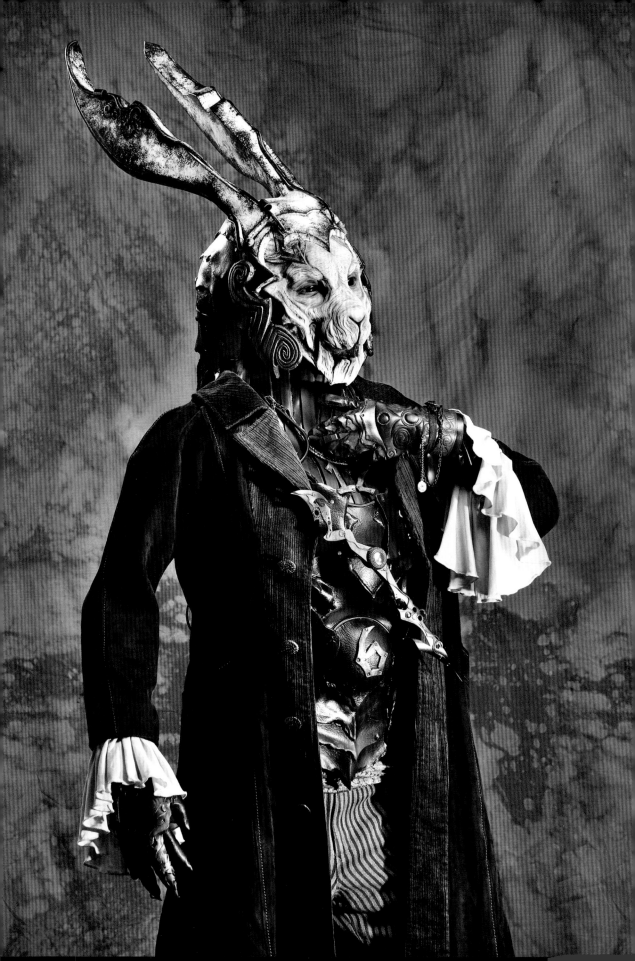

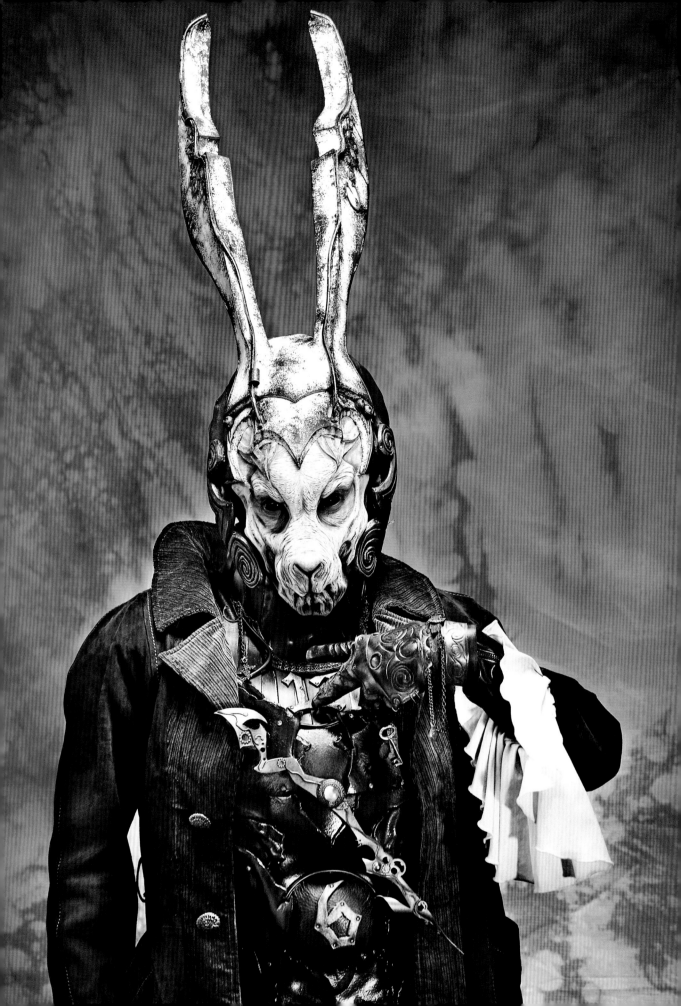

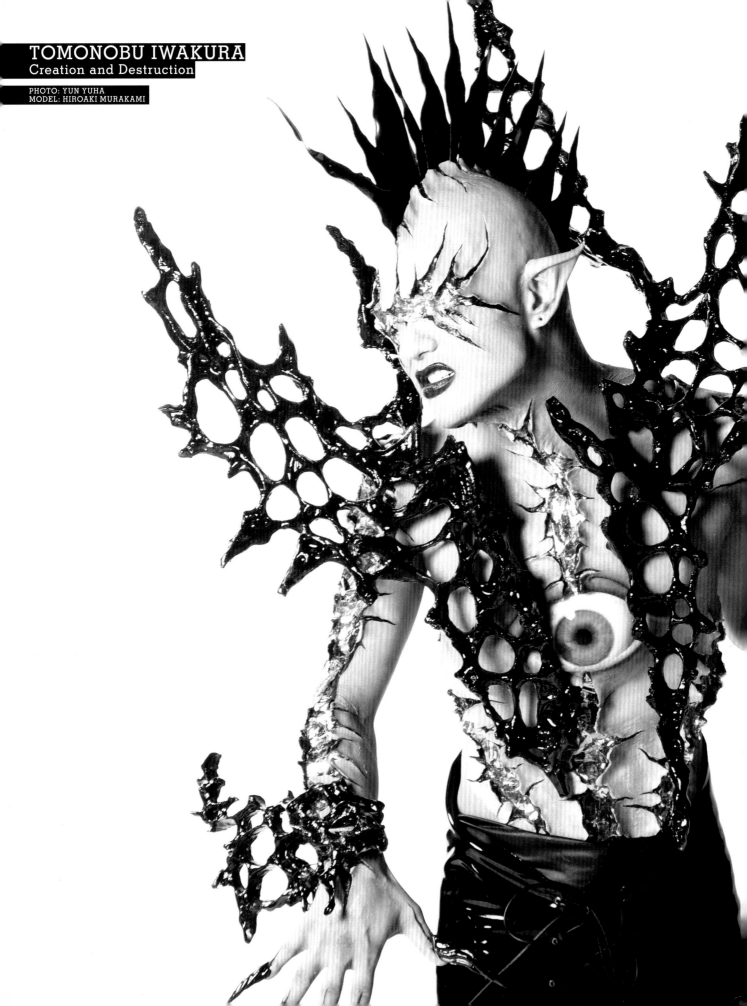

TOMONOBU IWAKURA
Creation and Destruction

PHOTO: YUN YUHA
MODEL: HIROAKI MURAKAMI

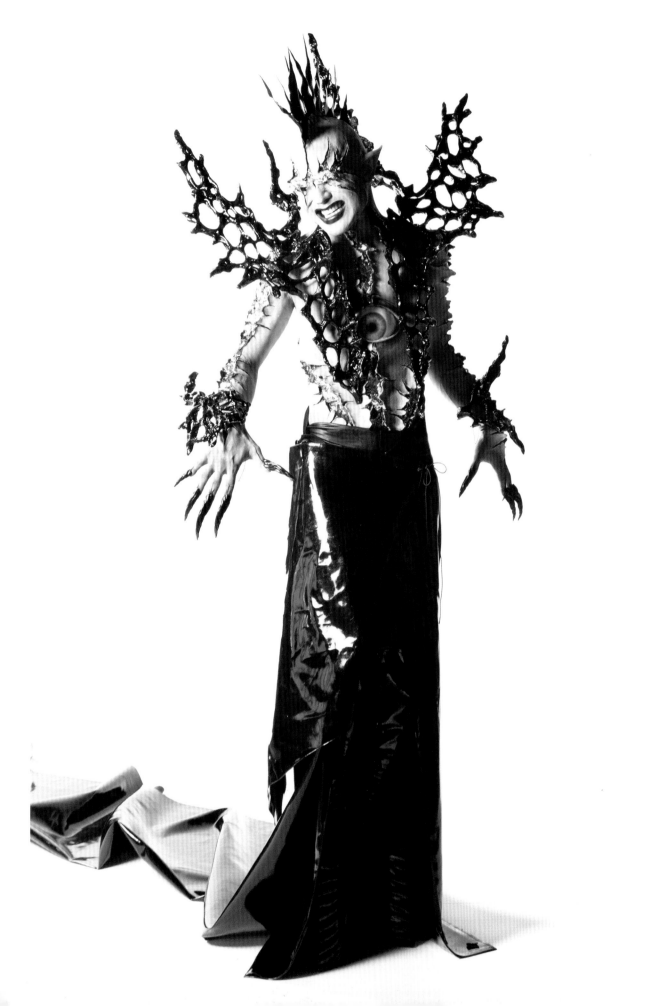

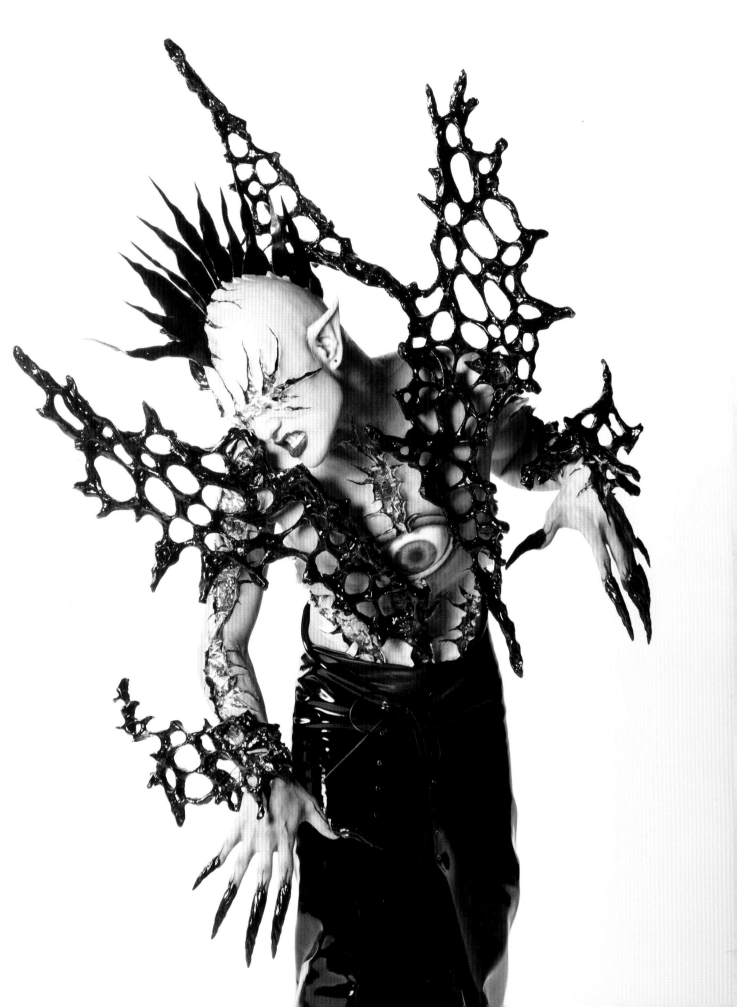

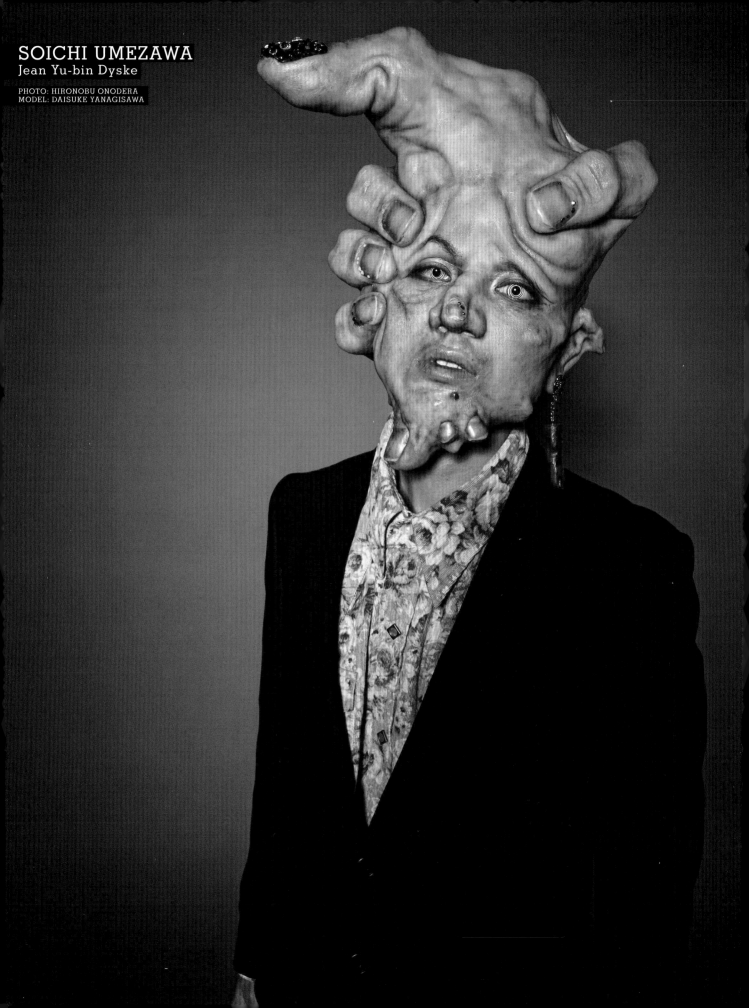

SOICHI UMEZAWA
Jean Yu-bin Dyske

PHOTO: HIRONOBU ONODERA
MODEL: DAISUKE YANAGISAWA

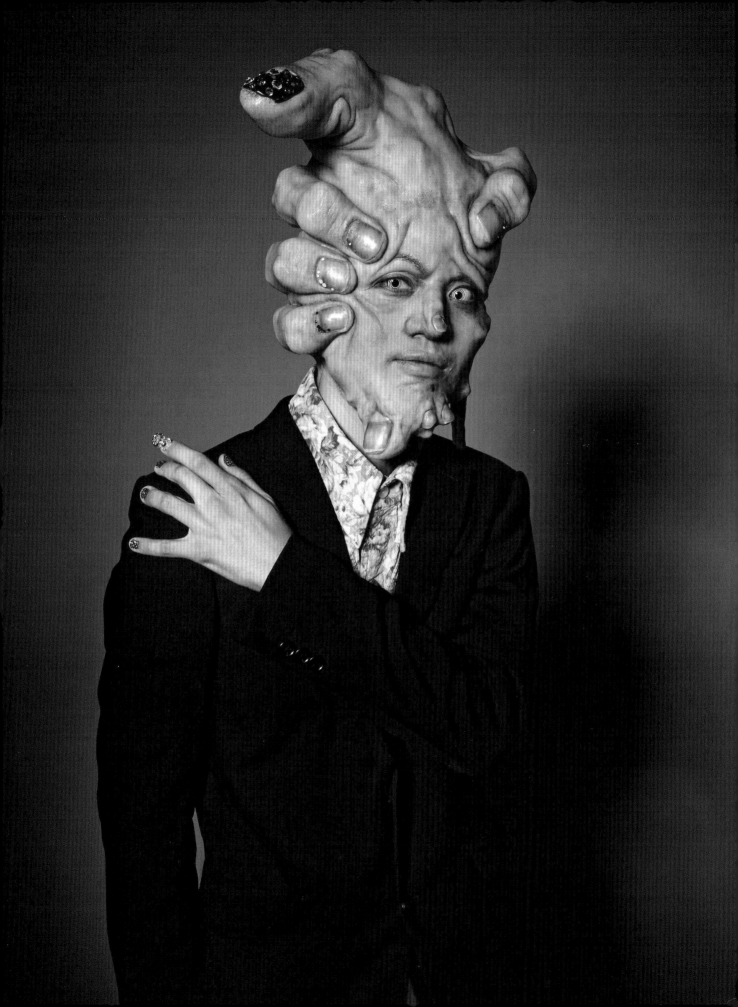

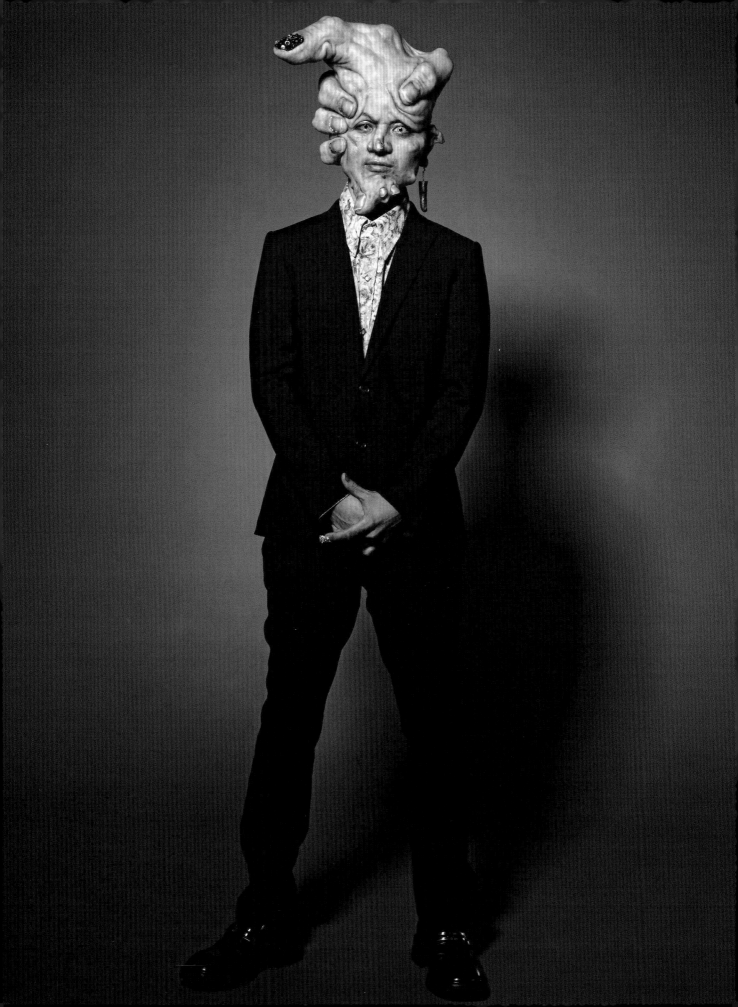

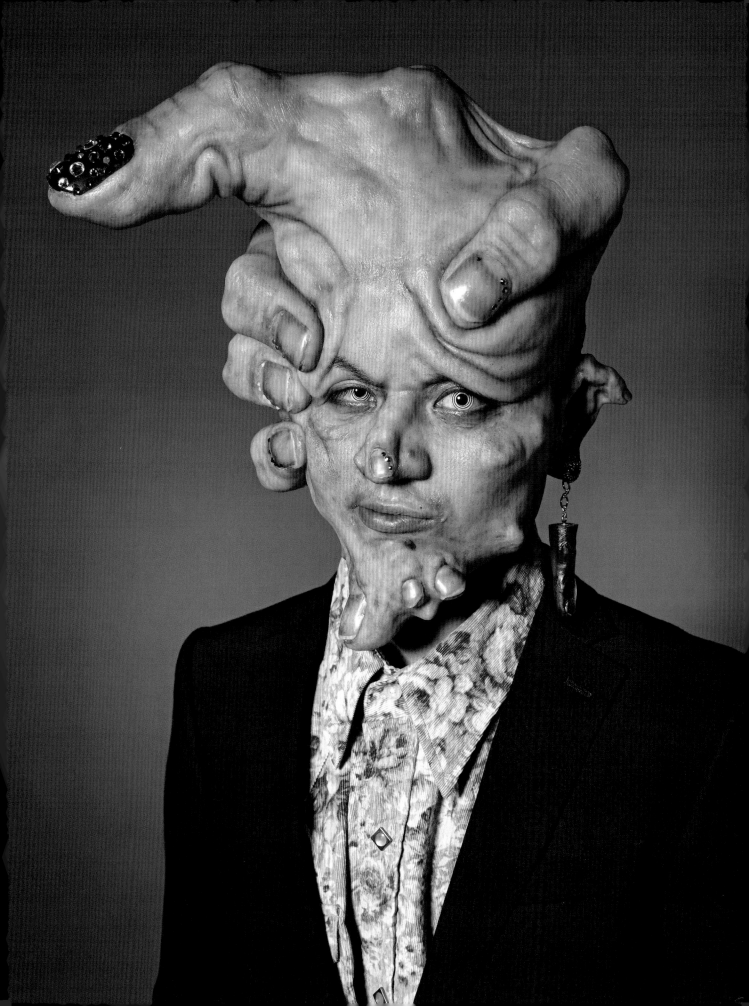

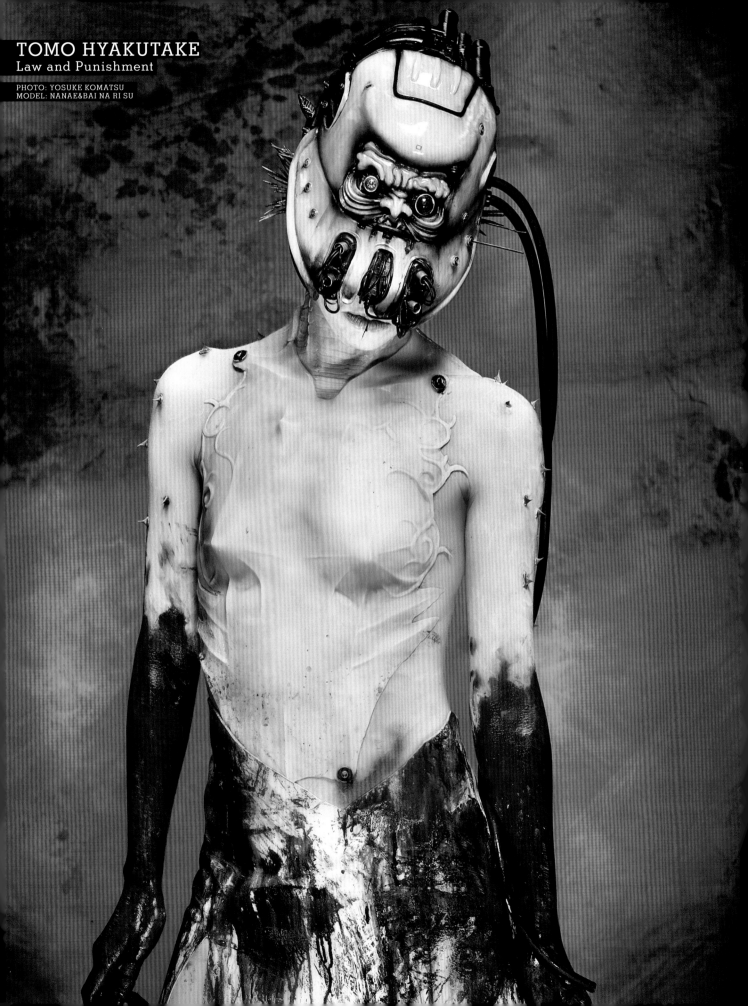

TOMO HYAKUTAKE
Law and Punishment

PHOTO: YOSUKE KOMATSU
MODEL: NANAE&BAI NA RI SU

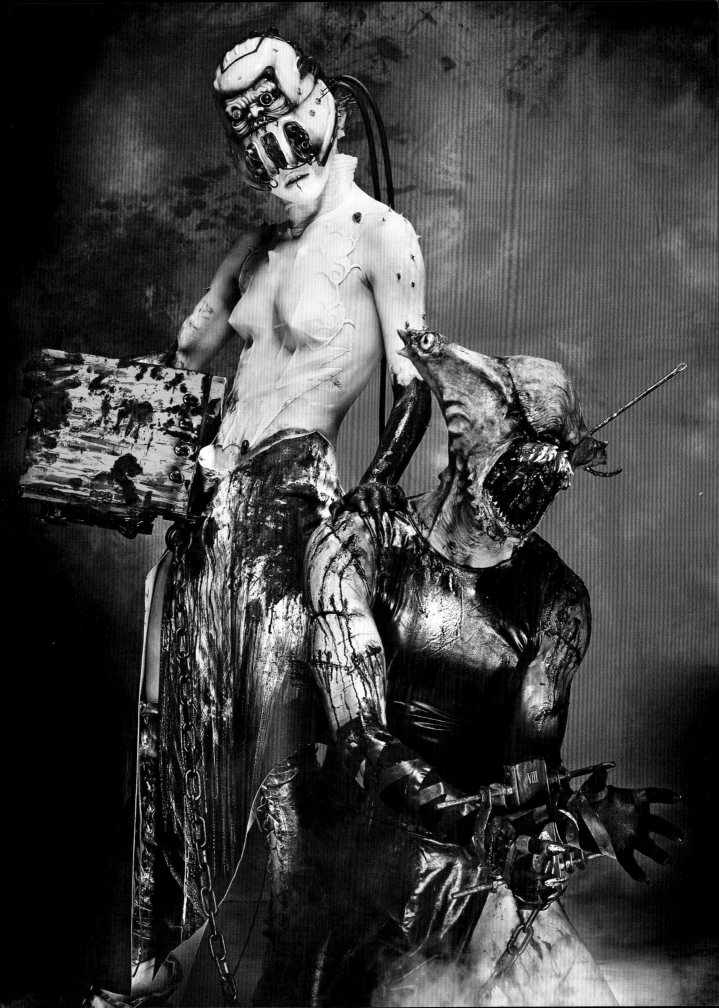

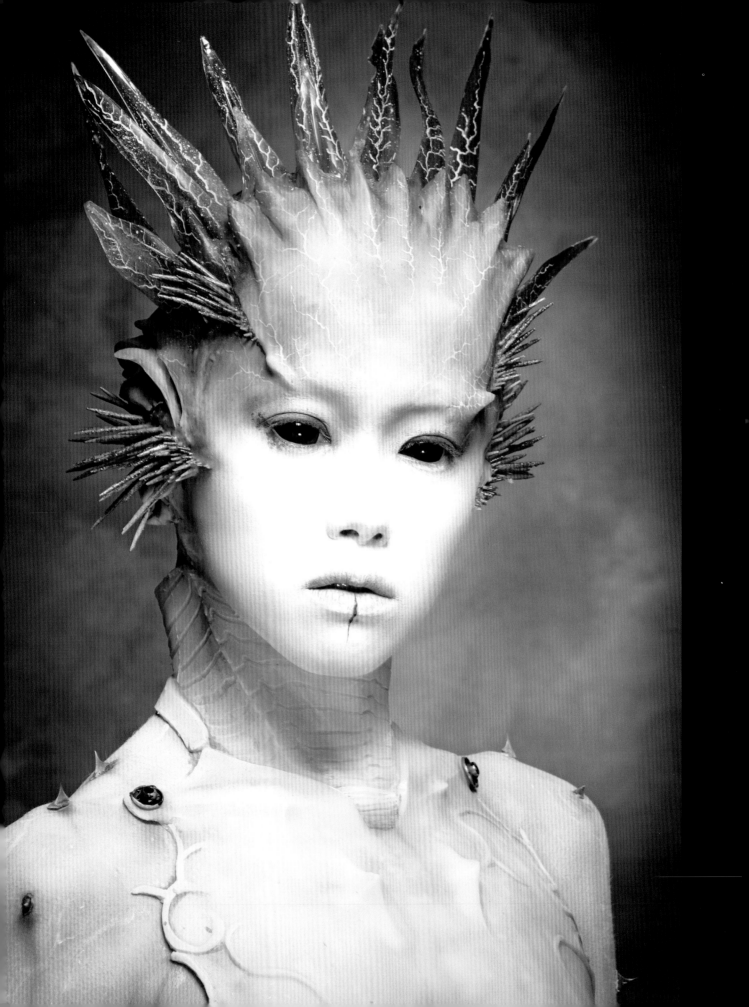

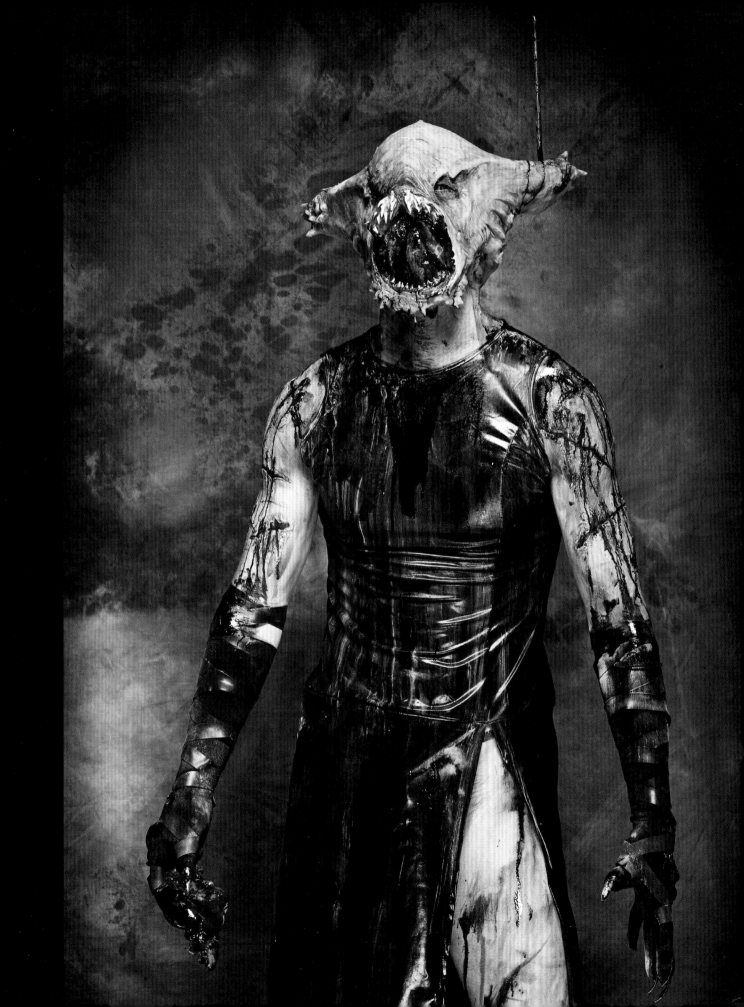

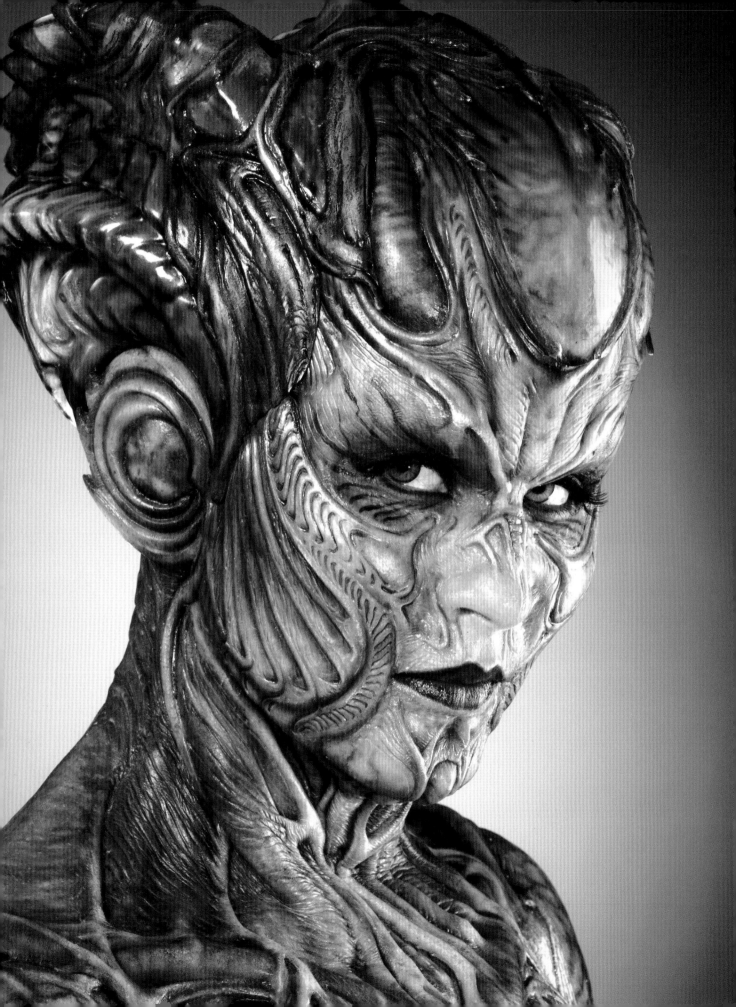

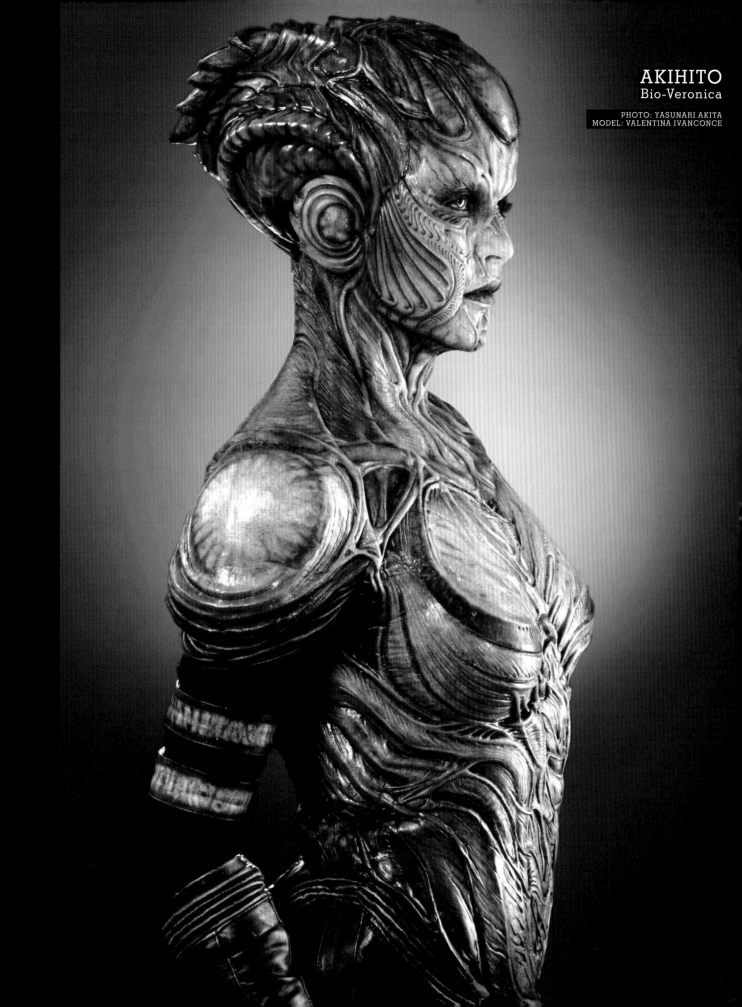

AKIHITO
Bio-Veronica

PHOTO: YASUNARI AKITA
MODEL: VALENTINA IVANCONCE

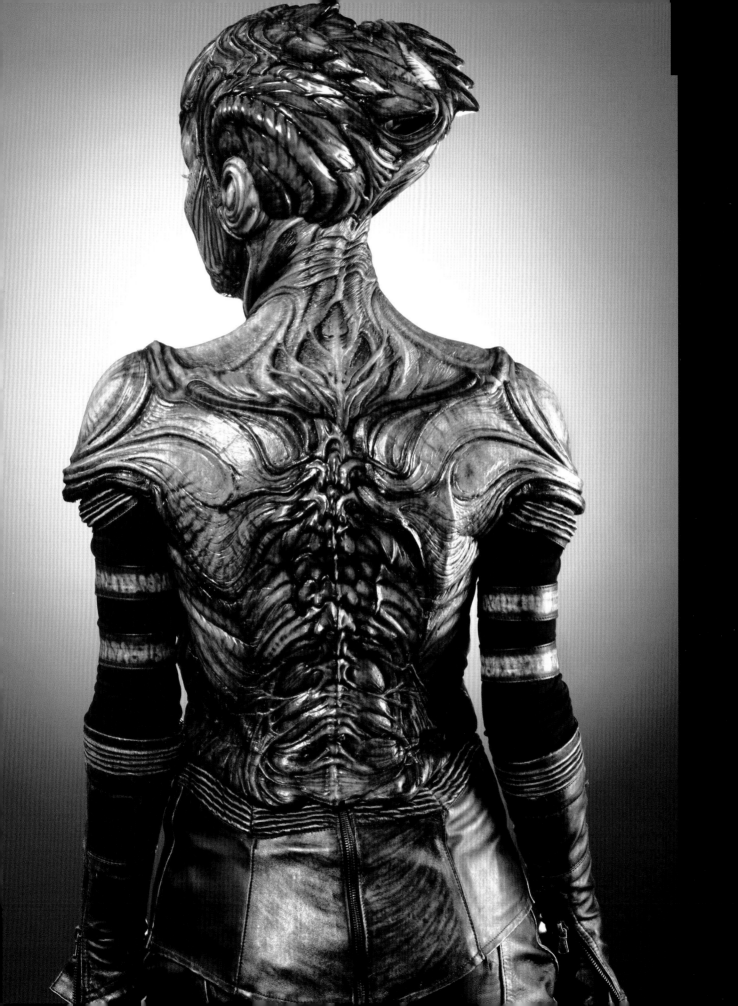

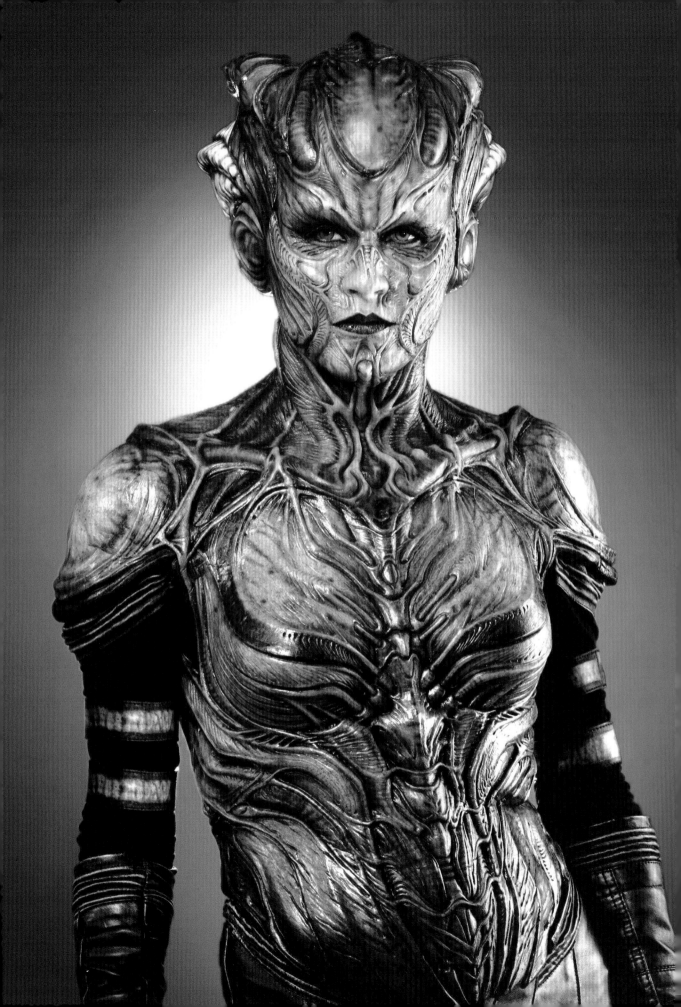

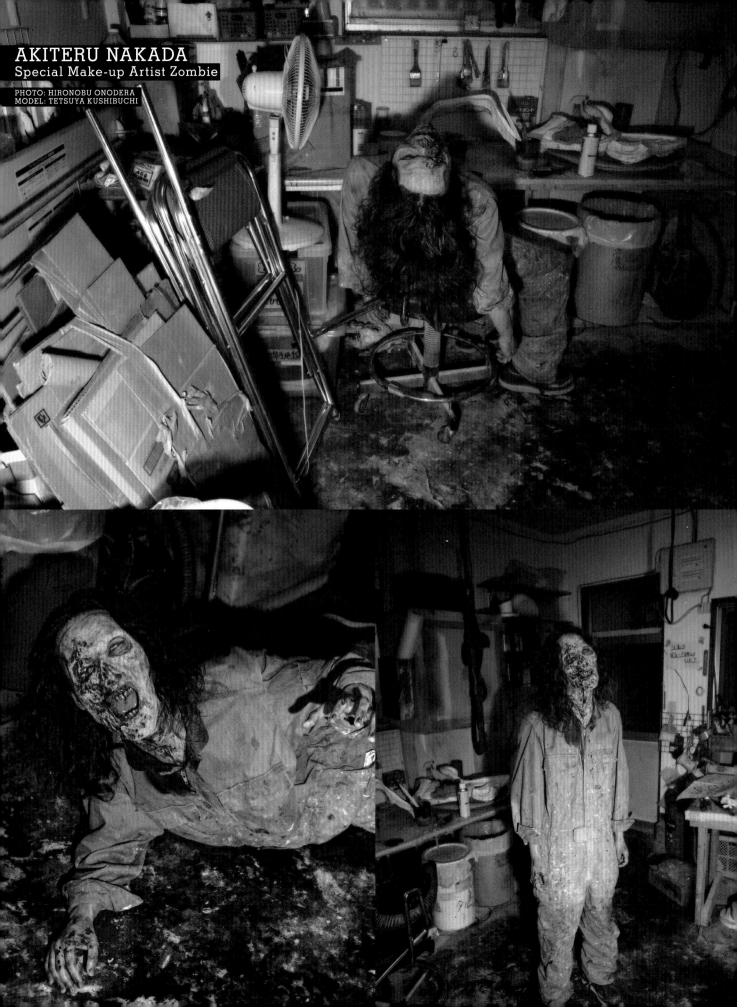

AKITERU NAKADA
Special Make-up Artist Zombie
PHOTO: HIRONOBU ONODERA
MODEL: TETSUYA KUSHIBUCHI

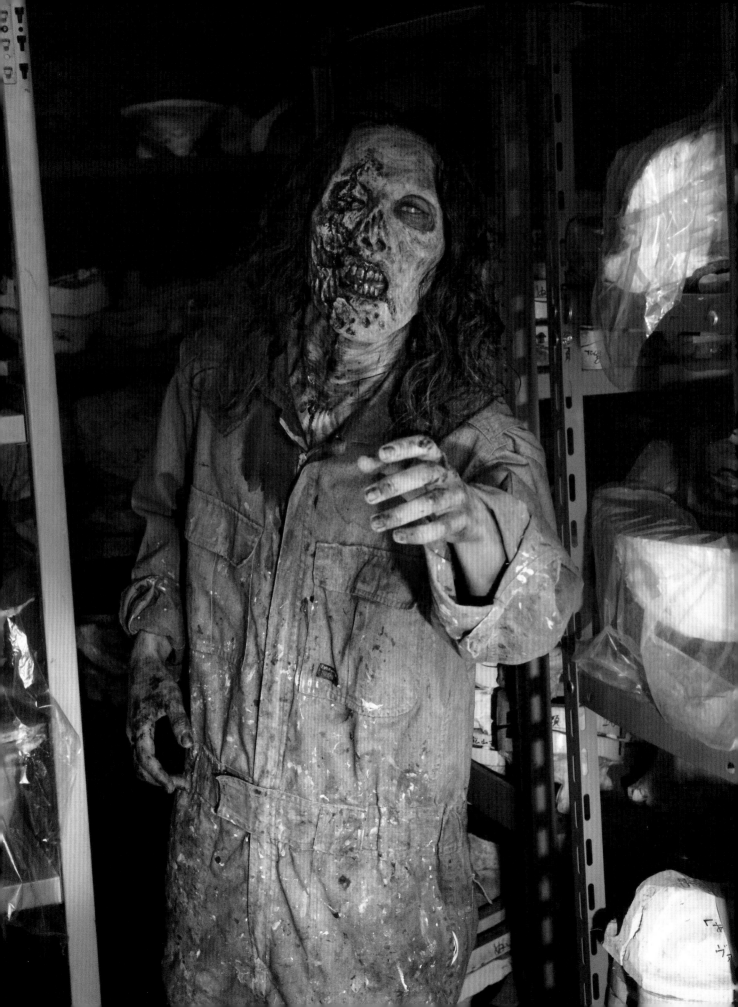

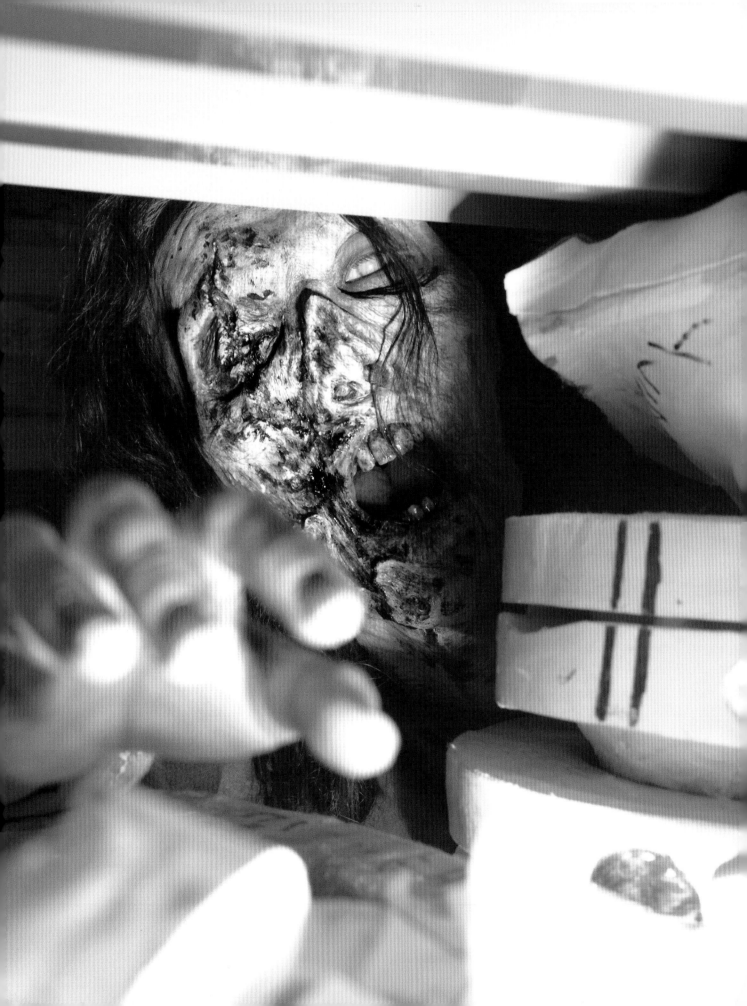

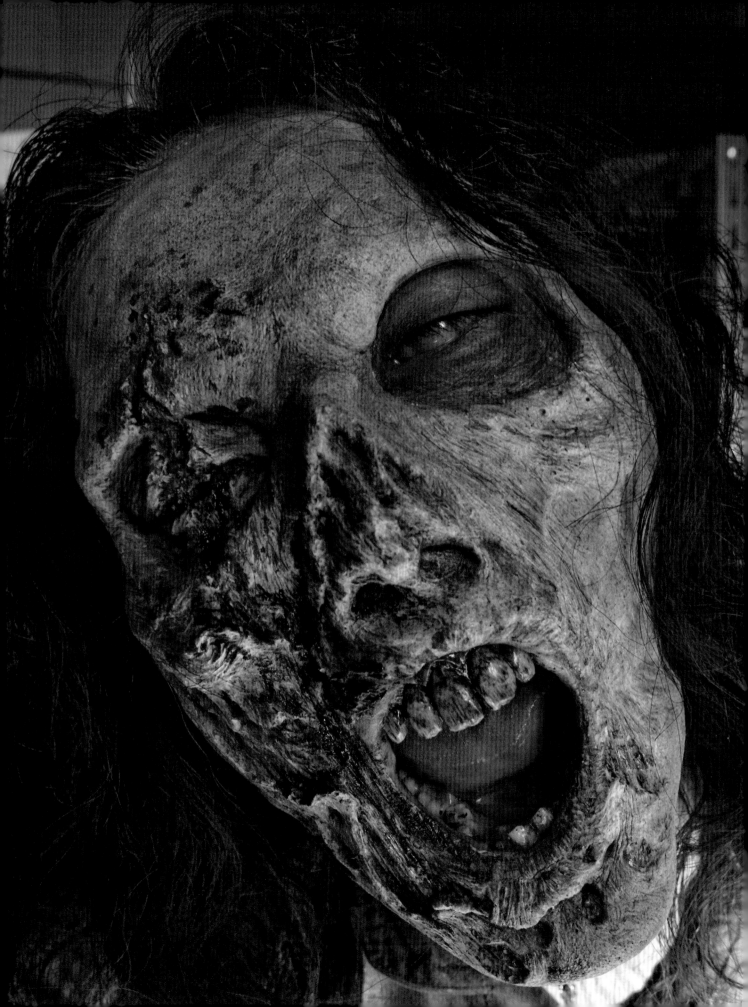

KAKUSEI FUJIWARA
MOTHER HYDRA (from Cthulhu Mythos)
PHOTO: YUN YUHA
MODEL: AKARI

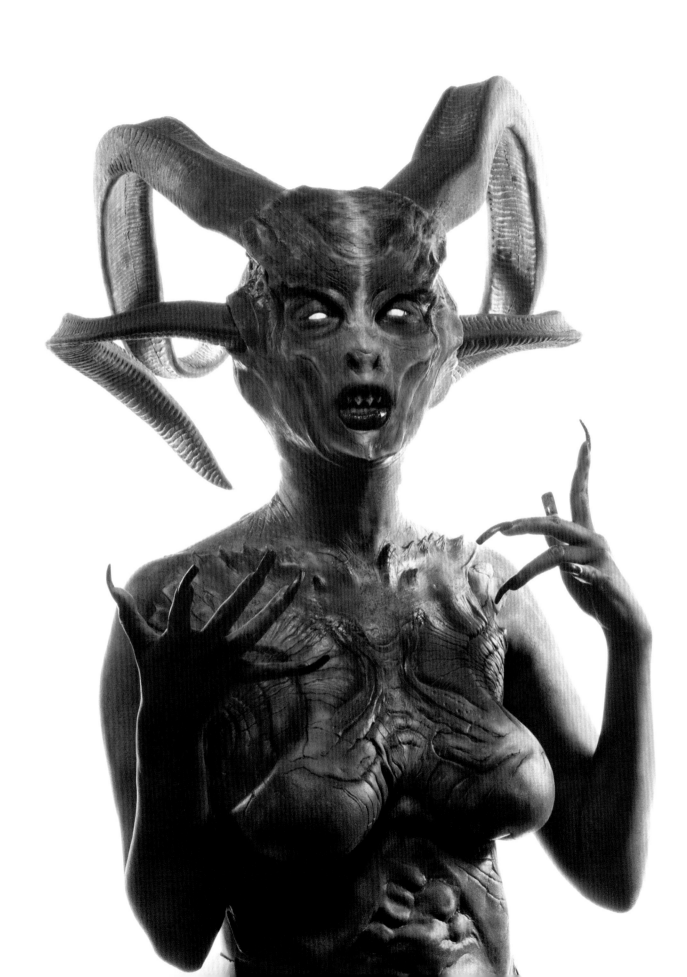

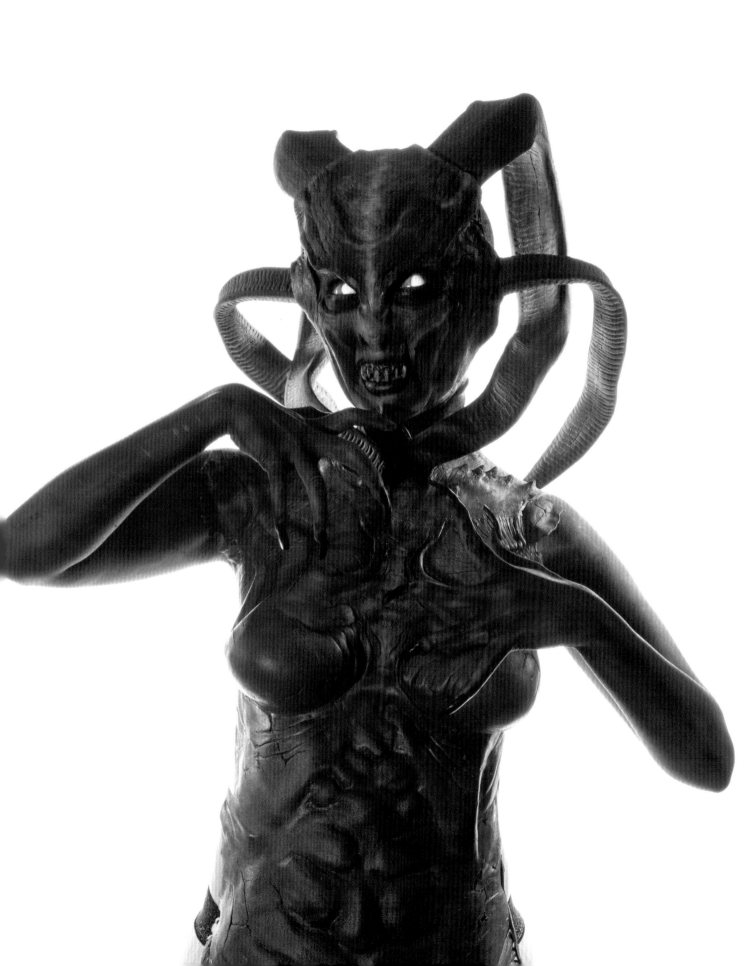

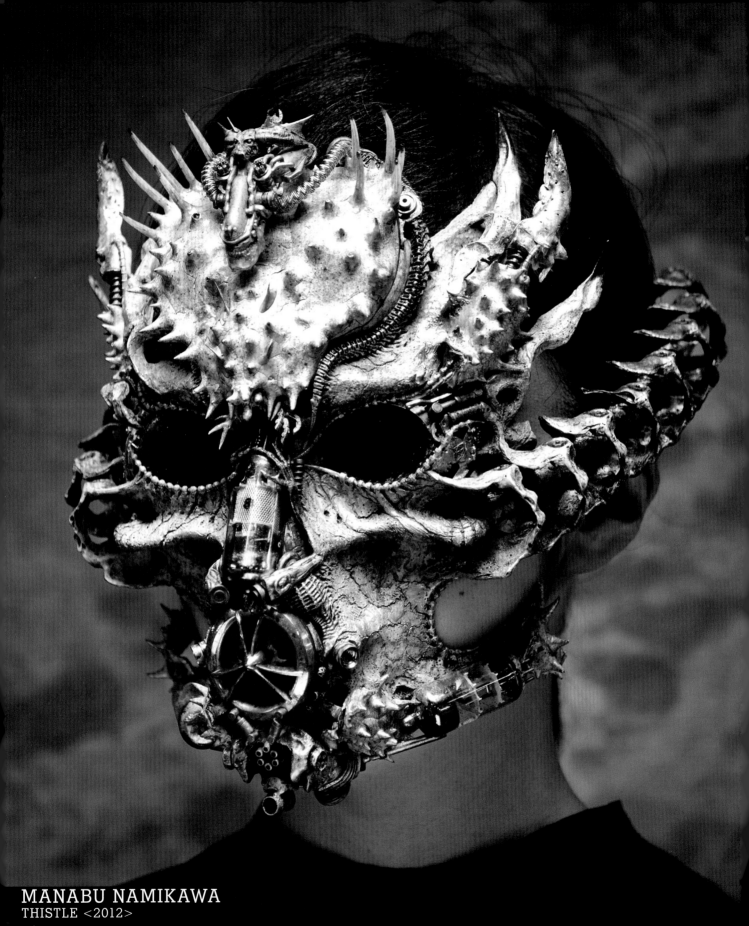

MANABU NAMIKAWA
THISTLE <2012>

PHOTO: YOSUKE KOMATSU
MODEL: MAYU KUMASAKA

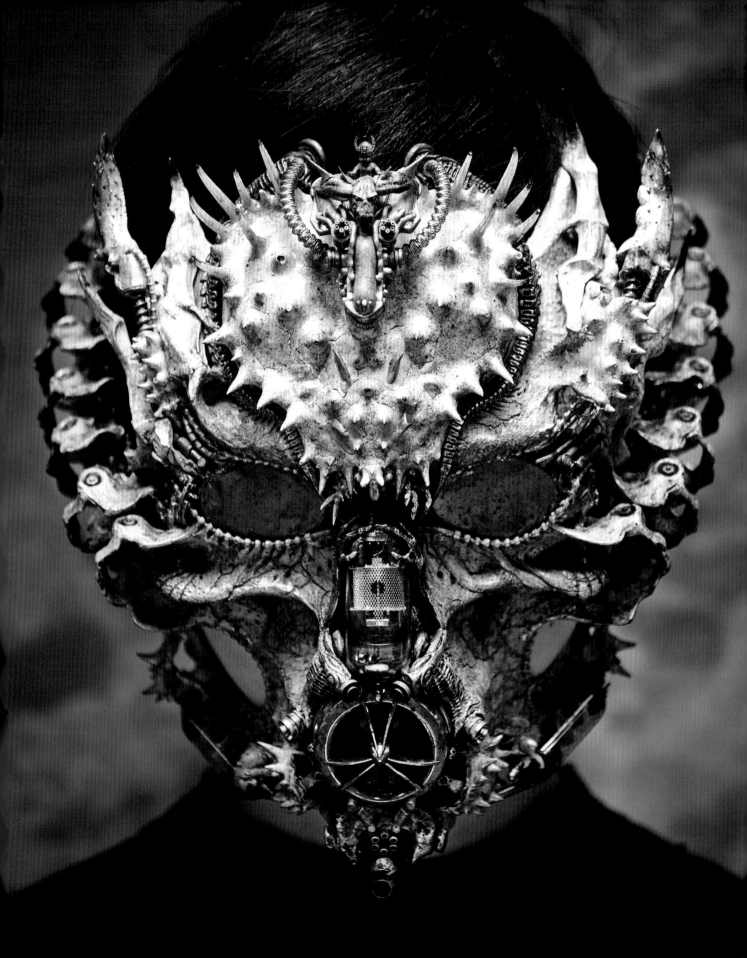

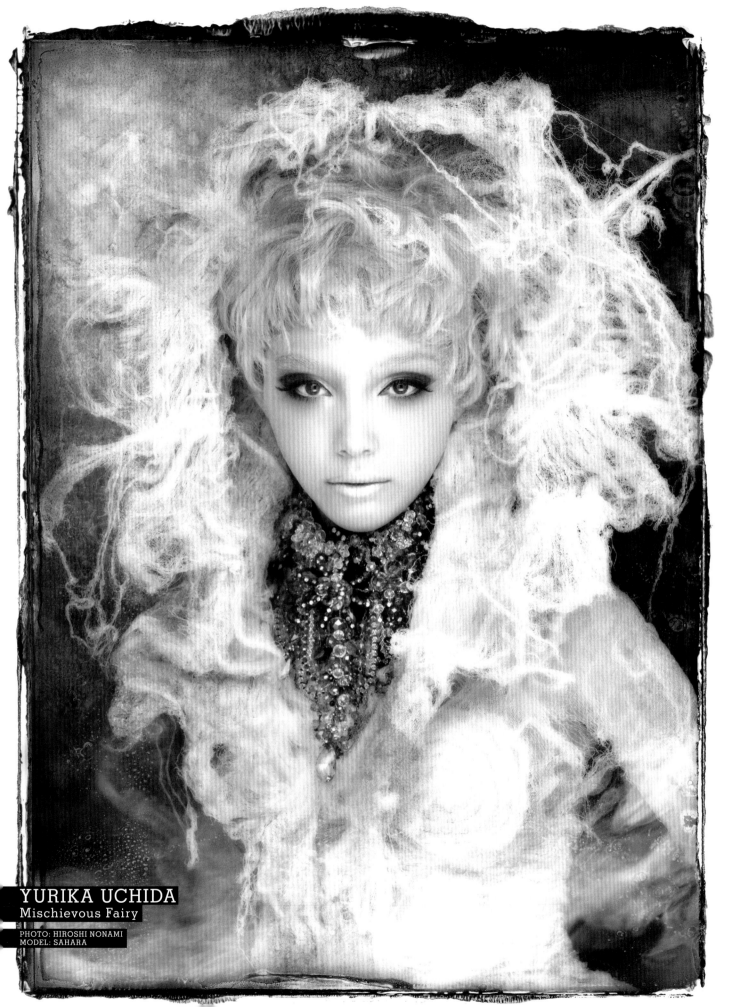

YURIKA UCHIDA
Mischievous Fairy

PHOTO: HIROSHI NONAMI
MODEL: SAHARA

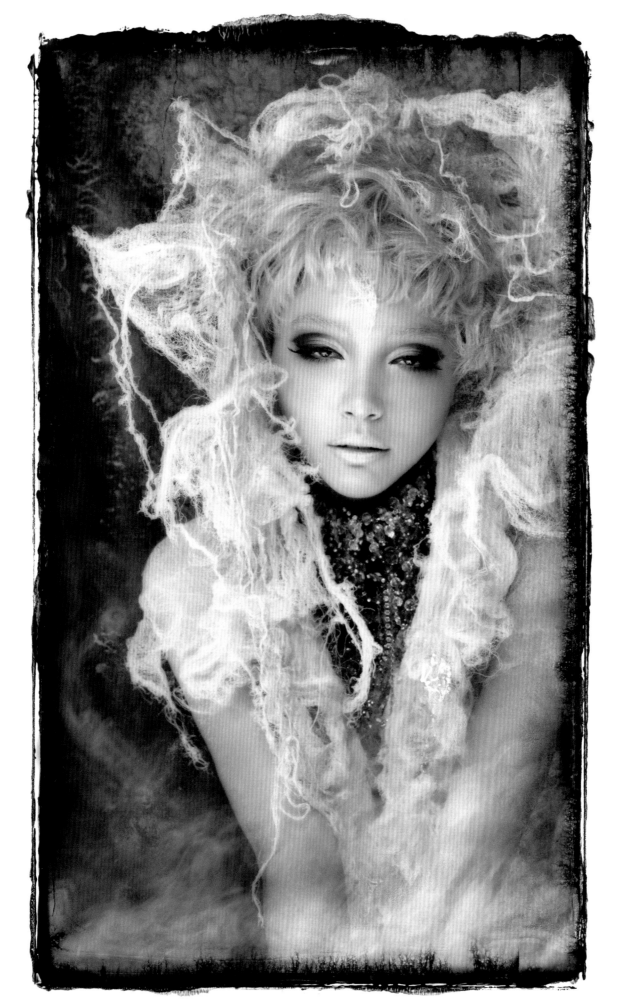

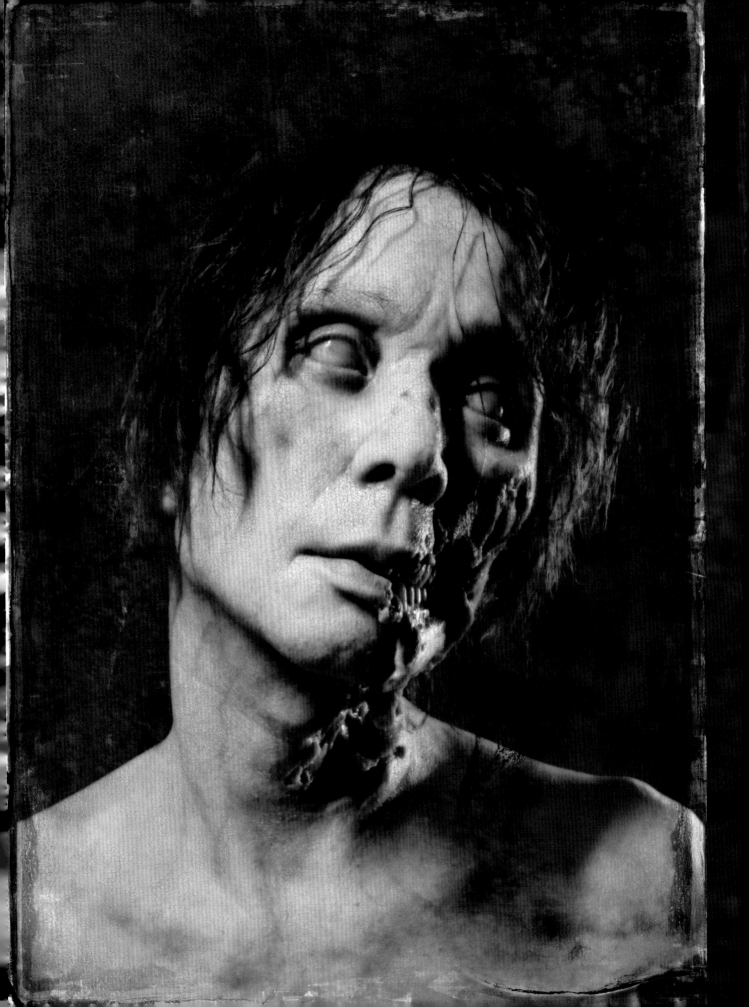

CHAPTER 01

CONCEPTUAL BEAUTY MAKEUP

by Yurika Uchida

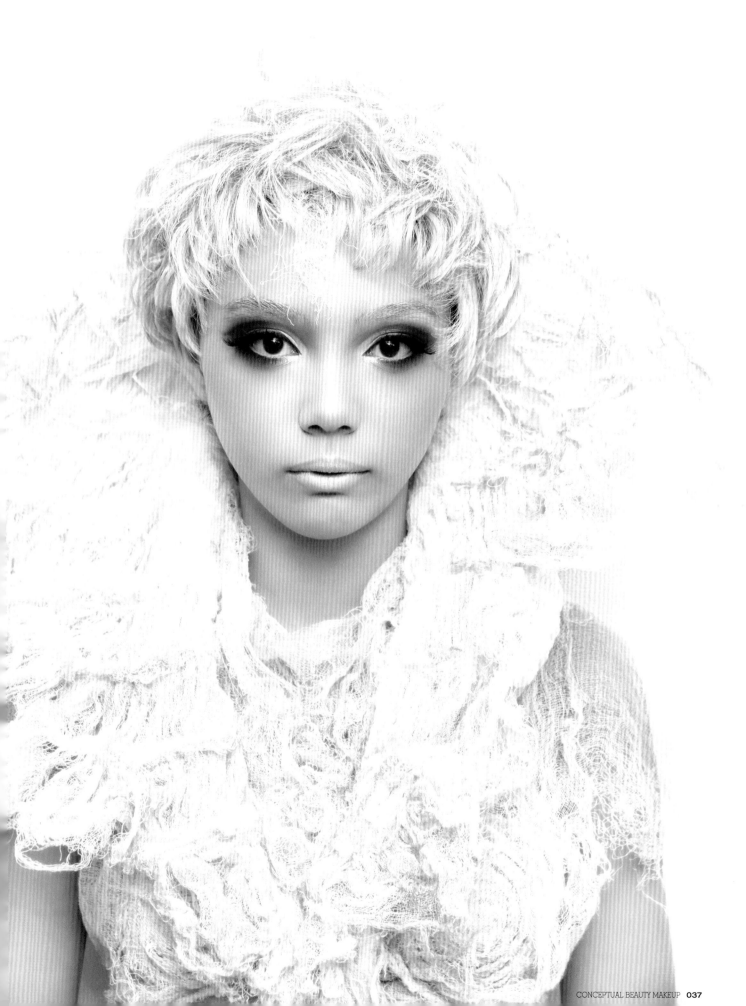

Special Effects Makeup Using Beauty Makeup
Fairy Makeup for Photoshoots

by Yurika Uchida

Apply "Mischievous Fairy" makeup by using two colors, black and red. Since the unevenness of any makeup application shows up clearly in photographs, you need to blend it completely, to the point where any unevenness is invisible to the naked eye. The point of fairy makeup is to accentuate the size of the eyes with a cut crease, to make the eyebrows less noticeable, and to make one's age and sex indistinct. In addition, pearl can help diminish the three dimensional feel and 'humanness' of the model.

Model: Sahara

[Materials]
Moisturizer, Concealer, Powder foundation (Lighter than the model's natural skin tone.), Foundation (White, Beige), Eye shadow (Grey, Red, Gold Orange, Black, White Pearl), Makeup pencil (Flesh color white, Black), Lip cream, Translucent loose powder, Liquid eyeliner (Black), White Brow Set (MAC), Pearl loose powder, Fake eyelashes, Wig, Hairpiece, Hair spray, Gauze, Black mascara

[Tools]
Sponge, Blush brush, Brushes (As many as you can prepare.), Concealer, Toothpicks, Heated eyelash curler, Fake eyelash tweezers, Powder puff

POINT
Wash brushes in lukewarm water using shampoo and then rinse them off and let it dry. This will help keep the brush soft.

POINT
Since airbrushed applications tend to dry out easily, applying foundation with your fingertips – except when concealing brown spots or moles – helps achieve a beautiful finish.

01

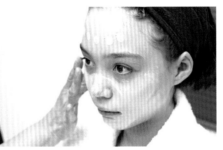

Using the back of your hand as a palette, mix RMK concealer and Make Up For Ever concealer together to make a foundation that is fairly white. Make the foundation about two shades lighter than your model's natural skin tone. Blot over the model's face and blend with your fingertips.

02

Blend the foundation evenly by dabbing with a sponge. Blend it so as to conceal the natural skin tone entirely. Do not make it "cakey" and ignore blemishes, dark circles under the eyes, redness of the skin, etc. Apply the foundation over the ears, the neck, the root of eyebrows, the hairline and the lips. At this point, create a base makeup that can hold up for the entire day.

03

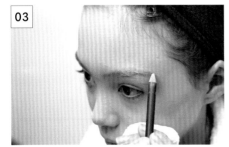

Since darker eyebrows produce a slightly harsh impression, you should apply flesh colored makeup pencil to the brows. A concealer would work as well.

04

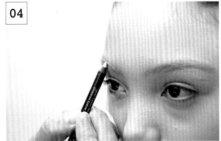

Apply white eyebrow pencil to the brows to make whiter.

05

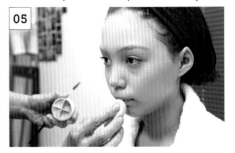

Apply concealer to the lips to produce a flesh-like color.

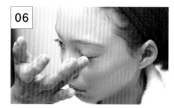

06

Apply white foundation around the eyes in order to make them one shade brighter. Be sure to use your fingertips because using a sponge tends to make the application uneven. Then, dust loose translucent powder all over.

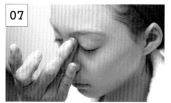

07

Prime all over the eyelids with white powder to bring out eye shadow colors that will be applied in later steps. At this point, do not touch the waterlines on both eyes as they will be finished last.

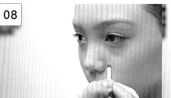
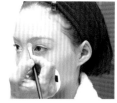

08

In order to make the eyes more three-dimensional, lightly trace the crease line using a color that is slightly darker than the natural skin tone. Apply eye shadow to the outside of the nose to bring out definition.

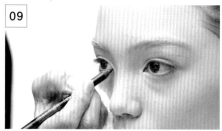

09

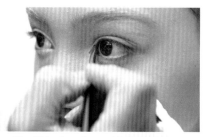

Determine the position of the inner corner of the eye while keeping the eyes open, then apply black eyeliner pencil at that position. Make fine adjustments with a brush by dabbing the brush tip onto the eyeliner pencil.

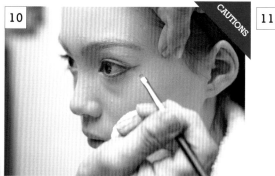

10 *CAUTIONS*

Make an outline on the outer corner of the eye. This will become the guideline when applying eye shadow.

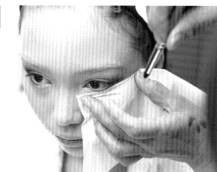

11

Hold a piece of facial tissue under the eye and apply a dark colored eye shadow, working from the outer corner of the eye toward the center. Then, blend with a clean brush to produce a graduated look.

POINT

First, do the application on the side of the eye that you feel is easier to work on. Then, work on the other side while being sure to match it with the side you just completed. This will make the application even on both eyes.

POINT

Do not use a cotton swab to blend as this will remove the base makeup. Be sure to use a clean brush to blend.

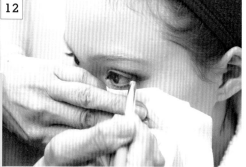

12

Apply eye shadow above the guideline, from the outer edge of the eye to the center. Then, blend it out with a clean brush.

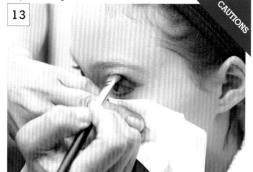

13 *CAUTIONS*

Similar to the cut crease, be sure to apply the eye shadow by drawing inward from the outer corner of the eye.

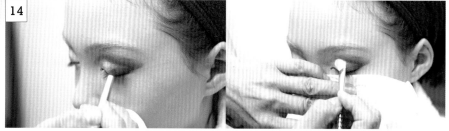

14

Apply white pearl to 1/3 of the eye lid, beginning at the inner corner of the eye. Then, blend it in with the eye shadow applied from the outer corner of the eye with a clean brush, all while being sure to create gradations.

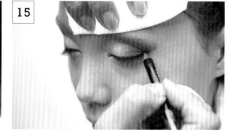

15

Apply black eyeliner to sharpen the outer corner of the eye.

16

Close the eyes. Use a black eyeliner pencil to extend the crease line to the inner corner of the eye and then blend out with a clean brush. Add gradations with grey eye shadow.

17

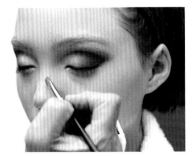

Apply beige eye shadow to a triangular-shaped area above the crease line, toward the inner corner of the brow. Then, blend it out toward the tip of the nose.

18

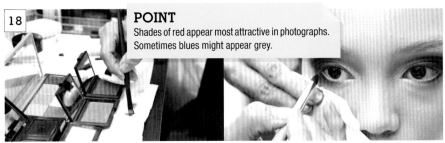

POINT
Shades of red appear most attractive in photographs. Sometimes blues might appear grey.

Use Gold Orange eye shadow to trace along the lower lash line, toward the wing of lower lash line, and then blend with a clean brush.

19

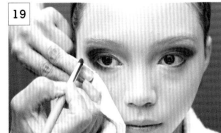

Soften the harsh impression of the lifted eye by laying black on the outer corner of the eye.

20

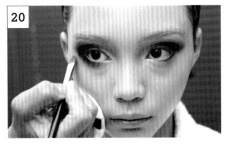

Apply more Gold Orange under the eye and then blend it out with a clean brush (see next step).

21

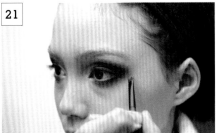

Apply the Gold Orange entirely above the crease line. Do not apply it all the way to the inner corner of the eye.

22

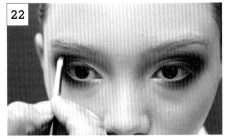

For the spot where the black eye shadow becomes soft, lay black over it again to give the eye a sharper look. Put some grey eye shadow on a small brush and then extend the crease line to the tip of the inner corner of the eye.

23

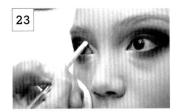

Line white pearl from the inner corner of the eye to the under eyelid, and then blend it out.

24

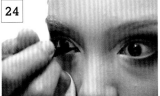

While keeping the eyes open, line the inner corner of the eye with black liquid eyeliner.

25

Close the eyes and then apply black liquid eyeliner between the roots of the lashes. After that, blend with a brush so it looks soft.

POINT
Apply using an outward stroking motion so as not to cause an upward "wing."

26

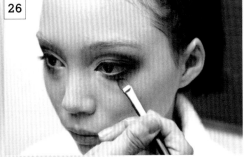

This step, along with step 23 above, should sufficiently cover black circles under the eyes.

27

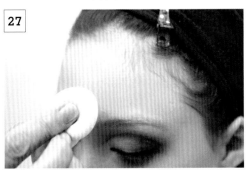

Check once again for blemishes and brown spots and apply concealer to cover them. Use a powder puff to dab powder foundation (the same color as the foundation that you applied in previous steps) onto the face in order to eliminate any overall unevenness. Be sure to press the powder foundation into areas around the nose where the makeup tends to come off easily.

28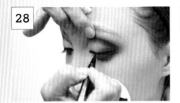

Use black liquid eyeliner to fill in between the roots of the eyelashes.

29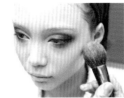

Apply a darker powder foundation from the highest point of the cheekbone down toward the jaw and blend it in the same manner as applying blush to a contour.

30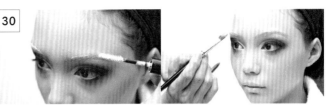

Apply MAC White Brow Set on the eyebrows and then apply foundation over that.

31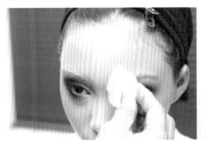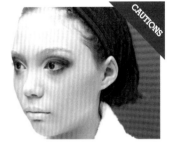

CAUTIONS

Apply loose pearl powder on the bridge of the nose and the forehead to highlight. Apply foundation to the lips and then loose pearl powder over that. Finally, remove any excess.

32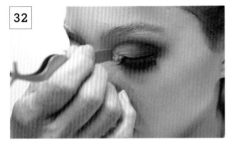

Lightly apply mascara to add volume and then apply fake eyelashes 2/3 of the way along the lash line from the outer corner of the eye. Apply the fake eyelashes with the eyes slightly lowered in order to prevent the eyelashes from hiding in the cut crease.

33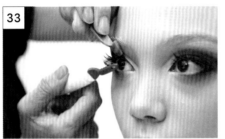

Apply mascara to blend the natural and the fake eyelashes together and then curl the natural eyelashes with a heated eyelash curler in order to lift them up to the same position as the fake eyelashes. For the lower eyelashes, only mascara is applied.

34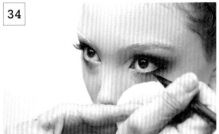

To produce a sharper edge, add a line with black liquid eyeliner from the outer corner to the center of the eye.

35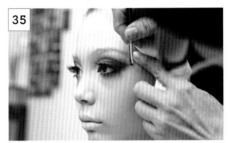

Make fine adjustments with red and black eye shadow. Fine adjustments are a must because attaching fake eyelashes changes the makeup lines.

36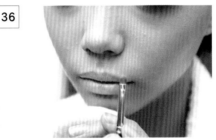

Draw an outline around the lips with beige powder and contour it with flesh color gradations. Then, add pearl.

37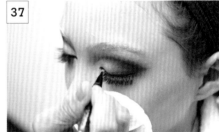

Once the fake eyelash adhesive has dried, paint it with black liquid eyeliner.

38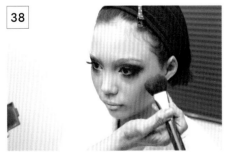

Apply blush and then blend in with powder.

39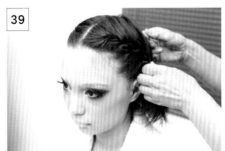

Wet the hair and braid it flat.

FINISHED!!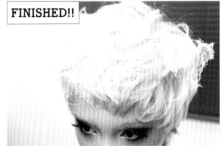

Put a wig on the model and add a hairpiece at back of the head. Adjust the shape of the hair and then strategically add cut up gauze (attached with pins) to decorate. Apply soft hairspray and adjust the hair style to complete.

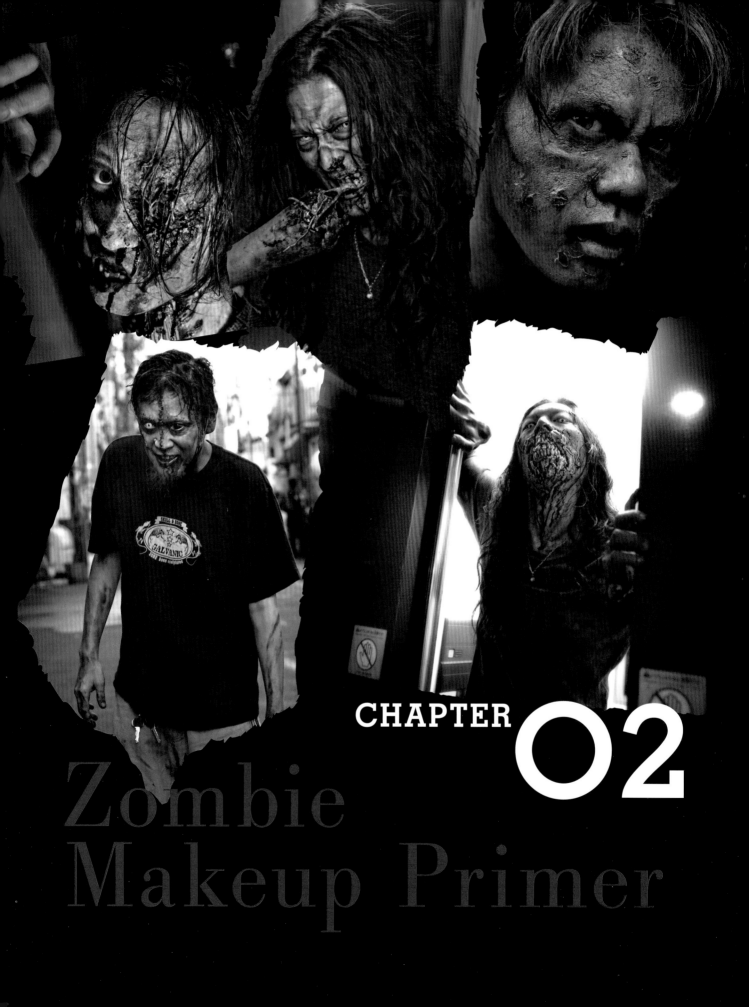

CHAPTER 02

Zombie
Makeup Primer

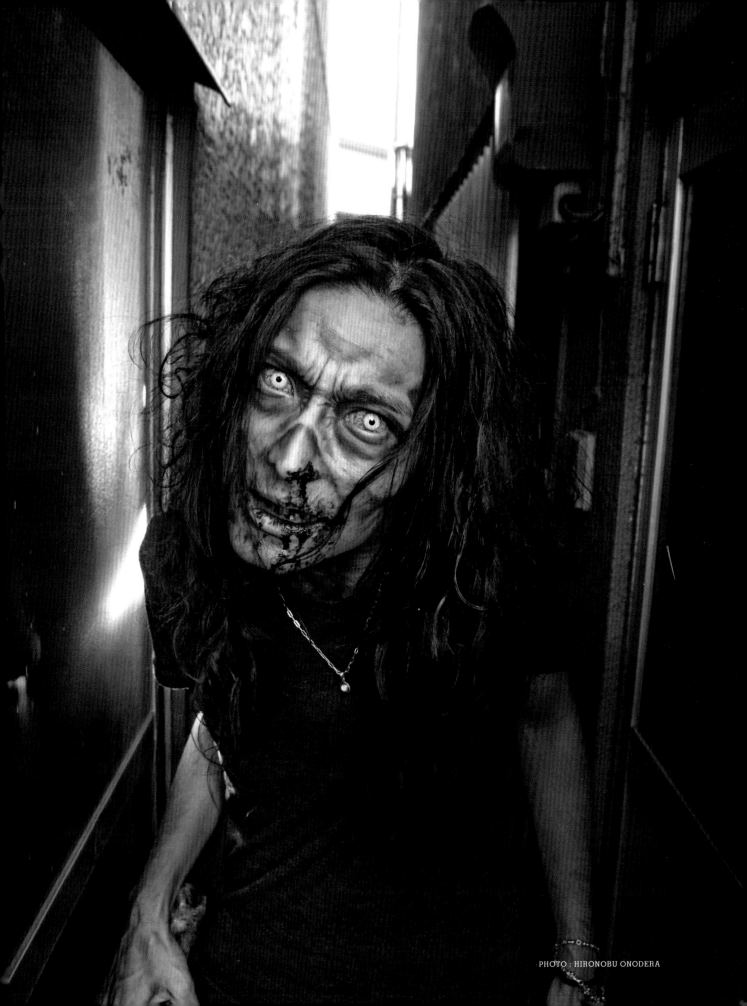

Zombie Makeup Primer

BenNye greasepaint and fake blood.
Using greasepaint only, give contour and definition to create a zombie look.

Flesh Zombie Makeup

by Akiteru Nakada (M.E.U)

Postmortem: 10 days. The hair and eyebrows still continue to grow even though water retained in the body has started to dry out. Thus, the eyes become hollow and the cheekbones become prominent. As a result, the body gets thinner.

Model: Shinjiro Saito

[Materials]
Greasepaint (BenNye Shadow Wheel, Death Wheel), Loose powder, Powder foundation for special effects makeup (RCMA), Zombie contact lenses, Aerosil®, Fake blood, Black Tooth Color (BenNye)

[Tools]
Large blush brush, Medium blush brush, Fine-point brush

POINT
Touch around the model's eyes in order to find the orbits. Then, apply greasepaint along the borderline of the orbit. If too large, the makeup may result in a look that is reminiscent of a panda, so be careful.

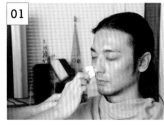

01

Use astringent to wipe excess oil from the face.

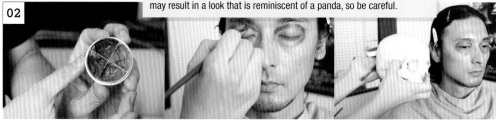

02

Although this procedure uses BenNye Shadow Wheel, other kinds of greasepaint should work. Shadow Wheel is a four color kit developed for aging makeup applications like wrinkles and shading. Choose a light color from the kit that contains a small amount of yellow pigment. Apply it in order to produce shadows around the eyes, and anywhere else you must, with a large brush.

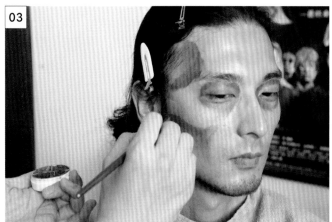

03

Apply greasepaint on the cheekbones and temples since they produce shadows. Make the most shaded areas dark and then blend out.

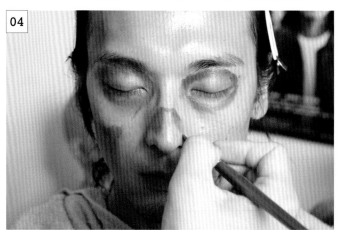

04

Apply greasepaint to the contours of the nose, as it is concave and the end of nasal bone tends to taper off.

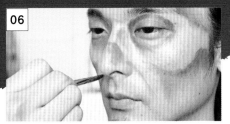

Apply to both side creases of the nose, as well as the laugh lines, to produce more shadows.

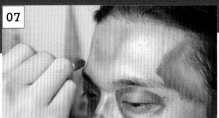

In order to emphasize the forehead, apply greasepaint to produce shadows. If you ignore the model's bone structure, the finished makeup will not appear realistic, so be careful.

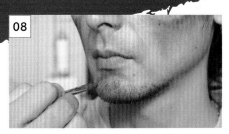

Apply greasepaint to define the jaw as well.

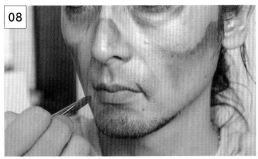

Apply greasepaint on both sides of the mouth to portray wrinkles from saggy skin.

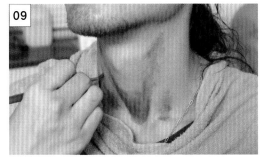

Add shadows toward the collarbone in order to emphasize the Adam's apple.

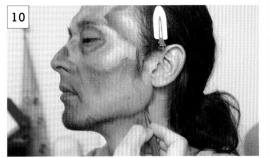

Add shadows under the jawline to accentuate the bone structure.

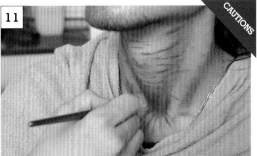

If the Adam's apple is left untouched it looks too clean. So, apply greasepaint to the Adam's apple with side strokes, blend it out, and then add details.

Blend out greasepaint that was applied in previous steps with the finger tips and then dab with loose powder. Make a layer by applying loose powder over greasepaint. Greasepaint is oil based and tends to be sticky. Prevent the colors from mixing by applying in layers.

Using a slightly fine-tipped brush apply the deepest dark brown available, in the darkest places, to tighten the application. Do not apply greasepaint where you initially didn't apply it.

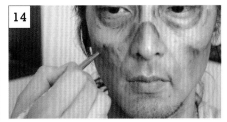

Dab on some greasepaint with a brush, or make the application speckled in order to add dimensions to the face.

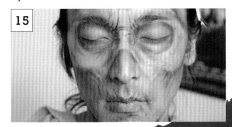

Since the lips become the most dry, add fine wrinkles, radially upward from the upper-lip, to make the lips look thinner.

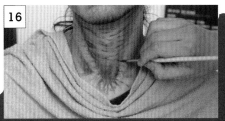

In a similar manner, add shadow on the darkest spots at bottom of the neck to bring out the three-dimensional feel.

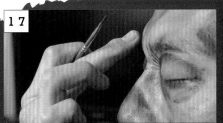

Change to a fine-tipped brush, add wrinkles with the dark brown greasepaint between the brows. Doing so creates an angry expression. Once again, darken around the eyes with the dark brown.

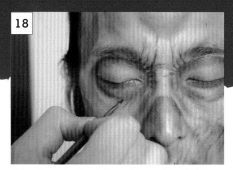

18 Dab with powder foundation and then add a black line where you intend to create a sunken, engraved, feel.

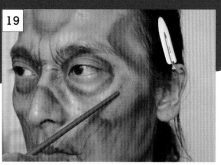

19 Adding shadows to the outside of the eyes makes the edges of the sockets more prominent. Do not trace over the brown greasepaint applied earlier with black greasepaint! Rather, apply black at the edge of brown shadow to be effective.

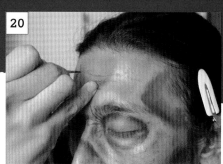

20 Using a fine-tipped brush, add wrinkles on the forehead with the darkest brown greasepaint.

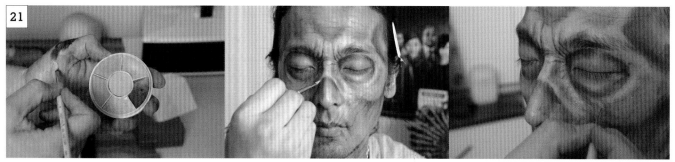

21 Using Ben Nye "Death Wheel" ivory (bloodless complexion white), add highlights to areas that are exposed to light.

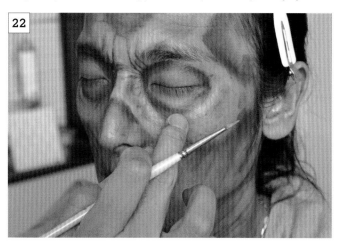

22 Dab it on with a brush then blend out with the finger tips. Express the dimensions of the face with an uneven application.

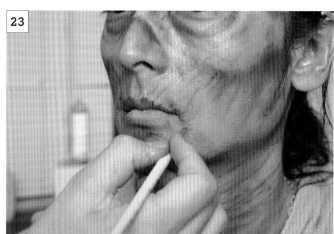

23 Apply Death Wheel ivory on the lips and then dab on powder.

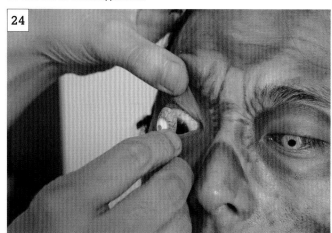

24 Put bloodshot eye/zombie contact lenses in.

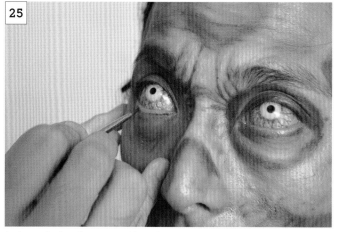

25 Apply purple along the upper and lower lashline.

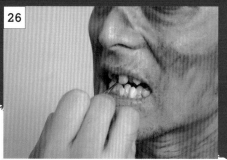

26 Wipe moisture off the teeth and then apply Ben Nye Black Tooth Color. Next, melt off any excess with alcohol.

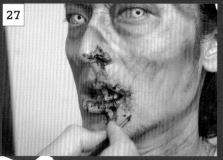

27 Mix a small amount of Aerosil® (a thickening agent) with fake blood to make a paste and then apply it on the lips and the nostrils. When doing this at home, use either blueberry jam or raspberry jam and blend out with the finger tips.

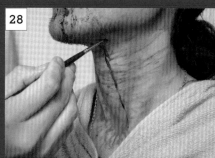

28 Add streaks of fake blood to the throat.

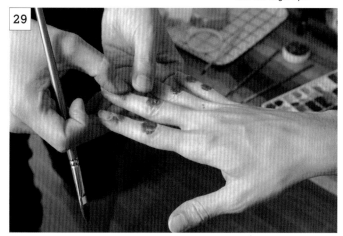

29 Apply dark brown greasepaint on the knuckles and blend out with the finger tips. Similarly, apply dark brown greasepaint between the fingers and blend out using the finger tips.

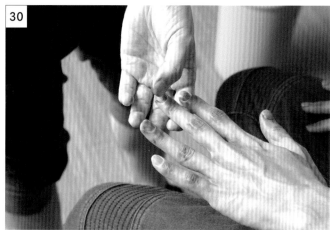

30 Outline the nails with black greasepaint and then blend out using the thumb.

POINT
Purple and brown go well together! Both are colors that show decay and death – a necessity for zombie makeup application.

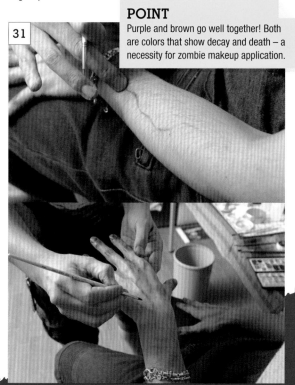

31 Trace the veins on the model's hands and arms with purple greasepaint since they look purple under the skin when the blood in the blood vessel decays. Dab with powder and then you are finished!

FINISHED!

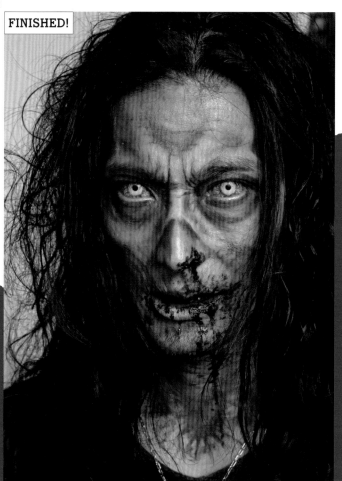

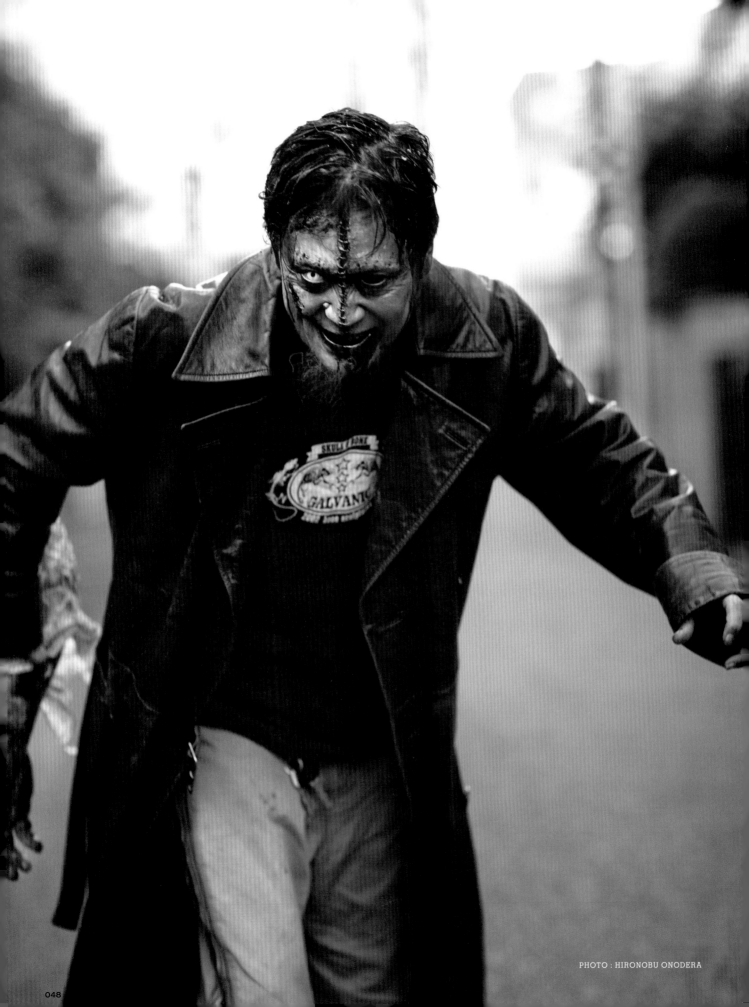

PHOTO : HIRONOBU ONODERA

Zombie Makeup Primer

Scars Made from Silicone Putty + Staples – Production of a Cracked Face Zombie

Cracked Face Zombie

by Tomo Hyakutake

Postmortem: over three months. The basic idea for this zombie is that decay has advanced from a knife wound and the zombie has stapled the wound himself in order to be able to move around. For this particular production, the face is painted a bi-color to turn the zombie into a character, although it should be noted that if you intend the zombie to be realistic, use just one color.

Model: Yasushi Nirasawa, a character designer

[Materials]
Shaving cream (for men), Makeup putty (from Mitsuyoshi), Silicone putty (A, B, C), Loose powder, Greasepaints (in Red, Black, Dark Brown, Brown, Blue, White, and Green from Mitsuyoshi), Colored contact lenses, Hair gel, Fake blood, Gauze, CD of Rob Zombie

[Tools]
Spatula, Paper cup, Flat brush, Fine-tipped brush, Engraving tools, Staples, Tweezers, Blush brush

01

For skin protection, apply men's shaving cream on the brows.

02

Take Mitsuyoshi Makeup Putty (eyebrow concealer) on a spatula, stretch it as thin as you can to conceal the brows by following the flow of the brow hair. Simply covering the brow hair is enough as it can be glossed over by applying color later.

03

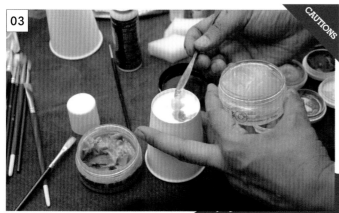

Using the bottom of a paper cup, mix together silicone putty A, B, C, in a 1:1:1 ratio. When you mix in part C the curing time will be slowed, so be careful.

CAUTIONS

04

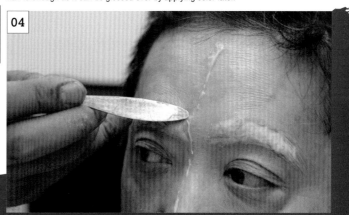

Apply mixed silicone putty on one side of the cracked wound to make a bulge. Then, smooth out the ridges.

05

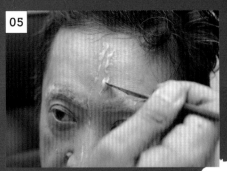

Apply mixed silicone putty on the other side of the cracked wound as well, in order to create a bulge. Then, smooth out the ridges.

06

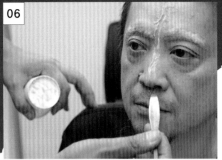

Apply mixed silicone putty under the nose and below the lips too.

07

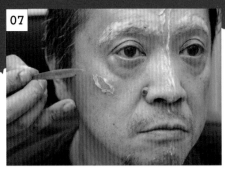

Apply mixed silicone putty to create a decaying wound.

08

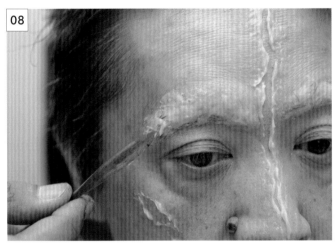

By applying the leftover mixed silicone putty on the brows, express the unevenness of the skin, while bringing out translucency at the same time.

09

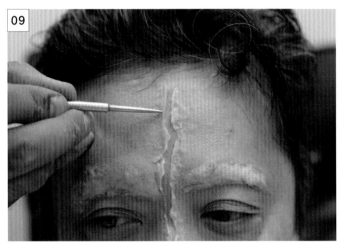

Dab with loose powder. Then, using an engraving tool, smooth the gap between the silicone putty and the skin before picking out the edges of the silicone.

10

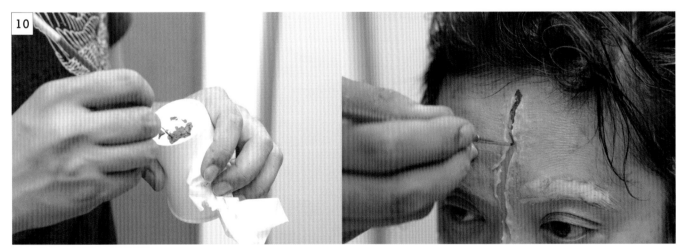

Mix red, dark brown and black greasepaint together. Apply the mixed greasepaint inside the wound with a fine-tip brush. In a similar manner, extend the wound onto the lips.

11

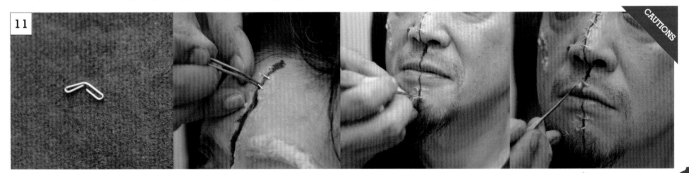

CAUTIONS

Punch out staples from a stapler and then bend them at the middle (See the above photo). One by one, carefully embed the bent staples into the silicone.

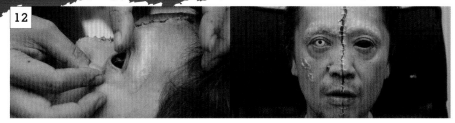

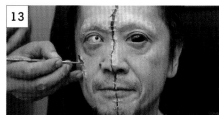

12 Put an unmatched pair of contact lenses in the eyes (of course you can use a matched pair if necessary). A contact lens where the white of the eye is made black helps to create an eerie look as the direction of the eye's gaze is unknown.

13 Mix red, dark brown, and brown greasepaint together and then apply it to the decayed wound.

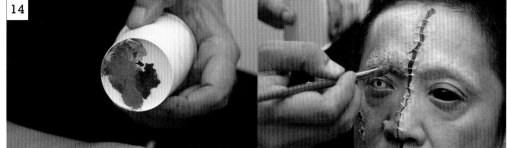

14 Make blue-grey by mixing black, blue, and white Mitsuyoshi greasepaint. Then, apply this to half of the face with a brush while making the application uneven. Apply it over the silicone putty but not on the edges.

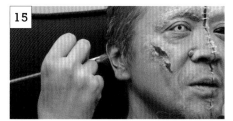

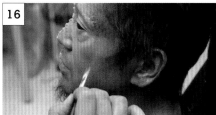

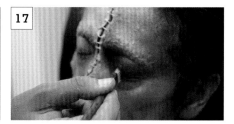

15 Apply blue-grey on the earlobe, inside the ear, around the eye and to the base of the neck.

16 Make green-grey by mixing green, brown, and black Mitsuyoshi greasepaint together. Then, apply it to the other half of the face.

17 Add black to the green-grey to darken the shadows. And then, using that, add shadows to wrinkles and to bone indentations.

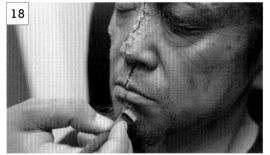

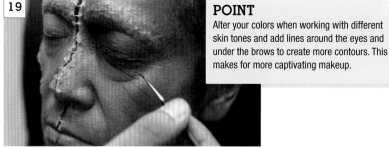

18 Add shadows on the lips where they are concave. Use a blush brush to add the shadows while blending the greasepaint.

19 Draw a dark line along the wrinkles with a fine-tipped brush. Also, apply dark green-grey wherever it looks hollow like between the brows, under the eyes, etc.

POINT
Alter your colors when working with different skin tones and add lines around the eyes and under the brows to create more contours. This makes for more captivating makeup.

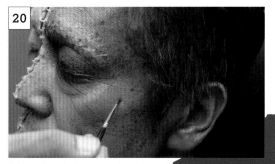

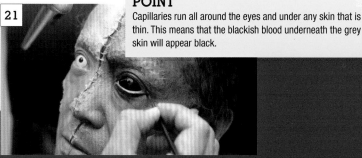

POINT
Capillaries run all around the eyes and under any skin that is thin. This means that the blackish blood underneath the grey skin will appear black.

20 Add death spots. These are similar to age-spots. Add many death spots on the side of the face.

21 Apply black greasepaint under the eye and then blend out while creating gradations. Apply black greasepaint slightly above the crease line.

22

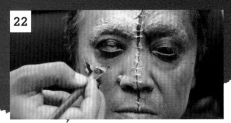

Add red greasepaint to blue-grey. Apply this around the eyes and then blend while creating gradations.

23

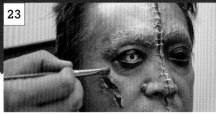

Using red, added to blue-grey, apply on the base of the staples by dabbing with a brush. Add uneven redness over the decayed wound and death spots using the color. Lightly apply on the forehead as well.

24

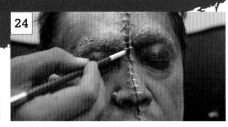

Blend using both the dried brush and the end of the brush.

25

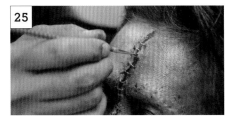

Apply red greasepaint around the bulged wound to make it look infected.

26

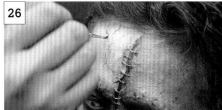

Mix reddish purple with black and then draw in capillaries with a fine-tipped brush. The veins come out from the temple - extend them by using a flat brush.

27

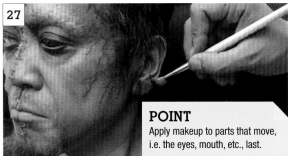

> **POINT**
> Apply makeup to parts that move, i.e. the eyes, mouth, etc., last.

Add red greasepaint on the earlobes and then dab with powder.

28

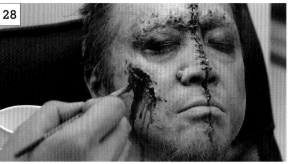

Drip fake blood inside the scar and in any large and small wounds.

29

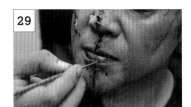

Mix fake blood and black greasepaint together and then apply to the lips.

30

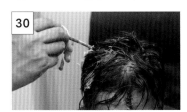

Using hair gel, tack the hair to the head. In order to add texture, apply fake blood and put pieces of cutup gauze all over the hair.

31

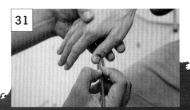

Apply brown greasepaint on the nails, add black shadows, and then you are finished!

FINISHED!!

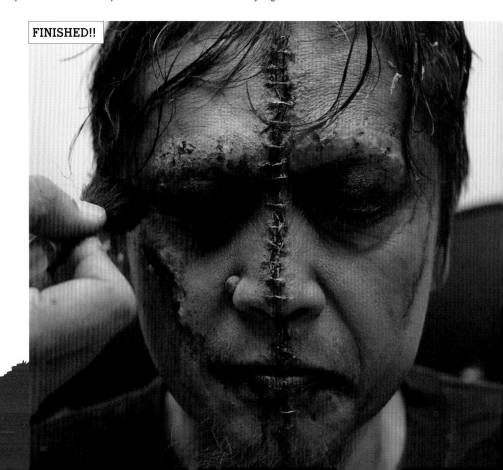

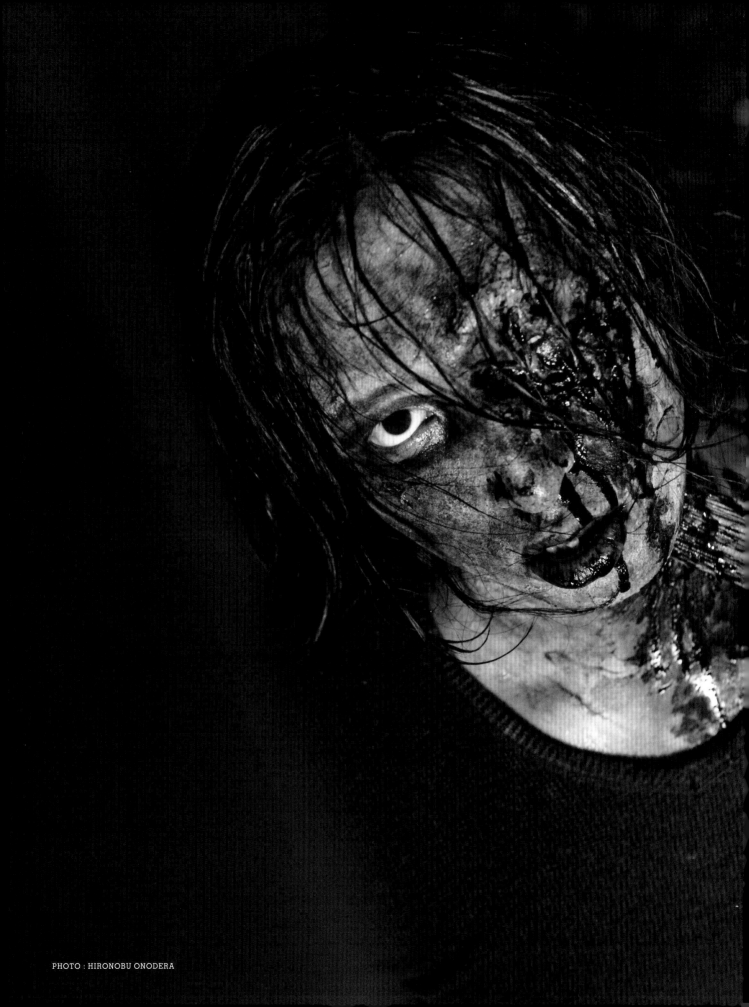

Zombie Makeup Primer

Latex and GEL10 – Production of a Decayed, Skin Peeled Zombie

Impaled Zombie (Self-makeup Application)

by Kakusei Fujisawa

Postmortem: more than ten months. Here we introduce the methods of self-makeup application for a complete version of the zombie – the eyes are destroyed, the flesh is decayed, and fat cells are exposed through the peeled off skin. Use olive oil and black sesame paste to finish.

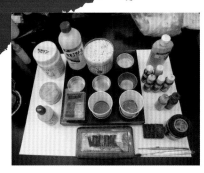

[Materials]
Moisturizer, Aeroflash (Turquoise Blue, Opaque Magenta, Sepia, Burnt Umber, Yellow Ochre), Pros-Aide, Mount ("Pasting mount" made from layered sheeting fabric glued together.), Wooden stake (Rigid urethane and Liquitex), Silicone (GEL10), Prosthetic Deadener, Ethanol, Vaseline®, Oil paint, Latex, Liquitex, Mizutoki Oshiroi (liquid white-color foundation from Butaiya), Latex appliance cream makeup "Undead Purple" (From Cinema Secrets), Cream foundation (Black), Skin Illustrator, TEMPTU DURA 313, Olive oil, Sesame paste

[Tools]
Airbrush, Brush, Urethane sponge for texturing, Engraving tools, Orange Stipple Sponge, Cotton swabs

Model: Kakusei Fujiwara, the make-up artist himself

01

Airbrush in the veins on the bottom layer as they can be seen through the rotten skin. Mix Aeroflash (liquid acrylic resin paint for airbrushing) turquoise blue and opaque magenta with water to make a bluish-purple.

02

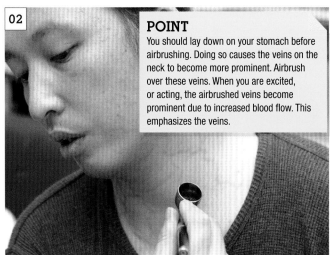

POINT
You should lay down on your stomach before airbrushing. Doing so causes the veins on the neck to become more prominent. Airbrush over these veins. When you are excited, or acting, the airbrushed veins become prominent due to increased blood flow. This emphasizes the veins.

Airbrush veins from the center of the face outward. On the neck, airbrush along the actual veins.

03

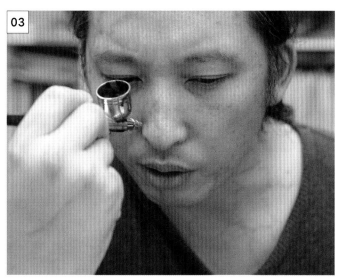

Using the same color, airbrush veins on the nose to simulate internal bleeding of the nasal cartridges.

04

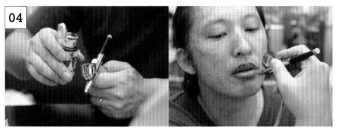

To conceal the redness of the lips, airbrush a mixture of sepia and burnt umber onto the outer line of the lips.

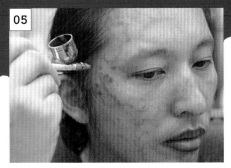

05

Airbrush in death spots using the same color you applied to the lips in the previous step. Produce a lot of death spots around the brows in order to make them less prominent.

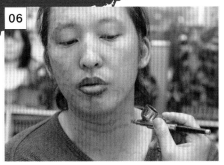

06

Add shadows along the wrinkle lines on your neck. Since latex is going to be applied in a later step, apply darker shadows here.

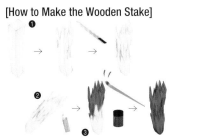

[How to Make the Wooden Stake]

❶ Using a utility knife, cut rigid urethane jaggedly to form the rough shape.
❷ Lightly "toast" the cut end with a lighter.
❸ Apply oil-based Liquitex over to finish.

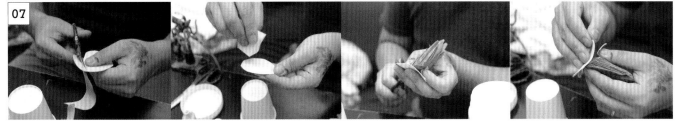

07

Paste on an "impaled wooden stake." Apply Pros-Aide to the back of the wooden stake and allow to dry. Next, put a mount (the "pasting mount") on the back of the wooden stake to adhere to the neck.

08

POINT
It looks cool when you attach the wooden stake diagonally!

Paste the wooden stake pasting mount in a position that does not feel uncomfortable, even when you move your neck.

09

Mix Silicone (GEL10) A and B in a 1:1 ratio and then add Prosthetic Deadener. Adding Prosthetic Deadener keeps the silicone sticky so it becomes soft.

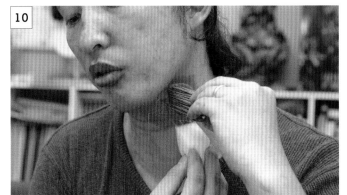

10

Apply Pros-Aide and then apply silicone over that. In about five minutes, it will begin to cure. If you have difficulties applying this by yourself, have a friend help.

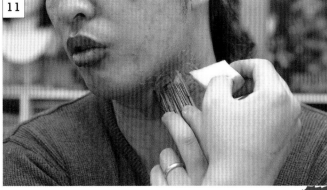

11

Dab a urethane sponge, used for texturing, in thinned ethanol. Then, in order to make the surface uneven, apply before the silicone sets.

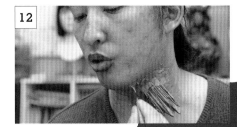

12

Add a claw wound using the tip of an engraving tool.

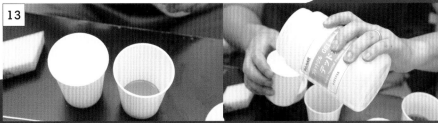

13

Prepare more silicone (GEL10) and then add Prosthetic Deadener for application around the eye. If you add more Prosthetic Deadener the silicone will become softer.

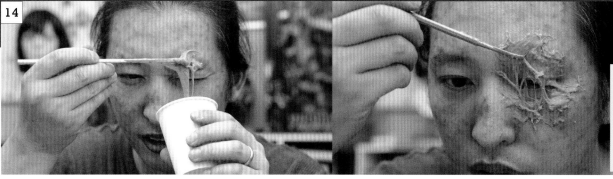

14

POINT
Only apply above the eye just before the silicone cures. This prevents dripping in the eye. Be very careful!

After covering about half of the eye, pull the almost cured silicone down to make it appear like muscle fibers.

15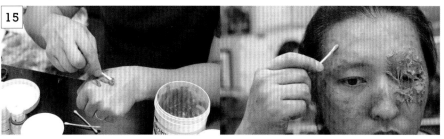

Prepare Vaseline® and add a small amount of red oil paint. Put this on the back of your hand and then apply to the face using a cotton swab. Since this application is to represent internal tissues, as seen through the peeled off skin, apply it on the cheekbones, tip of the nose, etc. Anywhere that skin can be easily peeled off.

16

Prepare grey colored latex by adding Liquitex.

17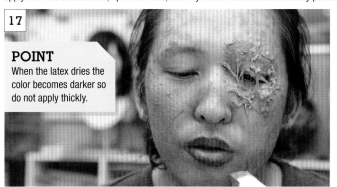

POINT
When the latex dries the color becomes darker so do not apply thickly.

Apply the latex by dabbing with a sponge.

18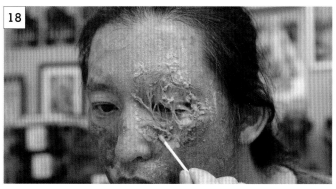

Thin the latex with water and apply further by dabbing over the application. Use a cotton swab for narrow spots.

19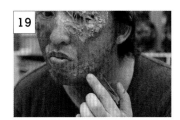

Peel off the Vaseline® applied in the previous step using your finger. Doing so makes it look as if the tissue inside is exposed through the peeled off skin.

20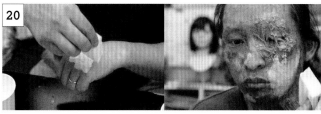

Apply Mizutoki Oshiroi (liquid white-color foundation), from Butaiya, thinly over everything.

21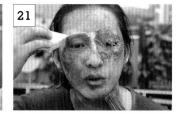

Make it really white where you intend highlights to appear.

22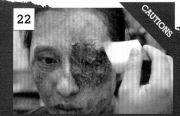

Dab flesh colored latex over the silicone tissue. On top of that, apply latex thinned with water. After that, peel the latex back with your finger so it looks like the skin has peeled off.

23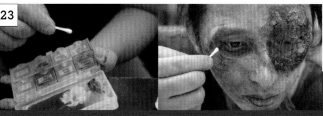

Apply "Undead Purple" (cream makeup for silicone from Cinema Secrets) around the eye.

24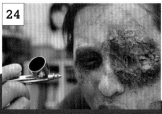

Airbrush the color for your dead spots into the hollows of the eyes and strengthen the death spots. Then, airbrush traces of body fluid that have leaked out.

25

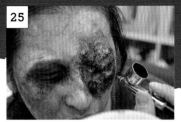

Add shadows at the edge of the silicone in order to make the wound appear to bulge.

26

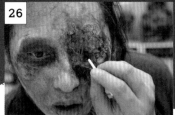

Remove any latex applied over the silicone using a cotton swab.

27

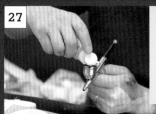

Dissolve black cream foundation in olive oil to thin.

POINT
If the black cream foundation is not thinned its application becomes unnatural. Apply repeatedly in thin layers to purposefully create unevenness.

28

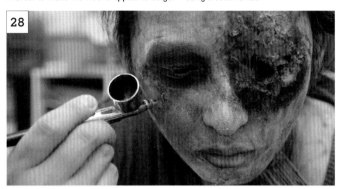

Airbrush black around the eyes.

29

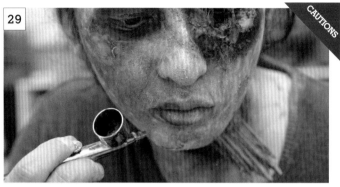

Add yellow ochre to the death spot color and then airbrush it on exposed interior tissues.

30

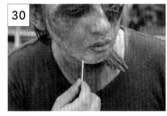

Apply reddish Vaseline® over airbrushed yellow. The Vaseline® melts away as time goes by and begins to look like the clear yellow color of fat.

31

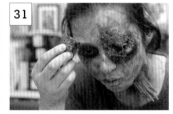

Dab Skin Illustrator on an Orange Stipple Sponge (a textured sponge for producing freckles) and then add small brown spots/unevenness to the face.

32

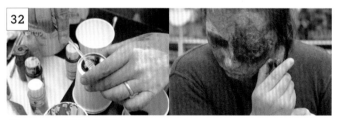

Thin out some TEMPTU DURA 313 using a small amount of ethanol. Put it on a toothbrush and then splat the brush toward your face (WARNING! CLOSE YOUR EYES DURING THIS PROCESS!).

33

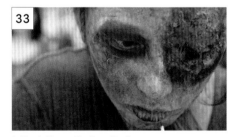

Add wrinkles vertically on the lips.

34

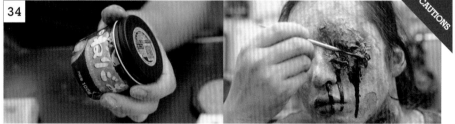

Use sesame paste to make some old blood! Mix well and apply to depict old blood that has gushed out and solidified.

FINISHED!!

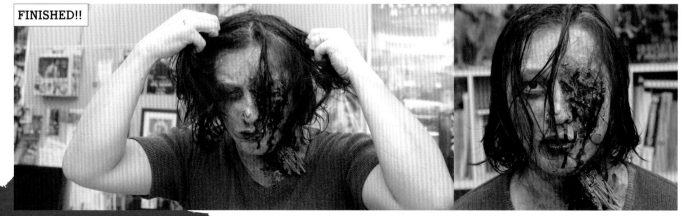

Wet the hair and then you are done!

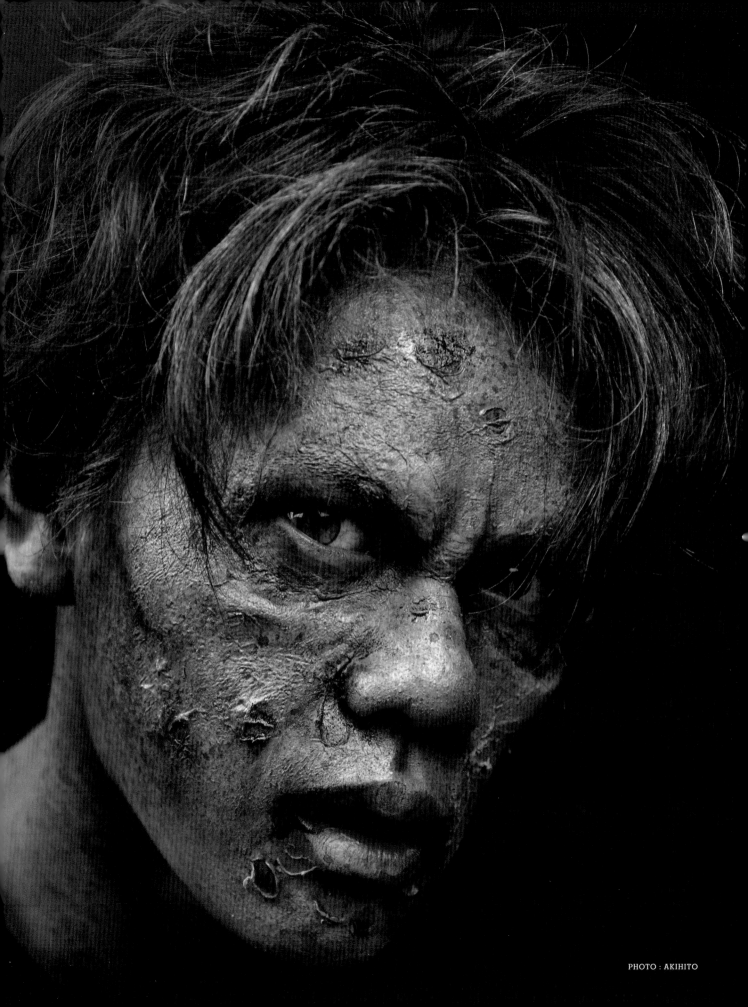

Zombie Makeup Primer

Reproduce Decayed Skin Using Tissues and Latex

Hollywood ★ Zombie Makeup

by AKIHITO

Akihito ~ a resident of Hollywood who was involved in the smash-hit TV show The Walking Dead – introduces the basics of zombie makeup.

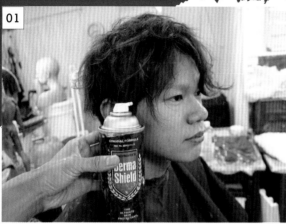

01

Apply Derma Shield for skin protection.

Model: Hiroshi Furuso (eighteen years old), a seventh generation student of AKIHITO Special Effects Makeup Private School.

[Materials]
Flesh tone wax, Derma Shield, paper tissues, Latex, PAX (mixture of Pros-Aide and acrylic paint), Skin Illustrator, Eye shadow, Highlight powder, Fake blood, Grey hairspray

[Tools]
Spatula, Engraving tools, Sponge, Airbrush

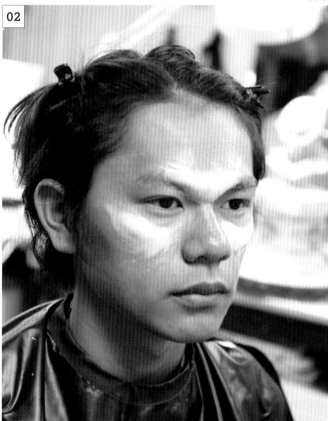

02

In order to accentuate the bones around the eyes, apply flesh color wax and sculpt.

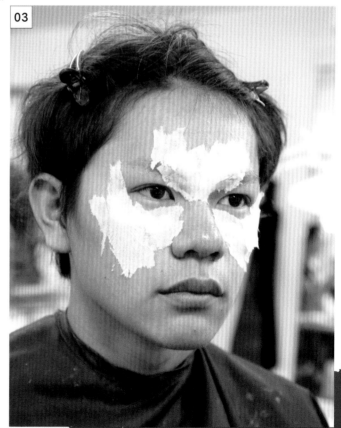

03

After sculpting the wax, tear a piece of paper tissue into small pieces and then put it on the wax across the forehead and the cheeks.

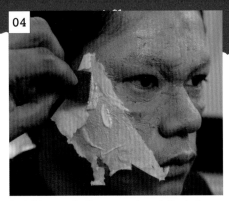

04

Apply latex over the tissue paper to paste it onto the skin.

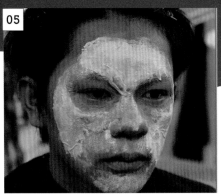

05

Paste tissue paper all over the face using latex.

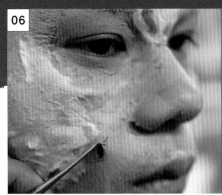

06

Peel portions of the pasted tissue off using a spatula in order to make decayed sections and small wounds.

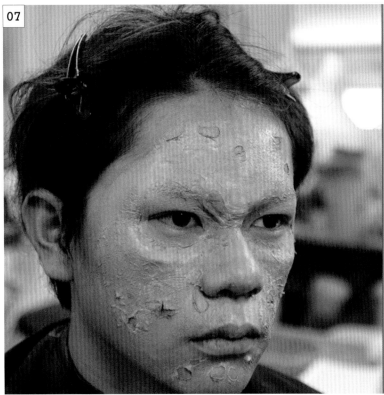

07

Adjust the overall skin tone using flesh color PAX (made by mixing a medical adhesive, Pros-Aide, and acrylic paint together).

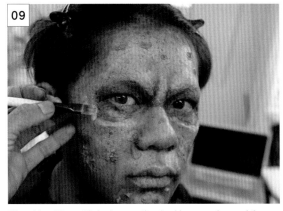

09

After airbrushing, add shadows on the cheekbones and around the eyes using a brush then highlight the T-zone. Add contours to the face to make the look more frightening.

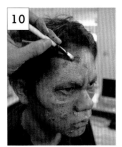

10

Add fake blood onto the wounds to make them look like injuries.

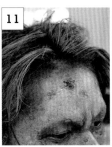

11

Apply grey hairspray to the hair to bring out the dirtiness of your zombie.

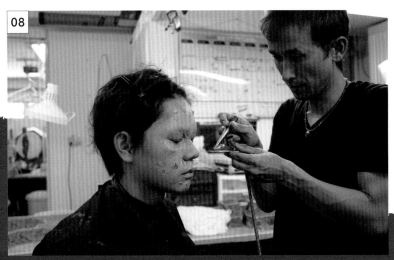

08

Using an airbrush, begin to paint by making dots. The paint used here is Skin Illustrator.

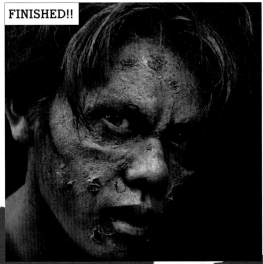

FINISHED!!

Complete!

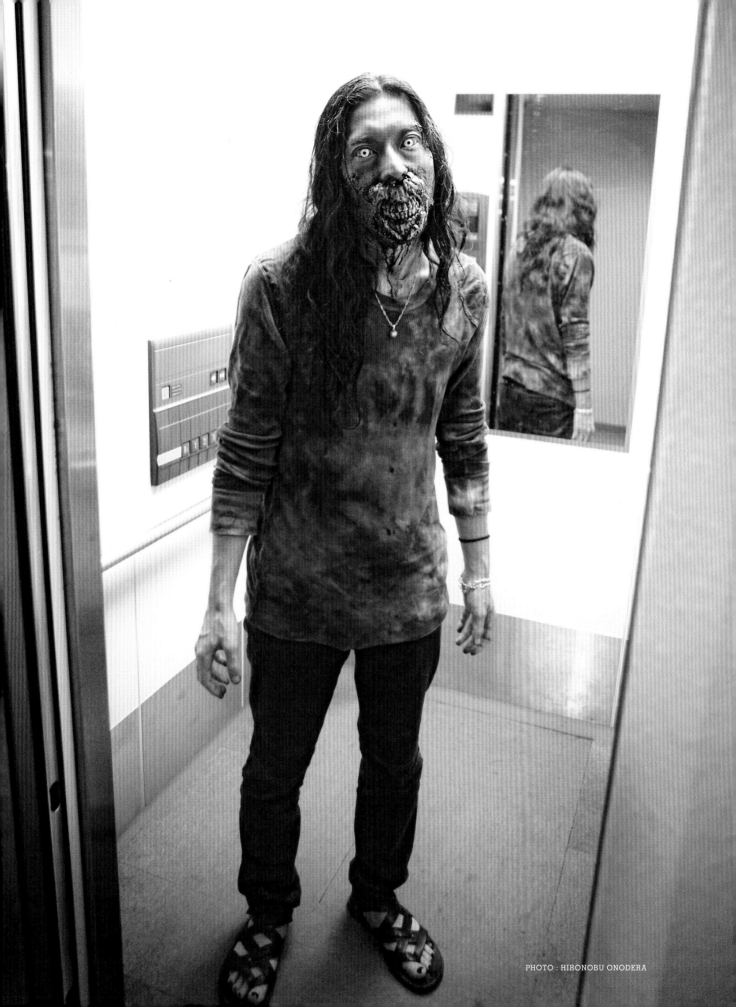

Zombie Makeup Primer

Produce Exposed Gums Using Dental Acrylic Dentures

The Fractured Lip Zombie

by Yuya Takahashi

Postmortem: three months with advanced decay. This zombie's lips are rotted and gone. This is a practical application that requires some preparation in advance. The exposed teeth are made out of dental acrylic and the rotten facial skin is produced using Pros-Aide Cabosil.

[Preparation 1. How to Make Prosthetic Wounds Using Pros-Aide Cabosil]

Pros-Aide Cabosil is a putty like material where Pros-Aide and silica are mixed together. This section introduces methods for making clean prosthetic wounds, in a short amount of time, by using tattoo paper.

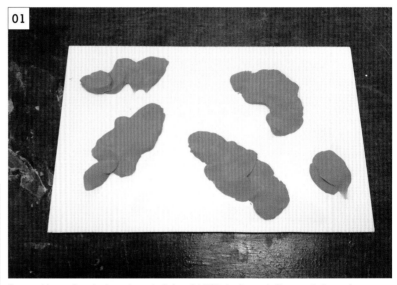

[Materials]
NSP clay, Wooden board, SUNPELCA® (polyethylene foam, for walling), Clear spray, Silicone & Curing agent, Cabosil, Pros-Aide, Mounting of transparent sticker sheet, Tattoo paper

[Tools]
Airbrush, Engraving tools, Brush, Spatula, Fridge

On a working surface (a piece of wood, etc.) sculpt NSP clay to create the overall shape of your prosthetic wounds.

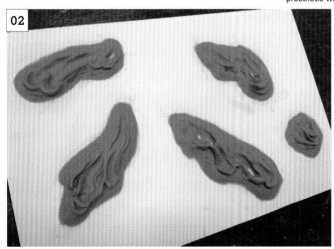

Carve out the details of each wound. Apply clay thickly and then scrape it off using the bottom of a brush to help achieve a hollowed out look. Shown above are original clay prosthetic wound sculptures.

Make a wall around the clay sculptures using SUNPELCA® (polyethylene foam). Actually, any material can be used as long as it encapsulates the sculptures.

04

Apply clear spray over the clay sculptures as a mold releasing agent. Mix silicone and curing agent in a ratio of between 100:1 and 100:5. Mix them well.

05

Drip silicone inside the wall thinly so it doesn't make any air bubbles.

06

Finish pouring the silicone. Then, use an airbrush to blow off any air bubbles and to distribute the silicone evenly into every nook and cranny.

07

Once the silicone sets, slowly remove it. The mold is now ready.

08

Mix Pros-Aide and Cabosil (silica) in a 2:1 ratio to make a paste that is toothpaste-like in texture. This is the Pros-Aide Cabosil. Carefully fill the silicone mold in using a brush and spatula.

09

After filling in the silicone mold carefully remove any excess using a spatula in order to smooth out a flat surface. Paste the smooth side of a sticker sheet mount onto the flat surface.

10

Cool for a half-day in the refrigerator. After the half-day remove the prosthetic wounds from the silicone molds, including the sticker sheet mounts, while being careful not to tear them off. Then, allow Pros-Aide Cabosil to dry completely.

11

Paste a piece of tattoo sheeting (an adhesive paper that loses adhesiveness when wet) over the prosthetic wounds.

12

Keep the piece as-is until the day of makeup application.

[Preparation 2. How to Make the Exposed Teeth Denture]

Gums and teeth for photo shoots, which you wear like a mouthpiece by attaching to your real teeth.

[Materials]
Dental cast, NSP clay, Oil-based clay (for making a wall), Clear spray, Silicone & Curing agent, Dental acrylic (a rigid and clear resin used for dentures), Airbrush paint, Latex skin

[Tools]
Engraving tools, Dremel, Sandpaper, Airbrush

POINT [How to Take a Dental Impression]
1. Put alginate on a dental tray and insert the tray into the mouth facing the upper teeth. Bite the tray firmly.
2. Without moving, put alginate over the lips and the bottom of the nose. When the alginate has set, cover it with bandages to reinforce.
3. Once set, remove the alginate from the face and take the dental tray out.
4. Pour plaster into the dental impression and the upper casing is done.
5. Similarly, take an impression of the lower teeth (please refer to p.75 in A Complete Guide to Special Effects Makeup for more details on taking dental impressions).

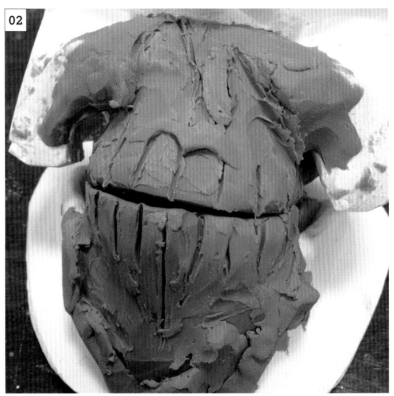

Put NSP clay on the cast teeth and then sculpt the exposed teeth of a zombie. Sculpt each tooth slightly large and adjust the bite of the upper and lower teeth.

Prepare a dental cast that includes a model up to the bottom of the nose.

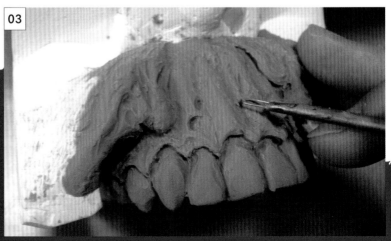

Engrave the gum details.

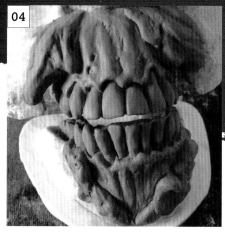

04 The original denture clay sculpture is done.

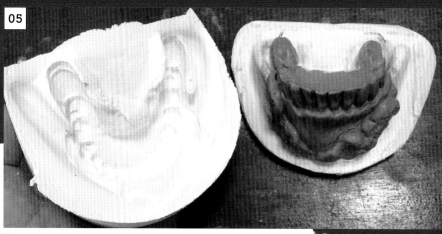

05 Make a wall around the clay sculpture and then apply clear spray as a mold releasing agent. Mix silicone and curing agent in a ratio between 100:1 and 100:5. Then pour to make a mold.

06 Prepare dental acrylic (a rigid and clear resin for making dentures). Mix ivory powder and acrylic liquid in a 2:1 ratio and then pour it in the silicone mold. Dental acrylic sets in about ONE minute, so be quick.

07 Hollow out the inside of the denture (where the model's teeth will fit) using a Dremel. If you are unable to make a dental cast of the model, just make a hollowed out space for the model's teeth. Then, fill in gaps between the dentures and the real teeth with a denture adhesive.

08 Shave down the surface of the denture teeth with sandpaper.

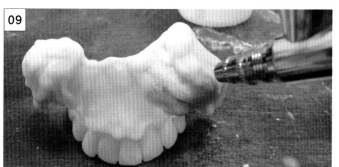

09 Mix black and green paint and airbrush the gums and the teeth.

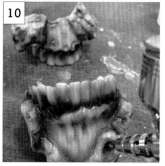

10 Mix brown, black, and green. Airbrush this in to add shadows. Airbrush black for the darkest spots in order to bring out the impression of rotting teeth.

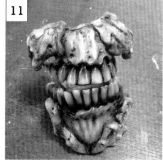

11 Airbrushing is done.

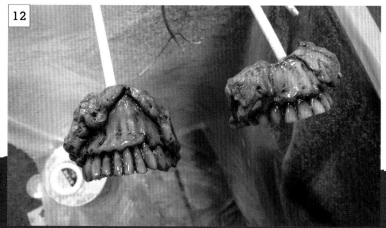

12 Coat with clear spray.

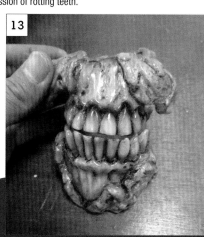

13 Paste latex skin inside of the denture to create a margin to glue down.

[Materials]
Astringent, Denture, Pros-Aide Cabosil prosthetic wounds, Pros-Aide, Greasepaint (Light flesh tone, Green, Black, Red), Castor oil, Denture adhesive, Loose powder, Skin Illustrator (Purple, Black, Brown), Fake blood, Zombie contact lenses, Skin Guard, Lotion

[Tools]
Spray bottle, Brush, Rubber sponge, Airbrush, Scissors, Urethane sponge, Facial cotton, Spatula, Powder puff, Mixing palette, Paper tissue

Model: Shinjiro Saito

01 Apply Skin Guard after removing excess facial oil with astringent. Put the denture in temporarily to test positioning.

02 Prepare the Pros-Aide Cabosil prosthetic wounds. These become the swollen and rotten areas.

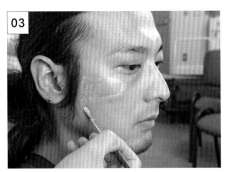

03 Apply Pros-Aide anywhere with contours that might be easily wounded, like the brows, cheeks, etc.

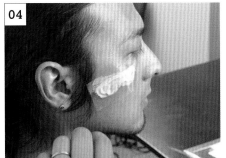

04 Remove the sticker sheet mounts from the Pros-Aide Cabosil prosthetic wounds and paste them on the areas where Pros-Aide is applied.

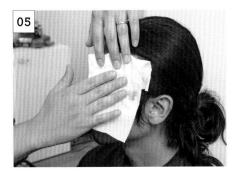

05 Wet a piece of Paper tissue using a spray bottle. Then, press the wet Paper tissue over tattoo paper that is attached to the prosthetic wound.

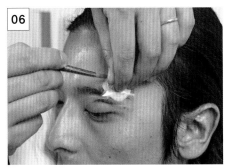

06 Remove the tattoo paper slowly by using a brush that has been dipped in water.

Mix light flesh tone, dark flesh tone, and green greasepaint with castor oil on a mixing palette.

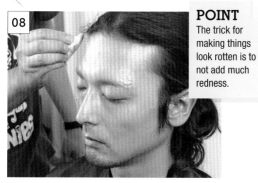

POINT
The trick for making things look rotten is to not add much redness.

Take that color on a sponge, dab it on the prosthetic wounds and the skin at the same time. Make the application uneven.

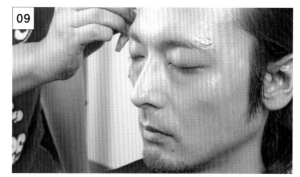

Dab yellowish flesh tone greasepaint on top.

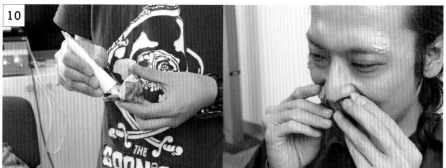

Apply denture adhesive inside of the denture and then bite it by inserting your teeth inside the denture.

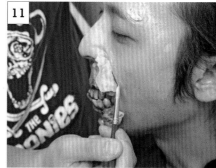

Secure the denture to the face using Pros-Aide. Use the latex skin attached to the denture as a pasting margin.

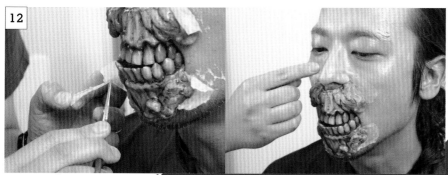

Cut off any excess latex skin (gluing margin) with scissors. Glue down the latex skin (gluing margin) up to the wings of the nose.

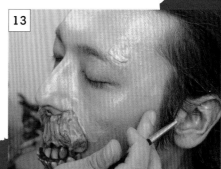

Mix green greasepaint with the base flesh tone, then apply this to make the face pale further.

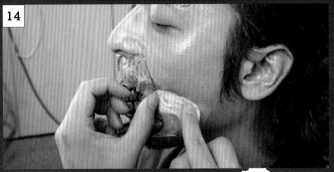

Glue down the Pros-Aide Cabosil prosthetic wounds over the gluing margin of the denture and then smooth out the edges and adjust.

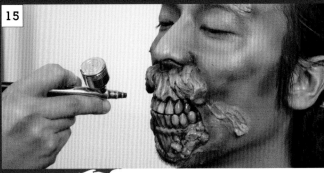

Fill the airbrush with Skin Illustrator black and then add shadows around the eyes and the laugh lines. Add shadows to conceal the edges of the gluing margin and blend in green greasepaint using the finger tips.

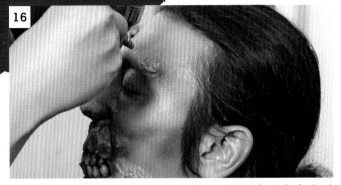

Airbrush the veins that run from the neck to the face, and the hairline to the forehead, using Skin Illustrator purple. Dab greasepaint over the veins and blend in.

Further, airbrush in some black to tighten the darker areas. Then, lower the air pressure of the airbrush in order to make the paint splatter. Add black dots to the face with this splatter.

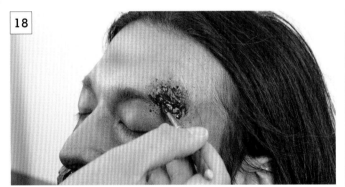

Apply red greasepaint inside the prosthetic wounds. Then, fill inside the prosthetic wounds with fake blood and dry using a hair drier.

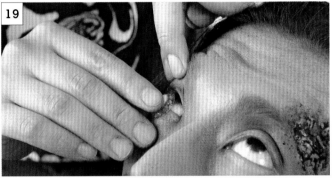

Put in zombie contact lenses that have larger whites than the model's eye.

FINISHED!!

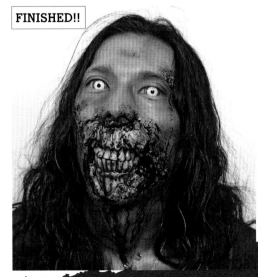

Wet the hair using a spray bottle and make the hair stick to the head. You're done!

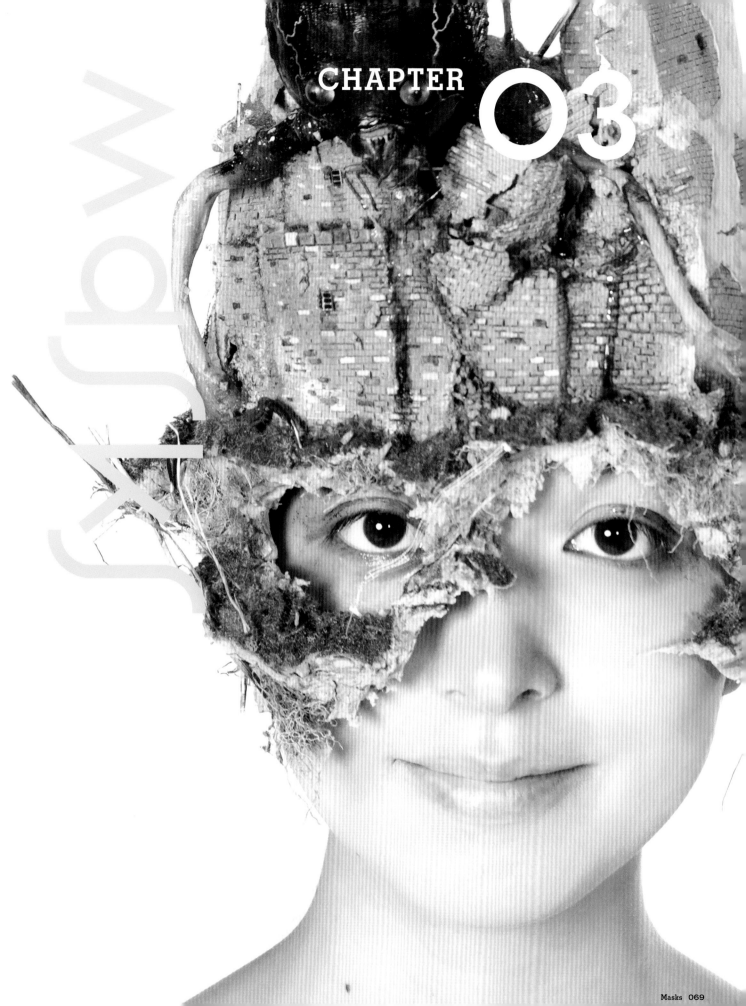

Eyewitness

A Steampunk-like Leather Mask
Made by remodeling swimming goggles

Using a face cast you already have on hand, make a mask foundation with aluminum wire mesh. Those who do not have a face cast can make a foundation by pressing aluminum wire mesh directly on their face. Attached brass wire is the striking visual point of this mask.

by AKIHITO
Photo: AKIHITO Model: Ayumi Saito

Mark a mask line according to the shape of your face cast by pressing aluminum wire mesh on the cast. Then, cut out the shape using scissors.

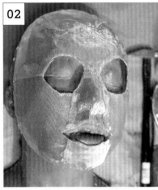

The foundation is done.

[Materials]
Aluminum wire mesh, Brass wire, Barge, Instant glue, Acrylic paint, Baring parts, Alcohol, Face cast, Leather

[Tools]
Swimming googles, Scissors, Airbrush

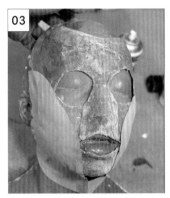

Apply Barge on the aluminum wire mesh, then glue leather on both cheeks.

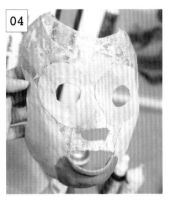

Glue on different colors of leather according to the shape of the aluminum mask and your design drawing.

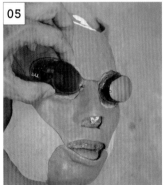

After gluing leather on the aluminum foundation using Barge, remove rubber straps from the swimming goggles by cutting them off. Attach only the goggle parts on the foundation using Barge.

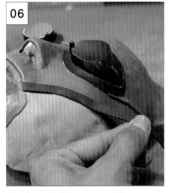

Glue the cut rubber straps of the swimming goggles along the seams between the goggles and leather.

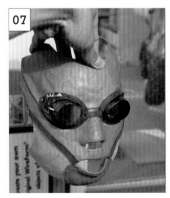

The photo above shows the black rubber after it has been glued on.

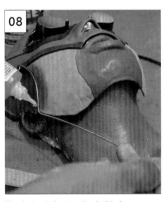

Use instant glue to attach thin brass wires at the corners of the leather. This gives a mechanical feel to the mask.

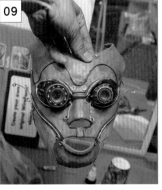

Carefully glue on brass and black wire. Attach bearing parts to the goggles in order to make them look like Special Forces goggles.

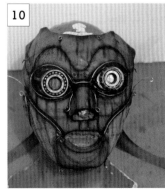

Airbrush on some paint and you are done!

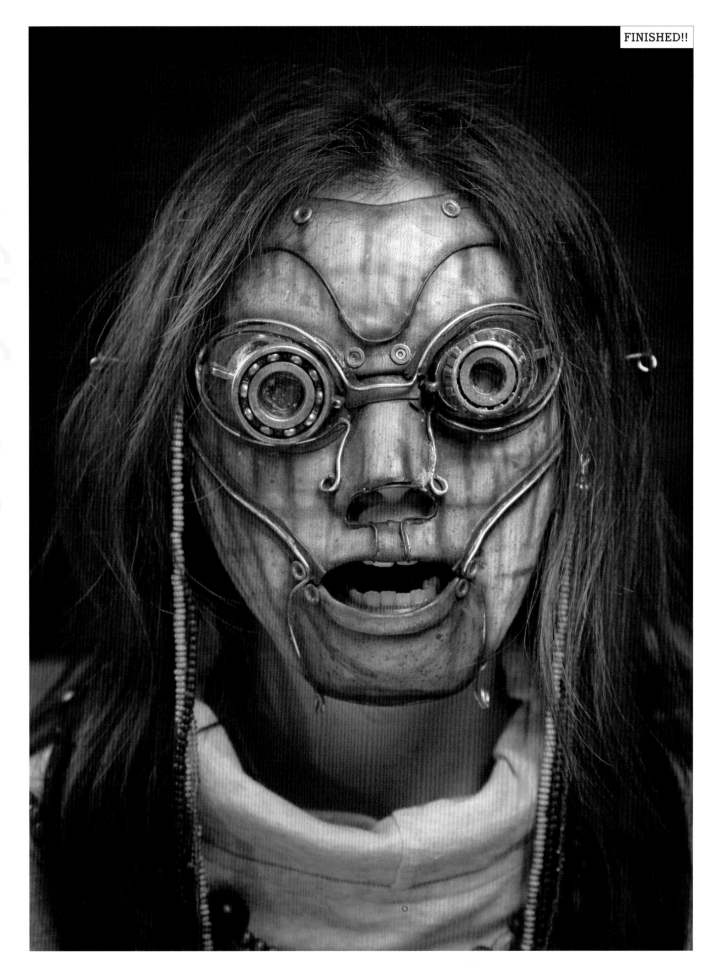

Miss Watermelon

A Summer Horror Mask
Made using mostly dollar store items

Use magazines to make the paper-maché foundation for the mask. Guess what! The seeds are made using cotton swabs. Once you see it, you will never forget this mask.

by Soichi Umezawa
Photo: Hironobu Onodera Model: Mayu Kumasaka

[Materials]
Clay, Plastic wrap, Old magazines, Paper-maché paste, Japanese rice paper, Acrylic paint, Bouncy ball, Clear spray, Instant glue, Cotton swabs, String, Watercolor, Urethane sponge, Ice pack

[Tools]
Hake brush, Woodworking glue, Wire cutters

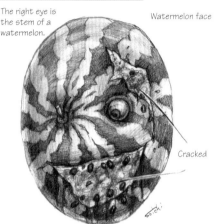

The right eye is the stem of a watermelon.

Watermelon face

Cracked

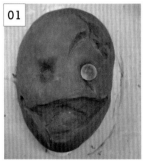

Shape an original model using clay (water-based, oil-based, paperclay, etc.).

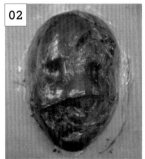

Cover the sculpted clay with plastic wrap.

Tear magazine paper into small pieces and glue them on using paper-maché paste (change the magazine paper color according to each layer so you will know where each piece needs to be glued).

After gluing on the seventh layer or so, glue on the last layer using Japanese rice paper.

Paint with acrylic paint. Painting yellow first helps to clearly show the green color of the watermelon.

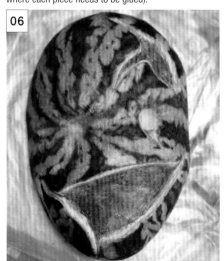

After painting, apply paper-maché paste on the surface to give a glossy appearance.

For the eye, just halve a bouncy ball or a wooden sphere and then paint it. Lastly, coat with clear spray.

For the inside of the mouth and the wounds, create red woodworking glue by mixing red watercolor with wood glue and dab it on using a urethane sponge. Apply about 3 to 4 layers. Lastly, apply regular woodworking glue (not colored) directly to bring out translucency.

POINT
For photo-shoots paint red-dyed ice pack gel on the mouth in order to bring out the crisp look of watermelon flesh.

For the seeds cut both ends of cotton swabs with wire clippers and then paint them like seeds. Glue them on using instant glue. Attach a string in order to make the mask wearable, then it's done.

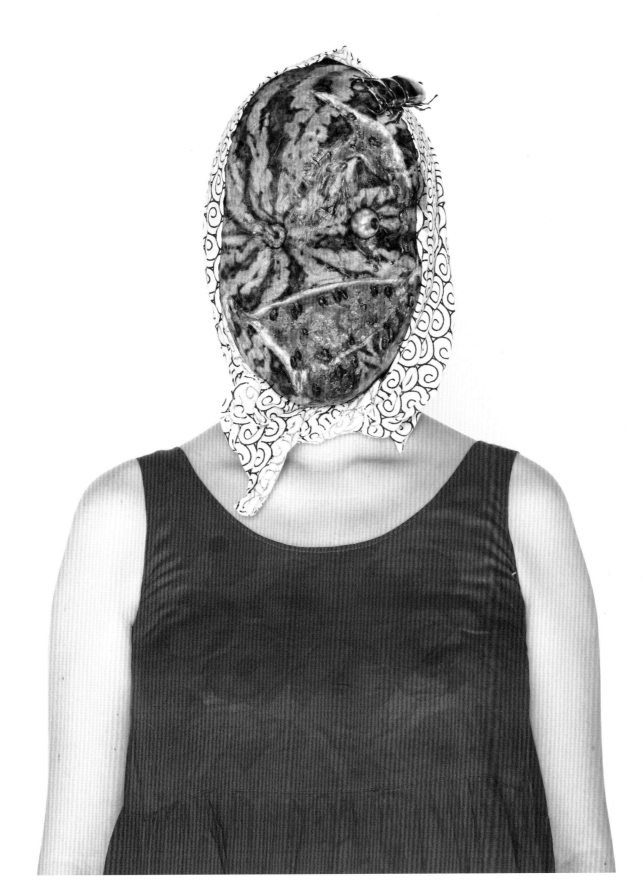

OIWASAN – Rockwoman

A Rough Looking Rockwoman Mask
Made using packing material, SUNPELCA® (polyethylene foam) and urethane

This is a tough looking mask, but it is actually a soft and warm mask that is good for wearing in winter. By engraving the layered urethane sheet you can form this shape.

by Yuya Takahashi
Photo: Yun Yuah Model: Mayu Kumasaka

[Materials]
SUNPELCA® (polyethylene foam), Urethane sheet, G Bond, Black fabric, Latex, Acrylic paint

[Tools]
Utility knife, Portable gas stove, Hake brush, Sponge, Towel

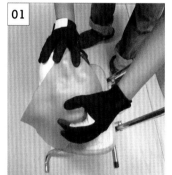

01 Heat SUNPELCA® using a portable gas stove. Once it is soft, press it over a cast of the model's face to form the desired shape.

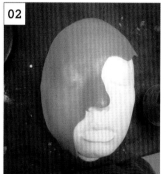

02 Cut the heat pressed SUNPELCA® out to shape the mask.

03 Make belts using SUNPELCA® and wrap them on the head cast. Then, glue on urethane sheets. Paste on a piece of black fabric to reinforce the seams.

04 The photo above shows the mask with an attached urethane sheet.

05 Glue on urethane.

06 After gluing on urethane, carve it using a utility knife.

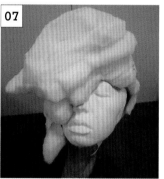

07 Put the mask on the face cast to check overall balance.

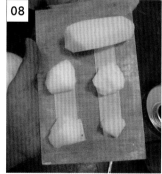

08 Make smaller rock-like pieces in order to adjust the balance and fill in gaps.

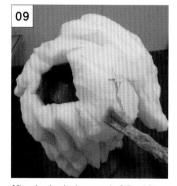

09 After shaping is done, apply G Bond for the filling process.

10 Apply latex all over (three applications in total). Do not forget to apply latex on the small rocks.

11 Allow latex to dry completely and then paint with acrylic paint. Add speckles by splattering on paint with a hake brush. This gives texture. Also, dab on some paint using urethane sponges, towels, etc., to make it appear more realistic.

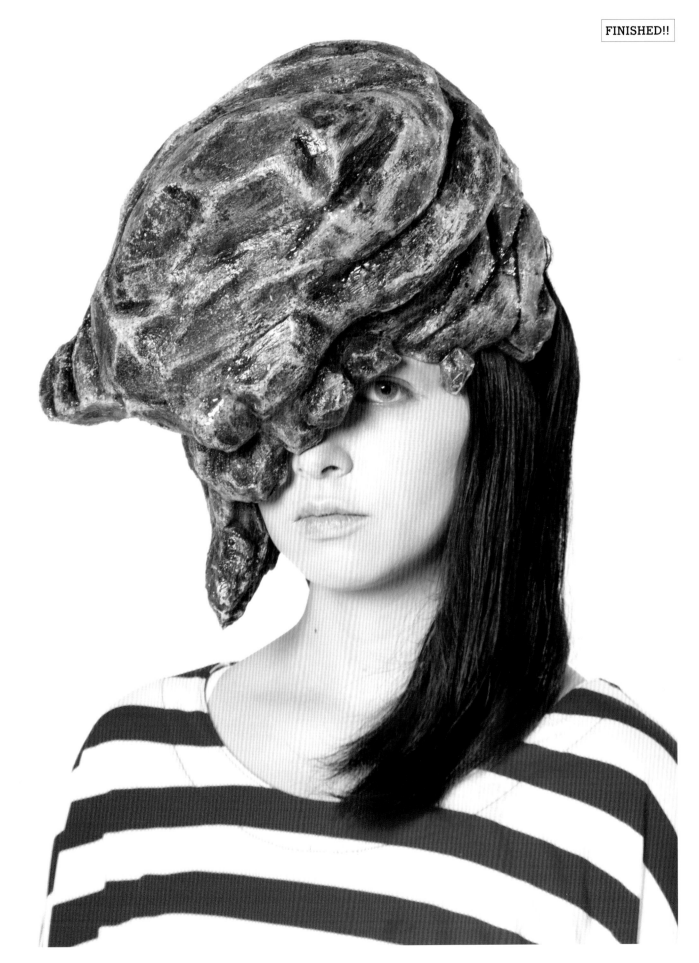

Littleboy

A Mask Featuring a Character that Destroys Buildings
Using a cicada's abandoned exoskeleton, an acrylic sphere, and some clay

Three different kinds of clay are used in this project - wood clay, translucent clay, and white and brown "Padico Mermaid Puffy."

by Tomo Hyakutake
Photo: Yun Yuah Model: Mayu Kumasaka

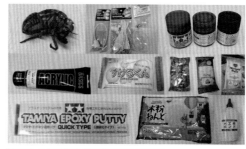

[Materials]
Light bulb, Socket, Electrical cord, Transparent acrylic sphere, Acrylic paint, Epoxy putty, A cicada's abandoned exoskeleton, Translucent clay, Colored "Padico Mermaid Puffy" clay, Wood clay, Plastic model paints, Dried plants, Acrylic balls, Wire

[Tools]
Woodworking glue, Engraving tools, Brushes

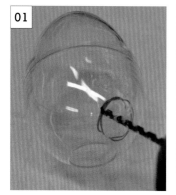

01

Open a hole in the acrylic sphere for threading an electric cord.

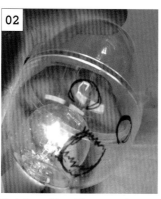

02

Mark the position of the eyes and mouth using a permanent marker.

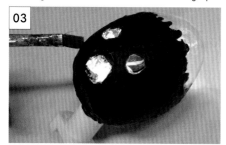

03

Paint the whole thing black acrylic, except the eyes, mouth, and top.

04

Make the body and arms with wire and then give them more substance by applying epoxy putty.

05

Sculpt the teeth of Littleboy using epoxy putty.

06

Embed a small acrylic ball in each eye socket and secure using glue.

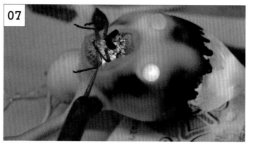

07

Glue a cicada's abandoned exoskeleton in the mouth, then give substance to the face using translucent clay.

08

Sculpt a hat, using wood clay, on a face cast. This becomes the foundation.

09

Put colored clay on the foundation. Make horizontal and then vertical lines in the clay using an engraving tool.

10

Paint using acrylic paint and plastic model paint.

11

Give a green basecoat to areas where plants will be attached. Then, glue on plants you have collected and dried. Sprinkle on store bought powder-like moss. It's done!



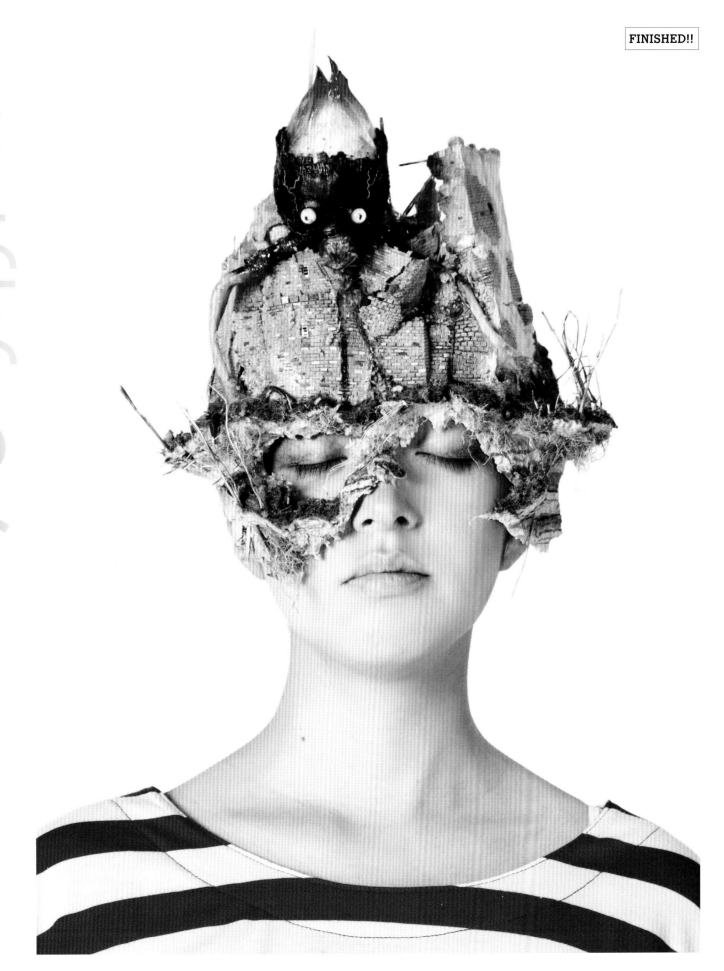

The Eyeball

A Glittered Eyeball Mask
Made with FRP and brass pipe

The eyeball is a transparent dome. In order to secure the mask on the head, make a helmet made of FRP (fiber-reinforced plastic) and attach the eyeball to the helmet.

by Tomonobu Iwakura
Photo: Hironobu Onodera
Model: Sachi Yanagida

[Materials]
Transparent vinyl chloride dome, Acrylic paint, NSP clay, Silicone, Curing agent, Gauze, Plaster, Burlap, Clear spray, Clear FRP (fiber-reinforced plastic), Shinetsu K Color, Cabosil, Fiberglass mat, Glitter, Brass pipe, Dental acrylic, Skin Illustrator, Epoxy adhesive, GEL poly (Resin + Talc + small pieces of fiberglass mat), Full-size head casting, Aluminum pole, Fiberglass

[Tools]
Packing tape, Utility knife, Brushes, Hake brush, Airbrush

01

Paint the fake eye using acrylic paint on the back of the transparent vinyl chloride dome.

02
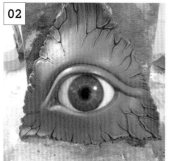
Sculpt an original model using NSP clay. Open up a space for the fake eye by digging out the back of the clay sculpture. Push the fake eye into the space.

03

Make a mold using silicone. The first layer is silicone. Cover that layer with gauze to prevent ripping of the silicone layer.

04

Insert keys in order to prevent misalignment of the plaster and silicone. After the silicone has completely cured, cover with plaster and burlap (as the third layer) to reinforce.

05

Remove the silicone mold from the clay sculpture. Apply clear spray inside the mold as a releasing agent. Add Shinetsu K Color to clear FRP in order to create a flesh tone, then fill in the negative space of the mold.

06

Filling in the negative space of the mold just using clear FRP may be watery, so mix Cabosil in to thicken. Produce the necessary thickness during this (the first layer) application.

07

For the second layer application, put fiberglass mat down and saturate it with FRP.

08
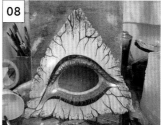
Once cured (after about thirty minutes), remove any burrs. Paint using acrylic paint and then sprinkle on some glitter.

09
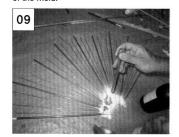
Cut brass piping to size and arrange in a fan shape. Apply dental acrylic at the base and allow to set. The halo is ready.

10
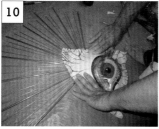
Glue down the eye using epoxy and attach the halo to the mask using GEL poly (resin + talc + small pieces of glass matting).

11
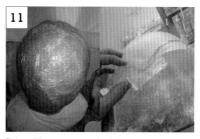
Put packing tape around a full-size head cast and then apply FRP and fiberglass mat over that to create a helmet.

12
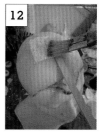
Attach aluminum sticks to the helmet and secure the mask to the helmet with GEL poly. It's done!

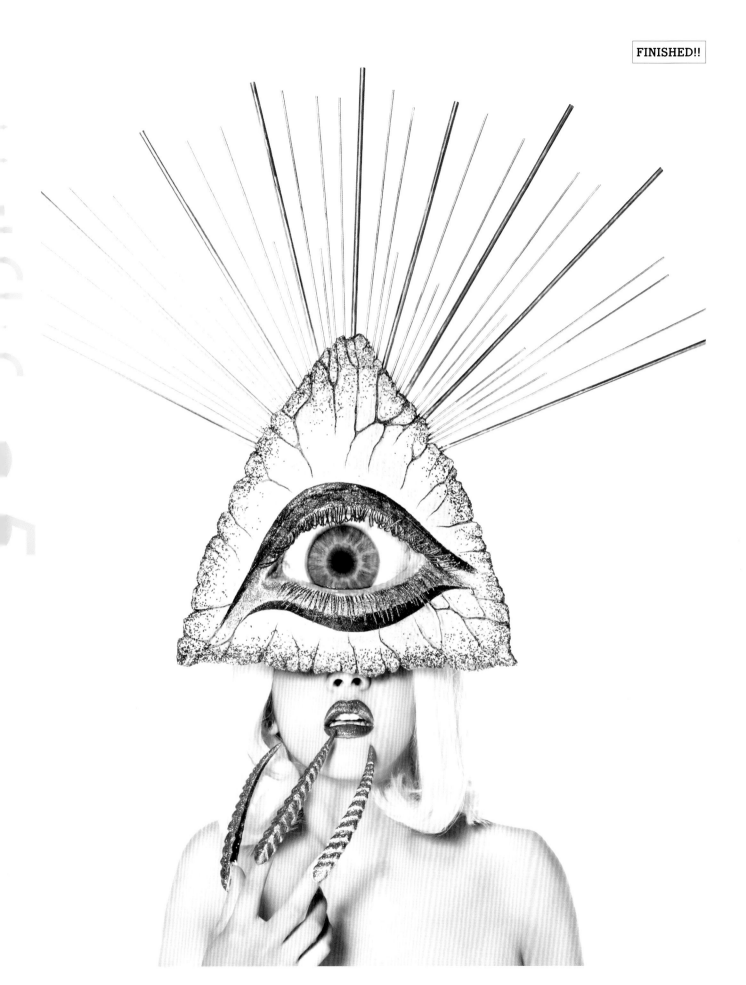

Easy Yeti

An Ecological Mask
Made using burlap

Every studio has to have burlap laying around for plastering.
By using such burlap we have produced a pop looking mask.

by Kakusei Fujiwara
Photo: Yun Yuah Model: Kakusei

[Materials]
Latex, Burlap, Vinyl chloride board,
Press die, Acrylic spray, Foam
Ace (polyethylene foam), G Bond,
Acrylic paint

[Tools]
Portable electric stove, Airbrush,
Brushes

01

Stretch out latex that is about 2 cm/0.75 in. wide.

02

Put burlap (cut to about 50 cm/19.75 in.) on top of the latex. Arrange it evenly, but do not overcrowd.

03

Add a layer of latex so the burlap is sandwiched between the two latex strips. Make a few sets this way.

04

Heat vinyl chloride board using a portable electric stove and then press it over a press die (a dome) that has the intended diameter of your eyes. The clear part of the eyes is ready now.

05

Spray white or cream color acrylic paint on the back of the vinyl chloride board. The picture above (right) shows the exterior view.

06

Remove excess.

07

Make the face part using Foam Ace. Heat the foam with a portable electric stove and then press over the face cast.

08

Decide on the position to attach the eyes.

09

Glue the burlap hair on with G Bond, beginning at the bottom.

10

The above photo shows when all the burlap hair has been attached. Glue on the eyes as well.

11

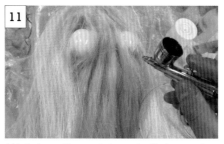

Add shadows with an undertone color like brown using an airbrush.

12

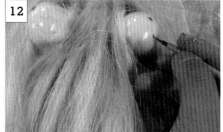

Paint the eyes and add some veins, etc., and then you are done! It took about an hour to finish this mask.

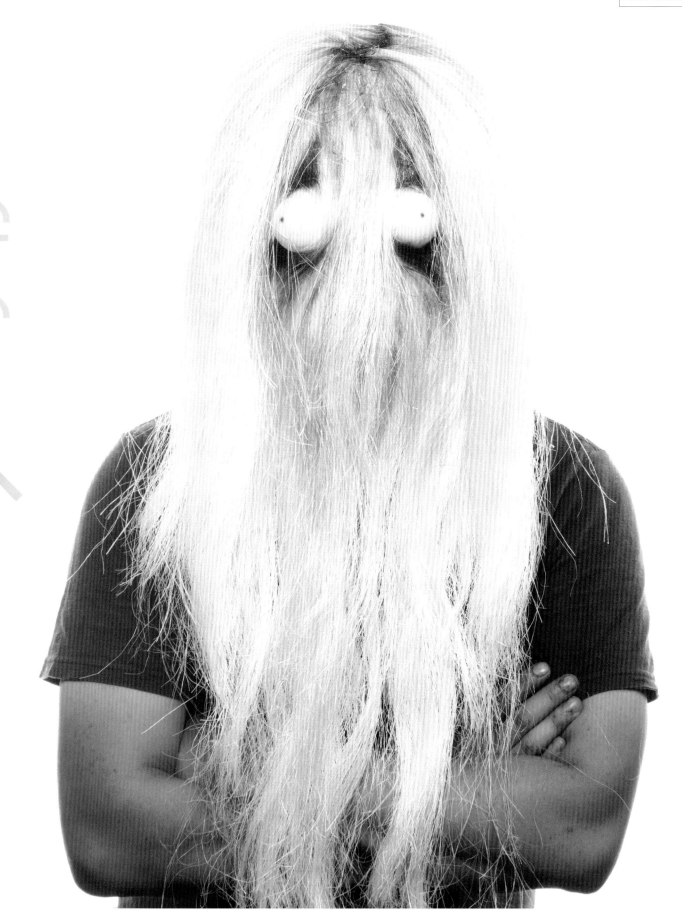

MOLD MASKING

PRODUCING SPECIAL EFFECTS
MAKEUP APPLIANCES

What is Mold Making and what is a Lifecast?

Mold making is used to produce a mold, like a cookie cutter, by covering a human face or head with a material called alginate. Alignate is soft and solidifies easily. Lifecasting is creating a solid object by pouring plaster into a mold. It is used to replace human faces, etc., in things like mannequins. A Lifecasting is fundamental to special effects makeup and all pieces applied on a face (appliances) are made by sculpting clay on a lifecast. The appliances fit closely on the face of the actor/model, and it just feels like wearing slightly thick makeup. As a result, the actor/model can talk and act without feeling constricted.

Mask

Appliance

Making a Mold for Producing a Complete Head Appliance

This section illustrates the procedure for making molds. If prosthetic makeup is not going to be applied to the entire head, a frontal face mold would suffice. You can make leg and arm molds in a similar manner.

01

The model.

02

Cover the model's head with a bald cap and then apply Vaseline® on the brows and lashes to protect them. Wet the bald cap to prevent alginate from sticking.

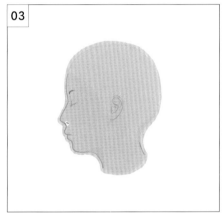

03

Pour alginate over the head.

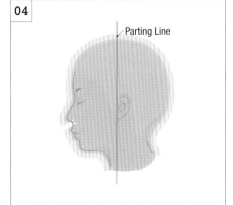

04

Parting Line

Wrap plaster bandages over the alginate (be sure to leave a parting line between the bandages, see page 87).

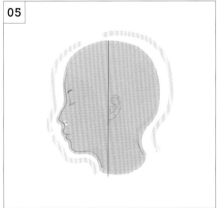

05

Once set, split the plaster bandages along the parting line.

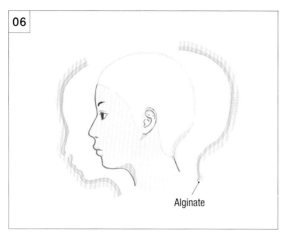

06

Alginate

Then, cut the alginate apart, remove it from the plaster bandages, and lay the alginate face back in the plaster bandage.

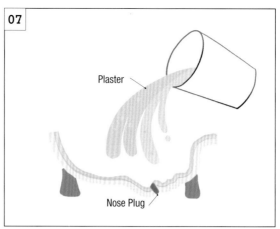

07

Plaster

Nose Plug

Secure the mold (bandage and alginate) in a flat position and then plug the nose holes. Pour plaster into the negative space of the mold.

08

Once the plaster has solidified, take it out.

09

The positive plaster mold is ready.

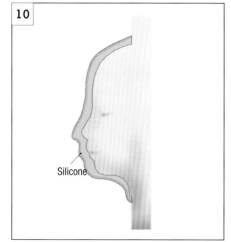

10

Silicone

Make a cast of the positive plaster with silicone (this method is used only when employing a partible mold).

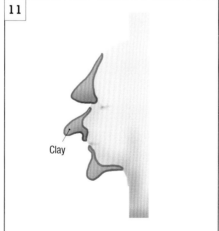

11

Clay

Sculpt the desired prosthetics out of clay on the positive plaster mold.

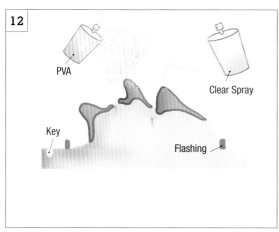

12

PVA

Clear Spray

Key

Flashing

Engrave keys on the positive plaster and build flashing out of oil-based clay. Then, apply clear spray and PVA.

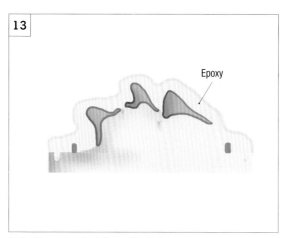

13

Epoxy

Cast with epoxy and reinforce with plaster.

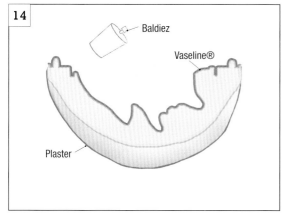

14

Baldiez

Vaseline®

Plaster

Apply Vaseline® on the epoxy negative and then spray with Baldiez.

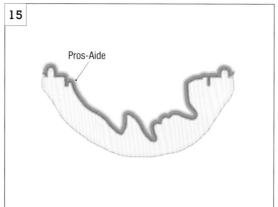

15

Pros-Aide

Apply Pros-Aide.

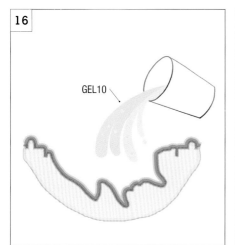

16

GEL10

Pour in silicone (GEL10).

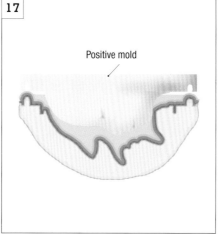

17

Positive mold

Apply Vaseline® and clear lacquer on the positive mold as a releasing agent. Spray Baldiez and then "press" the silicone by placing the plaster positive inside the negative.

18

Your silicone appliance is ready.

Full Head Lifecasting

MOLD MASKING 011

This section introduces how to make the full head lifecasts that are a necessity for full head prosthetic makeup applications.

by Soichi Umezawa (based on Jean Yu-bin Dyske)

[Materials]
Pros-Aide, Alginate, Vaseline®, Soapy water, Plaster bandages, Instant glue

[Tools]
Cape (or a garbage bag), Bald Cap (plastic wrap can be used instead), Permanent marker, Ear plugs, Spatula, Bandages, Surgical tape

Model: Daisuke Yanagisawa

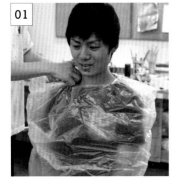

01 Use a cape that covers the whole body, or a garbage bag with an opening that allows the whole head through. Cover your model and secure the bag using surgical tape.

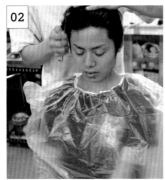

02 Put the model's hair back so it remains as tight to the head as possible.

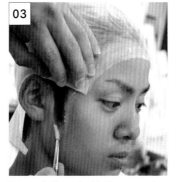

03 Put on a bald cap (a skin like cap made from latex. Plastic wrap can be used instead). Then, glue down the bald cap using Pros-Aide while making sure it closely covers the head.

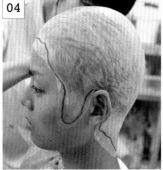

04 Mark along the hairline using a permanent marker. This mark will be copied onto the alginate negative and then transferred to the plaster mold.

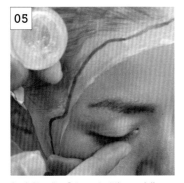

05 Apply Vaseline® to protect the model's brows and eyelashes.

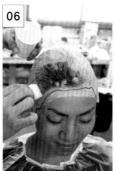

06 To prevent the alginate from locking onto the bald cap, lightly apply soapy water all over.

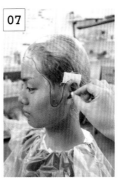

07 Put ear plugs in place.

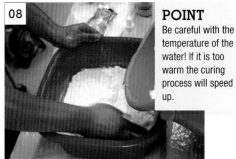

08 Add lukewarm water to alginate (powder) and mix. After pouring in the water, the alginate will start to set instantaneously so be quick.

POINT
Be careful with the temperature of the water! If it is too warm the curing process will speed up.

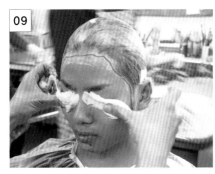

09 Begin applying alginate at the eyes. Keep the nose holes open at all times.

10 Apply alginate quickly by dripping it over the top of the head. Then, smooth across the facial features.

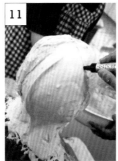

11 Once the alginate has cured, mark the parting line.

12 Soak the plaster bandages in lukewarm water. Lightly squeeze the bandages to remove excess moisture, before wrapping the cured alginate.

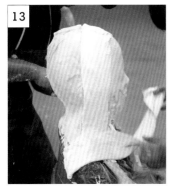

13 The reason we are using plaster bandages here is because alginate alone is too soft to maintain its shape when plaster is poured inside the mold. So, we reinforce the alginate with the plaster bandages.

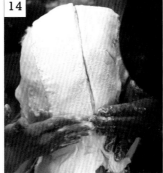

14 Do not cover the parting line.

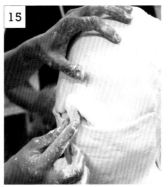

15 Put a thinly cut plaster bandage around the nose hole and then apply Vaseline® as a releasing agent.

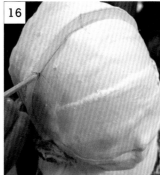

16 Mark a line along the parting line seam.

17 Once completely solidified, lightly chisel the plaster bandage layer open using a spatula.

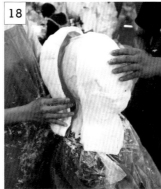

18 To prevent cracking, take the plaster bandages off very slowly.

19 First, remove the rear side of the bandage. Then, cut open the alginate at the rear-center by making an incision with a spatula.

20 Carefully remove the mold from the model's head and glue the alginate back together with instant glue. This leaves the inside completely hollow. Lastly, reattach the removed bandage (the rear side) to the alginate and secure the front and rear bandages with instant glue.

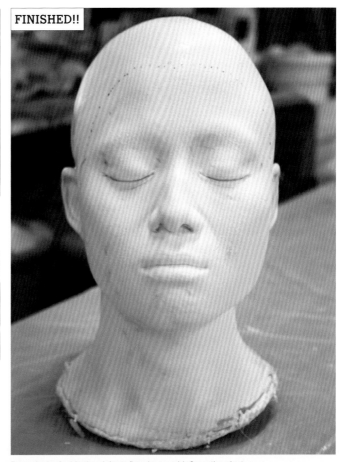

FINISHED!!

Pour plaster inside the alginate/bandage mold. Once the plaster has solidified you can remove the mold. The lifecast is ready!

A Must Have Item for Your Studio!

Sculpting Clay Silicone Appliance

There are various kinds of appliances (designed pieces made for application on the face) in prosthetic makeup. Materials for appliances are very diverse and continue to evolve: from water-resistant and sweat-resistant latex, to translucent gelatin, to durable & realistic looking silicone, to Pros-Aide Cabosil for creating wounds, etc. In this section, we give a thorough introduction to the method for making silicone appliances that came into popular use in film production.
(Please refer to A Complete Guide to Special Effects Makeup for foam latex appliances)

by Soichi Umezawa (based on Jean Yu-bin Dyske)

[Materials]
Plaster lifecast, Silicone (KE-12), Curing agent (Catalyst), Hair gel, NSP clay, Plaster (FX Stone), Burlap, Vaseline®, Oil-based clay (inexpensive is fine), Clear spray, PVA, Epoxy (Nissin resin GP-603A), Epoxy curing agent, Black toner, Acetone, Encapsulating Plastic (Baldiez), Silicone (GEL10 A, B), Deadener, Silicone cure retarder, Pros-Aide, Ethanol, Permanent marker, Skin Illustrator

[Tools]
Engraving tools, Needles, Pail, Hake brush, Oven, Urethane, Airbrush, Brushes, Mixer, Deaerator, Clumps

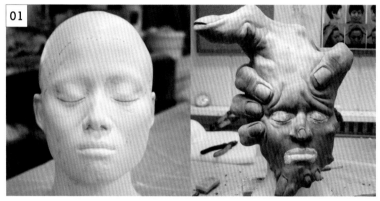

01

After making a silicone mold of the plaster lifecast, apply hair gel on the plaster lifecast and then sculpt using NSP clay. In order to put the carved clay pieces (which break down into sections) onto the silicone mold made in this step you must pour plaster in the silicone mold in a later step (see step 12).

02

Edge
Edge
Edge

POINT
The smaller the section, the thinner the edge becomes.

Break down the clay sculpture into sections. This time, it was broken down into four sections: the head, the ears, the forehead, and the face (below the nose). Decide on the order in which the sections go on top of each other.

03

Use a needle to mark a line on the sculpture where it is going to be divided and then soak the sculpture in water over night. Soaking in water causes the hair gel (applied previously) to dissolve so the clay comes off from the plaster lifecast.

04

Plaster
Key
5 cm / 2 in. 5 cm / 2 in.
Silicone Mold

POINT
Make a positive mold by pouring plaster in the intended area and spreading it out about 5 cm/2 in. past the edge of the part (for instance, for the ear, spread the plaster about 5 cm/2 in past the ear as shown above). Once the plaster positive is ready, carve out some keys.

While the clay sculpture is being soaked in water, pour plaster (FX Stone) in the silicone mold made in the previous step in order to make a positive mold of the ears, forehead, and face.

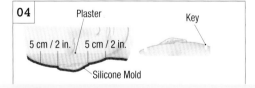

05

Put positive molds of each section in an oven to dry. Then, apply Vaseline® on the surface. Take your original clay sculpture out of the water and break it down into sections, then carefully place each section on its respective positive mold.

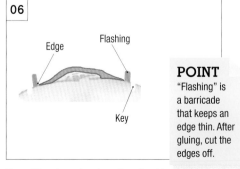

06

Edge Flashing
Key

POINT
"Flashing" is a barricade that keeps an edge thin. After gluing, cut the edges off.

The cutting plane of each sectioned part is untreated so the edge remains fairly thick. Stretch these edges out thinly and then build flashing around the original clay sculpture using soft oil-based clay (Leon Clay is used here).

07

Apply clear spray on each clay sculpture and then apply PVA over that as a releasing agent. Epoxy is used here to make the mold. Be sure to use PVA because epoxy has a really strong grip and if only lacquer is used as a mold release agent the mold might be damaged when demolding.

08

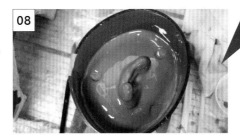

Make a mold using epoxy (Nisshin resin GP-603A). Apply the first layer of epoxy and then wait four to five hours. Once it has set, apply a second layer and then reinforce with burlap and plaster.

Important!!
The ratio of Epoxy to Curing agent must be 100:20 If your mixing is imperfect the epoxy will never cure. When epoxy and curing agent are mixed the color stays whitish, so it is hard to tell if it is completely mixed together or not. Add black ink toner to the mixture and you will know it is completely mixed when it turns grey.

[The Difference Between Plaster and Epoxy Mold Making]
• Plaster: Since the surface has a sponge-like texture it absorbs moisture easily and pores open on the surface when it dries. Thus, when attempting to make thin appliances, fine bits of silicone that are locked in the plaster will break off and open holes in the silicone when demolding. As a result, the edges of the appliance need to be thick to prevent breaking.

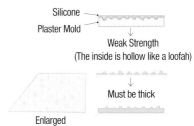

Silicone
Plaster Mold
Weak Strength
(The inside is hollow like a loofah)
Must be thick
Enlarged

• Epoxy: The surface is smooth like a sheet for stickers. Edges have plenty of strength so epoxy holds up, even when thin appliances are made.

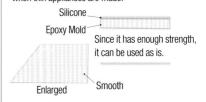

Silicone
Epoxy Mold
Since it has enough strength, it can be used as is.
Enlarged Smooth

09

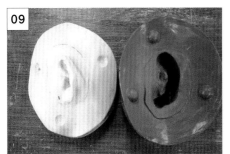

Demold and then remove any clay residue left on the epoxy mold using acetone. Apply clear spray on the positive mold you made in step 04. Apply Vaseline® thinly on both the epoxy and positive mold (be careful not to fill in the sculpted details imprinted on the epoxy mold with Vaseline).

10

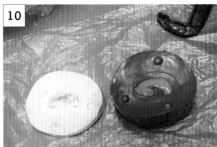

Dilute Encapsulating Plastic (Baldiez) with acetone until it reaches a thickness that can be airbrushed. Aim for a consistency where the airbrushed result will not become "spider webbed." Airbrush five to six thin layers on both the epoxy and positive molds.

11 Once the Baldiez dries completely, use a urethane sponge to apply Pros-Aide, which will act as an adhesive agent for the silicone (GEL10) that will be poured in later. Telesis can be used instead of Pros-Aide.

Important!!
Mix GEL10 A, B, and Deadener in a 1 : 1 : 2.5~3.0 ratio. First, mix A and Deadener and then adjust the color. Next, add retarder (slows the cure) which is 2% of the total mixture weight. Lastly, add B, mix, and then remove air bubbles using a deaerator.

12

Mix some silicone. Pour the silicone into the negative, and then remove air bubbles using a deaerator. Press the positive mold on top. Clamp them together to secure.

FINISHED!!

Once solidified, remove the clamps and take out the appliance. Wipe the surface with ethanol and then pre-paint it using permanent marker, Skin Illustrator, etc. Lastly, coat with Baldiez to prevent color fading.

ADI Trained Silicone Techniques

Hollywood Method ★ Silicone Appliance

MOLD MASKING 03

AKIHITO introduces methods of silicone appliance making that are used in the home of prosthetic makeup, Hollywood (where Akihito is currently working). A liquid resin called "1630" is used for mold making instead of epoxy.

by AKIHITO

[Lifecasting]

[Materials]
NSP clay, Alginate, Plaster, Burlap, Water-based clay, Oil-based clay, Silicone (V-1065), Curing agent, 1630, Cardstock, Epoxy Parfilm (epoxy releasing agent), Silicone (GEL10), Deadener (softener), Silicone cure retarder (an agent to slow curing), Oil, Acetone, Baldiez, Blocking, Injector (a mid-sized syringe), Telesis, Skin Illustrator

[Tools]
Engraving tools, Brushes, Hake brush, Pail, Paper cups, Airbrush, Airgun, Vacuum deaerator, Straps

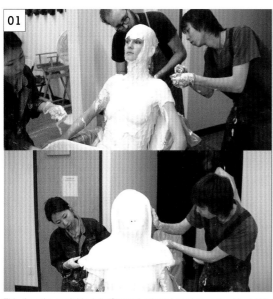

01

This time the model is Julia Senecal, whom I used to work with at ADI. She was nice enough to agree to a casting of her bust as well.

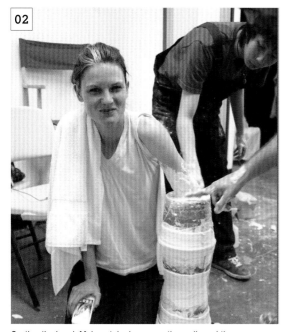

02

Casting the hand. Make a tube by connecting pails and then pour alginate into that.

03

Pour plaster into the mold.

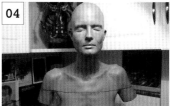

04

Apply brown paint on the completed plaster mold. Painting the mold brown makes sculpting with NSP clay easy. After painting, apply Alcoat all over.

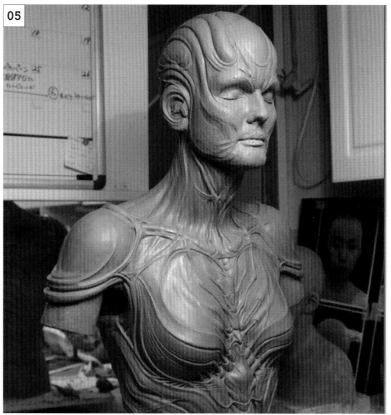

05

Put NSP clay on the lifecast and proceed to sculpt your prosthetics out of the clay.

01

Finish up to about 80% of your prosthetic sculpting.

02

Since molds are made by breaking down the clay sculpture into small parts, make cuts in the clay sculpture and soak in water overnight.

03

Make a base for the cheeks. This time, the head, forehead, cheek, chin, body, collarbone sections, and glove sections are made separately. Take the cheek off the clay sculpture and then make a mold (of the mother-mold) using alginate and reinforce with plaster.

04

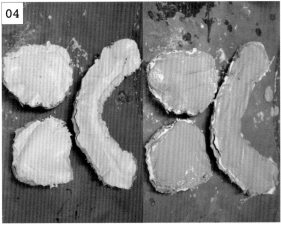

Since moisture in the alginate will evaporate after curing and the mold will shrink, you should pour the plaster right away.

05

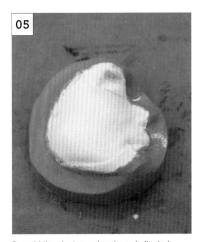

Demold the plaster and make a dedicated base for the cheek. Making the mold small enables you to create fine edges, which is essential to prosthetic makeup.

06

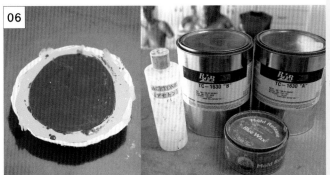

Again, make a silicone mold of the base that was completed in the previous step. Then, pour liquid resin "1630" into the silicone mold.

POINT
[The "1630" Used Here]
This is a type of urethane resin widely used in Hollywood. It is mixed in a 1:1 ratio and then poured into your mold. Since it sets in about an hour, it is very easy to use and very convenient. Even though it is a little expensive, it is often used in Hollywood when we do not have enough time. It is a very useful material because it can be used for molds made of almost any material (like silicone, gelatin, or foam) and it is durable. Since it is also resistant to water, it can be directly poured into molds made out of alginate.

07

Demold from 1630.

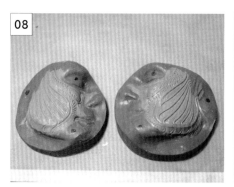

08 Place the separated cheek clay sculptures on the bases that you made in the previous step. Thin the edges and make any final adjustments to complete the clay sculpture.

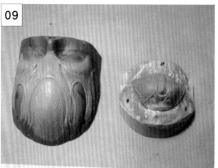

09 The forehead and chin sculpture are finished.

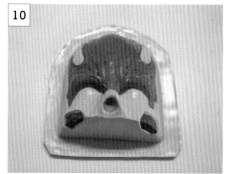

10 Build flashing (a bank used to make the edges thin) out of Klean Clay (a soft oil-based clay).

11 Build a bank out of cardstock and then pour in "1630" to make a mold.

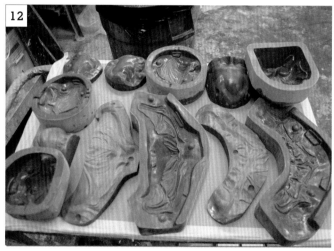

12 The photo above shows the completed forehead, cheek, chin, and collarbone molds.

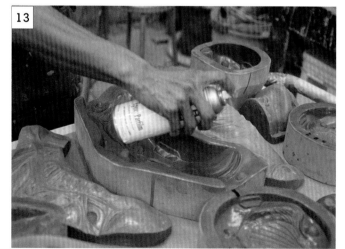

13 As a mold releasing agent, spray Epoxy Parfilm (epoxy release agent) on both the negative and positive mold.

14 Dilute Baldiez (the liquid concentrate that makes up vinyl-type bald caps) with acetone, and spray it carefully using a spray gun. After spraying Baldiez, spray on Telesis (an adhesive for prosthetic makeup).

15

Pour in silicone. The silicone used here is GEL10. After adding curing agent to the silicone, remove air bubbles using a vacuum deaerator. The photo above shows an assistant putting silicone, held in a cup, into the black tube (deaerator) in order to remove air bubbles.

16

Pour silicone in and secure the molds tightly with straps.

POINT

[The Materials Used for Silicone Appliances]
GEL10, Deadener (softener), Silicone cure retarder (an agent to slow curing), Oil paint, Acetone, Baldiez, Flocking (fine powdered fiber), Injector (a mid-sized syringe), Telesis

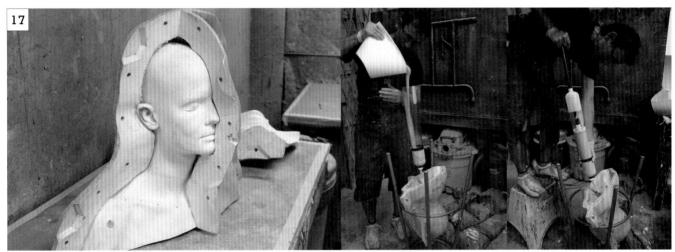

17

For the head mold, apply Baldiez and Telesis. Then, close the mold and inject silicone using a syringe. Since injecting silicone takes time, be sure to adjust the curing time properly.

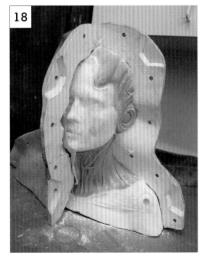

18

After the silicone has set, open the mold and take the silicone appliance out.

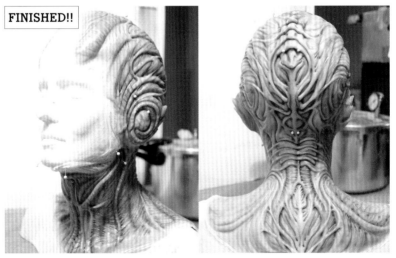

FINISHED!!

Correct any silicone burrs on the head using Baldiez. Then paint using brown and black colored Skin Illustrator. Paint to achieve a finish that is similar to the paintwork done on the body.

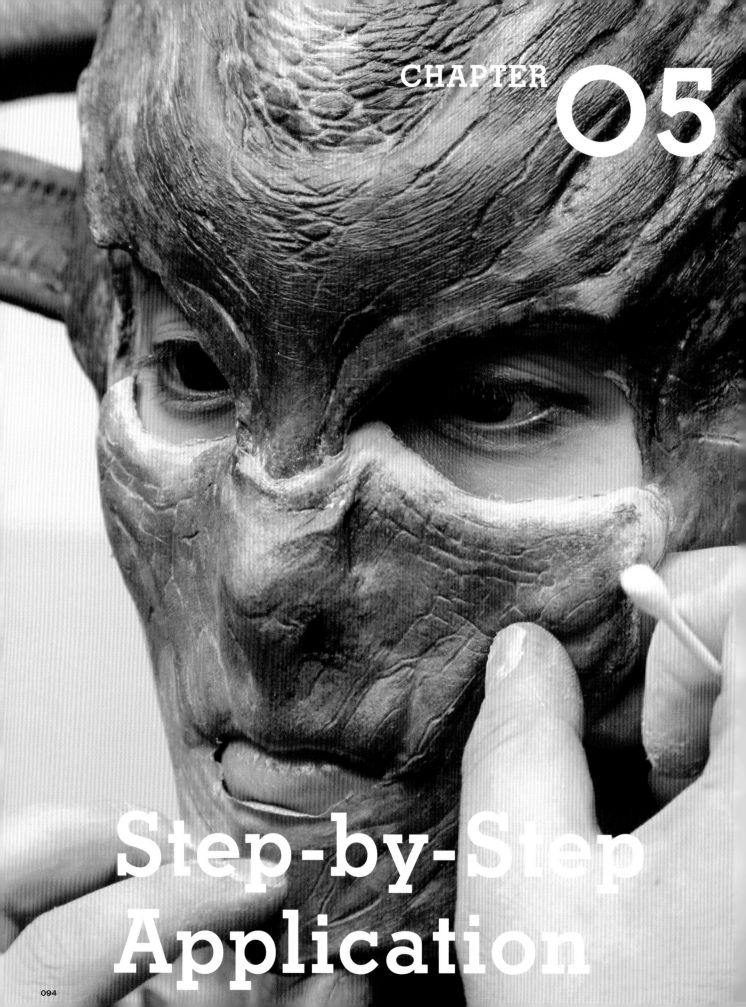

Step-by-Step Application

Even though they form a single finger, the skin and the nail have different textures and translucencies from each other. Therefore, if you make a prosthetic of a finger and its nail while using the same silicone, it will look unrealistic. This section introduces the method for making nails alone using FRP (fiber-reinforced plastic). Of course, this method can be utilized when making life-sized nails.

by Soichi Umezawa

How to Make a Fingernail

[Materials]
NSP clay, Alginate, Silicone appliance, Plaster, URM (releasing agent), Clear FRP (Polyester resin), Lacquer spray, Acrylic paint, Instant glue, Nail polish, Glitter

[Tools]
Brushes, Engraving tools, Sandpaper

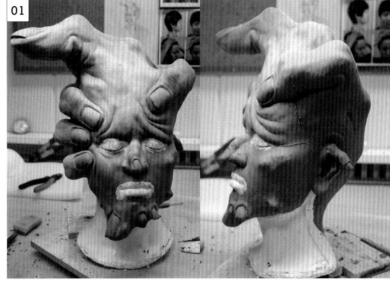

01

Shown above is the completed clay sculpture for Jean Yu-bin Dyske made out of NSP clay.

02

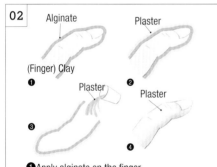

Alginate Plaster
(Finger) Clay
Plaster Plaster
❶ ❷ ❸ ❹

❶Apply alginate on the finger.
❷Apply plaster on top to reinforce.
❸Once set, remove and then pour in plaster.
❹The plaster mold of the finger is ready.

Cast the nail part of the clay sculpture using alginate and then replace with a plaster mold.

03

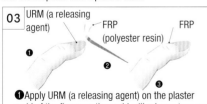

URM (a releasing agent) FRP
FRP (polyester resin)
❶ ❷ ❸

❶Apply URM (a releasing agent) on the plaster mold of the finger so the mold will release (you can substitute either oil-based wax or Vaseline®).
❷Apply FRP (polyester resin) using a brush.
❸Wait until it sets.

Apply URM (a releasing agent) on the plaster mold of the finger. Then, apply clear FRP (polyester resin) to form the nail.

04

Once set, remove from the plaster mold. Then, smooth the surface with sandpaper and paint, starting with the back.

05

Secure the finished nail on the silicone appliance with instant glue.

FINISHED!!

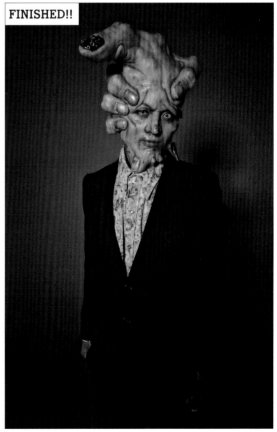

Apply nail polish and then decorate with glitter to finish.

How to Make
a Solid Transparent Head

A translucent, hard insect-like head that allows light through.
In this section, produce a prosthetic by combining appliances made from urethane resin
8750, with a base made out of plastic using vacuum forming.

by Akihito

[Materials]
NSP clay, Latex, Aluminum foil, Silicone (V-1065: A mainstream casting silicone used in Hollywood),
Curing agent, Cabosil (Silica powder), Plaster, BJB8750 (Urethane resin), Plastic board, Acrylic paint

[Tools]
Brushes, Engraving tools, Sandpaper, Hake brush, Vacuum form

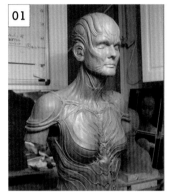

01 Shown above is a 70% complete clay sculpture.

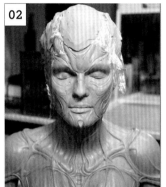

02 Cover the head with plastic wrap and start clay sculpting over the plastic wrap. Since we intend to make the head prosthetic out of clear acrylic board, be sure to separate the sculpture while thinking about how the sculpture is broken down.

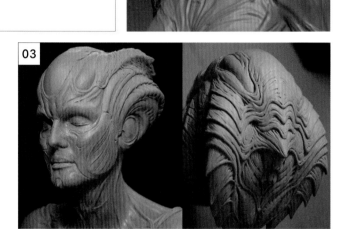

03 Shown above is the finished head sculpture.

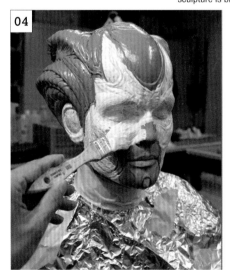

04 Make a silicone mold of the completed head sculpture. The white liquid shown in the photo above is latex. Latex is applied in order to prevent the clay sculpture from being spoiled by the casting materials and so the cast can be easily removed. Protect the body sculpture with aluminum foil.

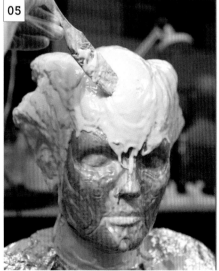

05 Shown above is a silicone casting of the head. For the first layer, apply silicone with a hake brush and let it set. For the second layer, apply silicone mixed with Cabosil (silica powder) and add thickness by layering.

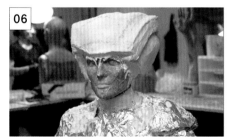

06 Since silicone is soft, it can't maintain the shape. So, after applying silicone on the head be sure to reinforce the mold with plaster.

07 The finished silicone mold of the head is shown above.

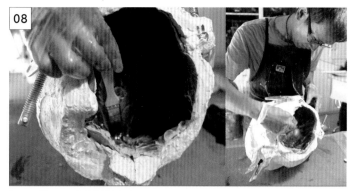

08

Pour urethane resin BJB8750 into the negative space of the head silicone mold and then fill evenly using a hake brush.

09

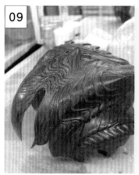

Shown above is the head made of BJB8750 once it has been removed from the head mold. Remove burrs and adjust the shape.

POINT

What is Urethane Resin BJB8750?

This is a product from a company called BJB, which sells a variety of casting and urethane products. 8750 is a urethane resin previously sold by Burman Industries. At KNB, this material was used for the masks that appeared in the film Predator. It is similar to soft FRP and has translucency. Also, it is fairly flexible and thus highly durable. As opposed to regular FRP, this product will not brake if dropped because of its softness. The drawback is that it has a strong odor and it takes time for that odor to go away.

10

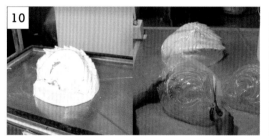

Using the plaster positive taken from the silicone mold of the head, make a plastic helmet using vacuum forming. The plastic helmet consists of three different parts: the top of the head and the two sides.

11

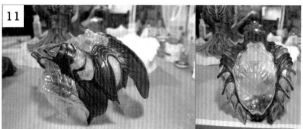

Assemble the two helmets, made from plastic and 8750 resin, to make a single helmet.

12

Put the silicone appliance over the helmet and then adjust the position and sizing.

13

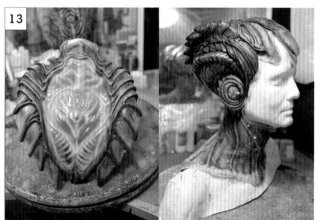

Assemble the helmet and the painted silicone appliance. Begin to paint the helmet.

14

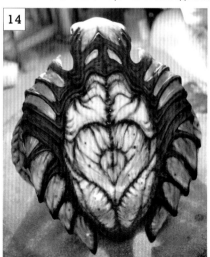

Paint with acrylic paint on the helmet. Since 8750 does not absorb paints easily, rough up the surface with sandpaper prior to painting. Be careful not to lose translucency when painting the translucent part.

FINISHED!!

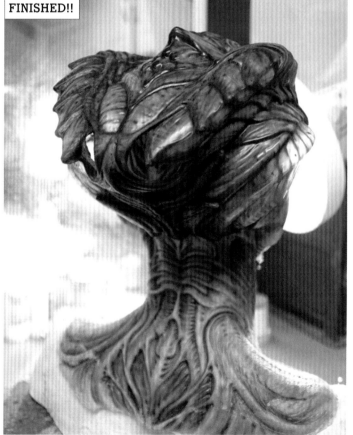

Done! Since the head is made of a transparent material, it is see through when lit from the back.

How to Make Black Flames

Using FRP (fiber-reinforced plastic), make wings shaped like spider-webs that spread out organically as if they are just black flames behind a character.

by Tomonobu Iwakura

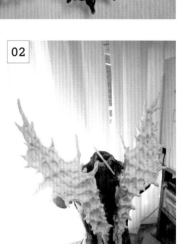

[Materials]
NSP clay, Plaster, FRP (fiber-reinforced plastic), Fiberglass mat, Talc, Primer surfacer, Clear spray, Silicone (KE-12), Curing agent, Lacquer spray (Black), Aluminum bar, GEL poly

[Tools]
Dremel, Engraving tools, Hake brush, Paper cups

01

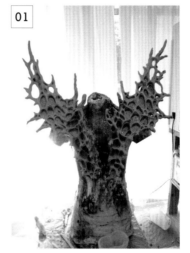

Build a framework using aluminum bars and put NSP clay on to make an original model.

02

Apply clear spray as a releasing agent. Mix silicone and curing agent together and then apply over the original model. Since the backside is not visible, apply silicone only on visible surfaces.

03

Once the silicone sets, take the clay out to complete the silicone mold.

04

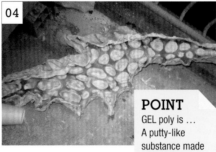

Apply a layer of GEL poly and allow to solidify.

POINT
GEL poly is ...
A putty-like substance made by mixing talc with FRP.

05

Add fiberglass matting to the second layer of GEL poly. Allow to solidify.

06

The FRP model is ready.

07

Make shoulder straps, by bending an aluminum bar, in order to be able to carry the flames on your back. Then, attach the aluminum bar to the flames made of FRP with GEL poly.

FINISHED!!

Using the silicone mold, make a few more flames out of FRP. Put the flame parts together like patchwork and then secure them to the aluminum shoulder straps using GEL poly. Apply black paint to finish.

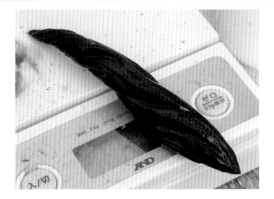

How to Make Black Nails

Make black, undulating, sharp nails that shine on all ten fingers by using Hei-CAST.

by Tomonobu Iwakura

[Materials]
NSP clay, Silicone (KE-12), Curing agent, Plaster, Water-based clay, Hei-CAST, Thinner, Talc, Acetone, Primer surfacer, Clear spray, Silicone spray, Lacquer spray (Black), Clear nail polish

[Tools]
Engraving tools, Brushes, Paper cups, Wire cutters, Dremel, Cotton swabs, Permanent marker, Scissors, Utility knife, Rubber gloves

01 Make an original model of a nail out of NSP clay.

02 Use the heat of your finger to make the clay soft and then smooth out the surface.

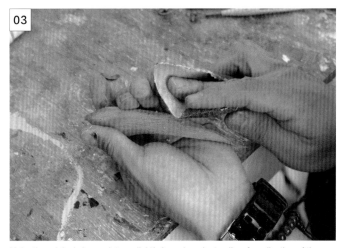

03 Make the original clay sculpture slightly large in order to allow for adjusting of the shape where it is going to be attached on the model's nail. Once the prosthetic nails are ready, each one will be shaved according to the shape of each of the model's fingers.

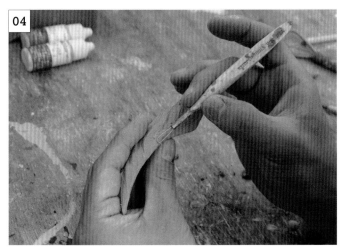

04 Cut out the undulations using a carving tool.

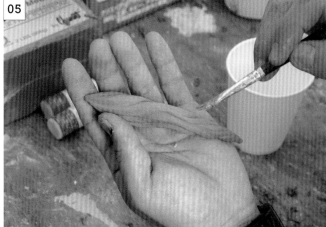

05 Pour thinner in a paper cup and smooth the clay surface with a brush.

06 Dust with talc powder.

07 Apply lacquer spray as a releasing agent.

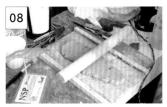

08 Roll out water-based clay thinly using a rolling pin.

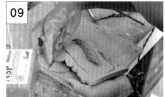

09 Embed the original model halfway into the rolled out water-based clay and then remove any excess clay.

10

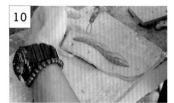

Carve out keys using an engraving tool.

11

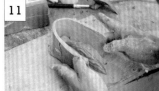

Build a wall around the clay sculpture by rolling out water-based clay.

12

Mix 250g (approx. 0.5lb.) of silicone and curing agent (approx. 0.2 oz.) together, then stir.

13

Apply lacquer spray as a releasing agent and then brush silicone in while being careful not to make any air bubbles.

14

After brushing in some silicone, pour the rest of the silicone in at once.

15

Once set, turn it over and wash away the water-based clay.

16

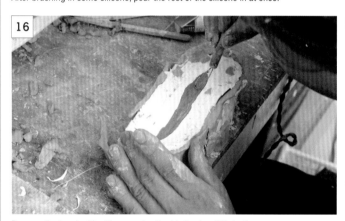

Remove the brushed in silicone using the blade of a utility knife.

17

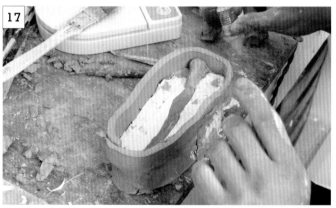

Build a wall out of water-based clay and then make a drain for pouring the casting material into the mold.

18

Apply lacquer spray as a releasing agent.

19

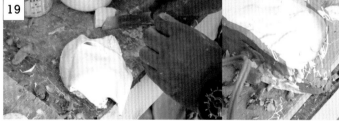

Mix silicone and curing agent. After brushing in some silicone, pour the rest of it in.

POINT
If there is not enough silicone to fill the mold, throw a cured silicone scrap in to fill up the space. By doing so, the level of the silicone will rise and the curing process will speed up.

20

Once set, remove the wall (water-based clay) and then cut the edge off with scissors.

21

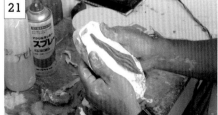

Open the cured silicone and then take out the NSP clay inside.

22

POINT
You can apply acetone so it dries faster.

Any moisture left in the mold causes incomplete curing, so be sure to completely remove any moisture. After it has dried, mark the joint with a permanent marker in several places.

Thoroughly treat the mold for releasing by applying silicone spray and lacquer spray. Since ten nails are made using this mold, apply these releasing agents many times.

While wearing rubber gloves, pour Hei-CAST A (Black) in a paper cup.

While wearing rubber gloves, pour Hei-CAST B in a paper cup.

Match the silicone mold pieces back up, place them between a wooden board, and then secure them by wrapping in gold tape.

Pour silicone (Hei-CAST) into the drain hole.

Once set, take the wooden boards off and remove the cast.

Remove large burrs with wire cutters.

Sand with a Dremel and then make a space according to the curve of your model's nail.

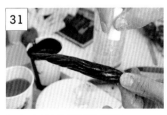

Apply clear nail polish to finish.

FINISHED!!

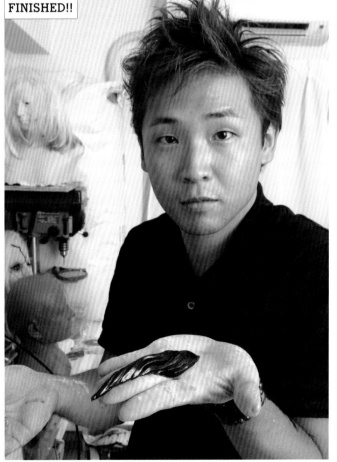

It's done!

How to Make
Super High-heeled Black Boots

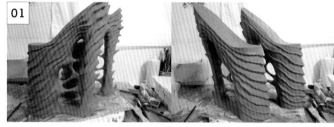

These are sadistic looking black enamel boots with heels that are over 30cm/11.8 ins. In general, Japanese models tend to have proportionally more volume on their heads. But, wearing this pair of boots helps them obtain Marilyn Manson-like presence, and his body proportions too!

by Tomonobu Iwakura

① Making the Heels

Using FRP (fiber-reinforced plastic), make super high heels that support weight.

[Materials]
NSP clay, Plaster, Vinyl chloride sheet, Burlap, FRP (fiber-reinforced plastic), Fiberglass mat, Talc, Primer surfacer, Clear spray, Lacquer spray (Black), Vaseline®, Polyester putty

[Tools]
Packing tape, Hake brush, Engraving tools, Brushes, Sandpaper (60-grit), Clamps, Hammer, Utility knife, Urethane cushioning

01

Make an original model out of NSP clay.

02

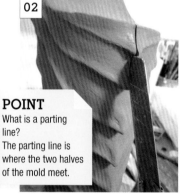

POINT
What is a parting line?
The parting line is where the two halves of the mold meet.

Insert a sheet of vinyl chloride into the completed clay sculpture. The clay is hard and the sheet cannot penetrate. So, make an incision about 8 mm/0.25 in. deep, along the parting line, with a utility knife.

03

After making an incision with a utility knife, insert a sheet of vinyl chloride that has been cut into a rectangular strip.

04

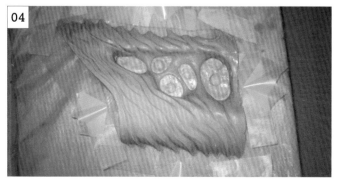

Place the clay sculpture on a soft urethane cushion. Secure the section where the vinyl chloride sheets overlap each other with packing tape.

05

Spray on clear lacquer as a releasing agent and then cast each half with plaster. For the first layer, apply plaster and let it set. For the second layer, reinforce with burlap.

06

Once set, turn the molds over and take the vinyl chloride sheet off. Apply Vaseline® thoroughly on the plaster as a releasing agent.

07

Also, on the other side, apply plaster and let it set. For the second layer, reinforce with burlap.

08

The plaster mold is ready.

09

Clean up the plaster mold and then take the clay out. Apply clear spray as a releasing agent and then brush in GEL poly (a mixture of FRP and talc).

10

Once the first layer is cured, apply FRP for the second layer. Then, put two layers of fiberglass over and saturate with FRP to cure. Lastly, put GEL poly on the matching faces of the plaster mold edges, put the halved mold back together, and press with clamps.

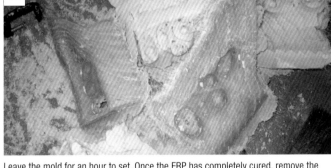

11

Leave the mold for an hour to set. Once the FRP has completely cured, remove the heel by taking the plaster mold apart with a hammer.

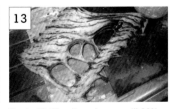

12

Shave off burrs on the demolded heel. Then, paint with black lacquer.

13

Sand with 60-grit sandpaper until 80% of the black paint is removed (until the bumps become smooth).

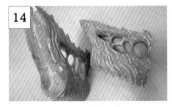

14

Concave areas look like black spots. Apply polyester putty on these areas and then smooth out with sandpaper after letting the putty set.

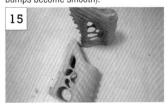

15

Once shaped, apply primer surfacer. This is the basecoat before you paint the heels black.

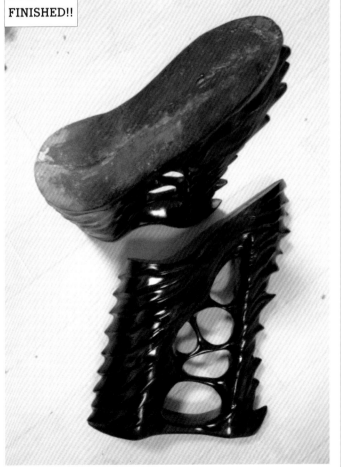

FINISHED!!

Paint with black lacquer spray and the heels are done!

Since the sole slopes steeply, due to the heel's height, the toe part needs strength to support one's weight.

[Materials]
NSP clay, Plaster, GEL poly, FRP (fiber-reinforced plastic), Fiberglass mat, G Bond, Vaseline®

[Tools]
Packing tape, Hake brush, Scissors

01

Since the boot needs a sole that matches the shape of the sole of the FRP made heel, mask the sole with packing tape and then place fiberglass over that.

02

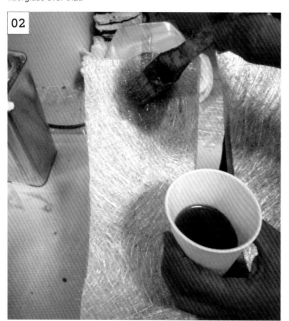

Saturate the fiberglass with FRP to cure.

03

Trace the shape of the sole.

04

Cut the fiberglass along the traced line.

05

In order to make caps for the toe and the heel, put the cut out fiberglass back on the sole of the heel. Temporarily secure the heel and the cut out fiberglass with packing tape and then sculpt one cap for the toe and one for the heel out of clay.

06

Apply Vaseline® as a releasing agent and then cast with plaster.

07

Put fiberglass on the mold and saturate it with FRP to cure. Then, cut off burrs.

08

Cast FRP once again, in the same manner as above, in order to prepare two pairs of caps.

09

Secure the toe and the heel pieces, completed in the previous steps, onto the sole with GEL poly. Once they have set, it's done.

Assemble the heels and the soles with a shaft made out of enamel.

③ Assembling the Boots

01

Cut enamel fabric the length of the boots and then cut it vertically in half.

[Materials]
Enamel, Zippers, Heels, Soles, Glue, G Bond, Epoxy adhesive
[Tools]
Paper for patterns, Sewing machine, Iron, Sewing tools, Scissors, Non-slip rubber

02

Fold a seam allowance over and iron it.

03

Sew zippers on using a sewing machine.

04

05

Put the pattern on the fabric again and then trace it using a marking pencil. Machine sew along the marked lines, then cut off the excess fabric.

Make a pattern out of newspaper, etc. Then, put the pattern on the fabric over the zippers and cut off any overlapping fabric.

Lay two pieces on top of each other.

06

Prepare a pair
Turn inside out

Cut the fabric to make a pair of boots. Sewing along the marked line creates a sock-like shape when turned inside out.

The picture above shows after zipper has been sewn.

07

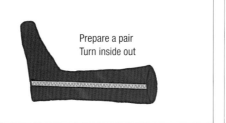

Use G Bond to attach the sole made out of FRP and the sewed enamel fabric, then the sock is ready.

Apply G Bond on the sole.

08

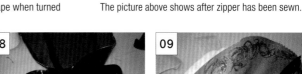

Apply epoxy adhesive on the enamel fabric where the sole is going to be attached.

09

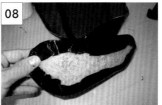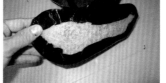

Glue the sole and the shaft of the boot together.

10

Tuck the top of the boot inside and machine sew.

11

Glue the heel and the sole together using epoxy adhesive.

12

To assemble, apply epoxy adhesive on the back of the sole made of FRP.

To complete, secure non-slip rubber on the bottom of the heel using G Bond.

How to Make a Rabbit Bodysuit

Make a rabbit bodysuit that might appear in a fantasy film by attaching urethane and SUNPELCA® (polyethylene foam) directly on an old t-shirt.
Use a heat gun and oil-based varnish to make it look like leather.

by Yuya Takahashi

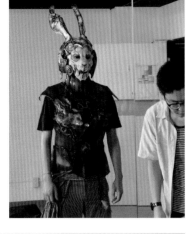

[Materials]
SUNPELCA® (polyethylene foam) 10mm / 3/8 in., and 5mm / 1/4in., Urethane foam, G Bond, Acrylic lacquer spray (Black), Water-based acrylic (Black, White), Acrylic color (Black, Copper), High Conc.* (White), Cow leather, Round rubber cord, Strip-shaped sponge, Window railing packing, Motif items, Instant glue, Oil-based varnish, Acrylic board
* Solvent-based concentrated coloring agent

[Tools]
Heat gun, Airbrush, Pliers, Spatula, Design knife, Permanent marker, Scissors, Utility knife, Various types of brushes

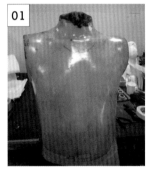

01 Prepare a full torso lifecast. If you do not have the model's lifecast, you can use a torso that has a similar figure to the model.

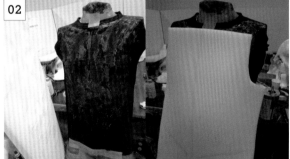

02 Put unwanted t-shirts on the torso lifecast and apply G Bond so you can apply urethane foam.

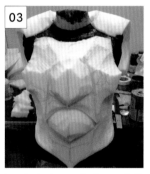

03 In order to shape out a form, cut off urethane foam using a utility knife.

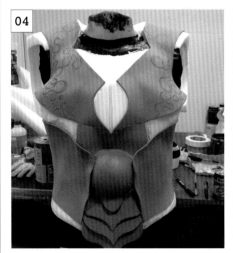

04 Glue SUNPELCA® on the urethane foam with G Bond.

05 Keeping the edge of real leather in mind, curve the edges of SUNPELCA® using a heat gun.

06 Think about the composition of each part.

07

In order for patterns to emerge, draw some curve-like sketches.

08

While being careful not to cut sketched patterns all the way through, trace them with a utility knife.

09

Heat the cut from both sides and emboss the patterns as the SUNPELCA® warps.

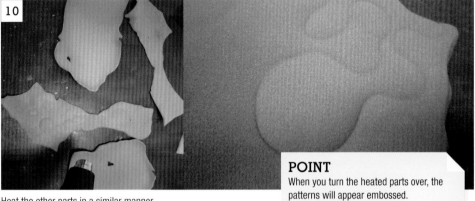

10

Heat the other parts in a similar manner.

POINT
When you turn the heated parts over, the patterns will appear embossed.

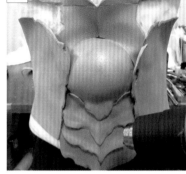

11

Heat the parts you glued together before, using the same method.

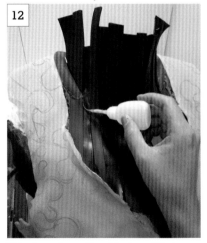

12

Make the neck part. Glue strip-shaped black sponge on with instant glue.

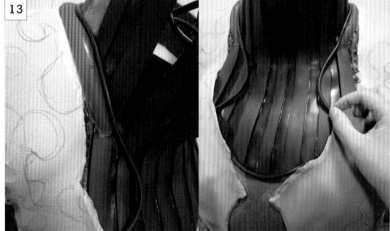

13

Glue on some rounded rubber cord.

14

For the round part of the stomach, cut out some leather.

15

Heat it using a heat gun to round the edges to bring out a worn texture.

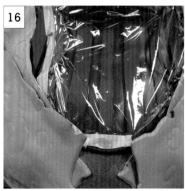

16

Mask around the neck using plastic wrap, etc.

17

Coat the body with G Bond (for sealing and as a basecoat).

18

Make white colored paint by mixing G Bond with High Conc. white (toner) and thinner.

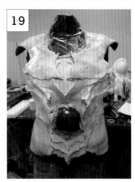

19

Apply this over the parts.

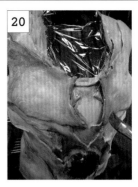

20

In order to bring out the leather-like texture, apply oil-based varnish on the edges unevenly.

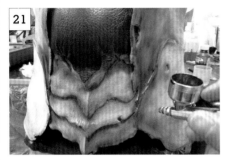

21

Airbrush on oil-based varnish.

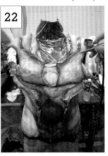

22

Add patchy coloring using a few different kinds of oil-based varnish.

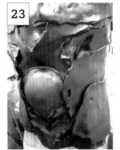

23

Finish painting, while keeping the leather texture desired in mind.

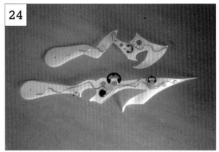

24

Assemble an acrylic sheet and motif items to make the clock hands.

25

Make numbers out of SUNPELCA®.

26

Paint the numbers and then glue them on the body.

27

Draw the pattern for the back of the costume on a piece of paper.

28

Make a copy and reverse it in order to create a symmetrical pattern.

29

Copy the pattern on cardstock and cut it out. Then, place it on the back of the costume and spray silver paint over it. Then, you're done.

FINISHED!!

Attach the clock hands to the body to complete.

How to Make the Rabbit Head

This section introduces the method for making a leather-like helmet using SUNPELCA® (polyethylene foam) and urethane foam, just like with the body.
An annealed wire is inserted in order to make the ears extend.

by Yuya Takahashi

[Materials]
SUNPELCA® (polyethylene foam) 10mm / 3/8 in., and 5mm / 1/4in., Urethane foam, Acrylic lacquer spray (Black), Acrylic paint (Black, White), Acrylic color (Black, Copper), Cow leather, Round rubber cord, Strip-shaped sponge, Window railing packing, Motif items (Screws, Tacks, Rivets, etc.), Annealed wire (Large wire), White High Conc.*, Black fabric, Oil-based varnish, G Bond, Instant glue

[Tools]
Heat gun, Airbrush, Pliers, Spatula, Design knife, Permanent marker, Scissors, Utility knife, Various types brushes, Portable gas stove, Bandsaw, Hollow punch

* Solvent-based concentrated coloring agent

03

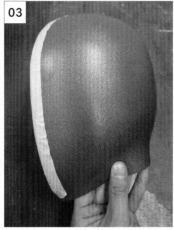

Do the same for the other side and then cut off any excess.

04

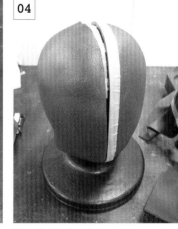

Put both sides together.

01

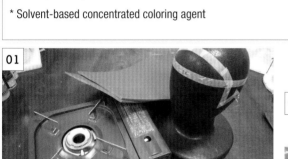

Prepare a portable gas stove, SUNPELCA®, and a mannequin head. Get ready to heat press.

05

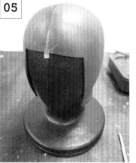

Cut out where the face is exposed. Now, the helmet that forms the foundation of the head is ready.

06

Put a second layer on the helmet to reinforce.

02

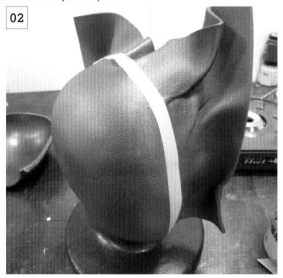

Using heat from the portable gas stove, make the SUNPELCA® soft and then press it over half of the mannequin's head to form the shape of a face.

07

On back of the helmet, glue urethane foam in layers.

08

Cut off excess urethane foam in order to form the shape of the head.

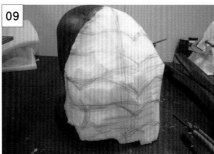

09

Sketch lines for gluing on the cow leather parts.

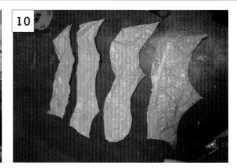

10

To make patterns, trace the sketch onto a piece of paper.

11

Trace the pattern on SUNPELCA®.

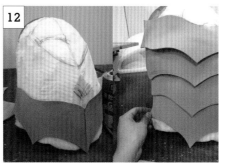

12

Glue on the cut out SUNPELCA® using G Bond.

13

Cut the edge of each piece of SUNPELCA® using a utility knife to make it look like cut up leather edge.

14

Sketch a rabbit ear to make a pattern.

15

Trace the pattern and cut out an ear.

16

Carefully, cut one ear using a bandsaw.

17

Apply G Bond on the cut out ear part. Then, glue on a second piece while inserting an annealed wire (large wire) between the two pieces.

18

Carefully, cut off extra material with a bandsaw.

19

The piece of black fabric is for reinforcement when attaching the ears to the head.

20

Shave off the urethane foam to adjust the shape.

21

Bend (it will maintain its shape because of the inlayed annealed wire) to create a nice curve.

22

To decorate, glue round rubber cord around the ear using G Bond. Then, apply G Bond over everything.

23

The photo above shows after G Bond has been applied.

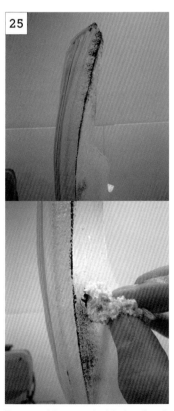

25

From top of the ear, make it look as though the paint is weathered (paint by dabbing with a piece of towel).

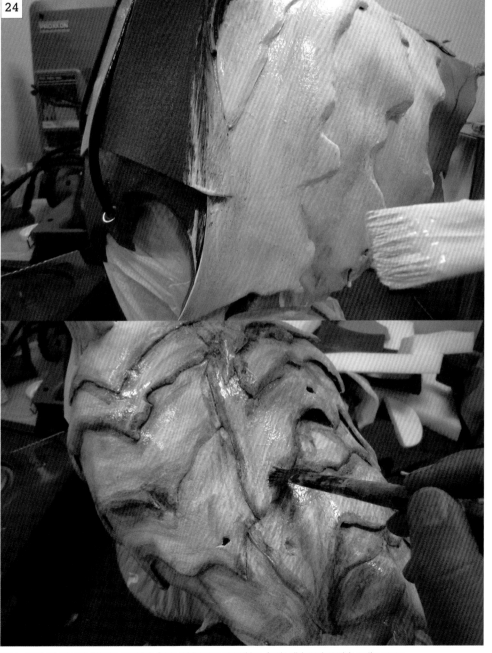

24

Apply paint mixed with G Bond and High Conc. white over everything. Apply oil-based varnish on the areas that are supposed to look like leather in order to bring out the leather texture.

26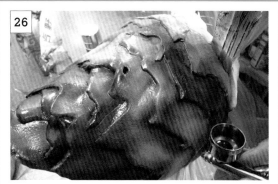

Apply oil-based varnish on the areas that are supposed to look like leather.

27

Apply oil-based varnish on the areas that are supposed to look like leather.

28

Create weathering, like oil stains, peeled off paint, rust, etc., on the metal on the ears.

29

The picture above shows when 80% of the fabrication is done. At this point, more weathering needs to be done, so add it at any time.

30

Glue on motif items, like screws, tacks, rivets, etc., using instant glue.

3 1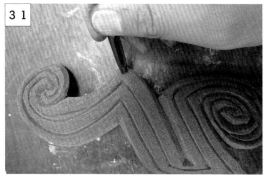

Make designer pieces that cover from the cheek to the temple using SUNPELCA®. Press a hollow punch into the SUNPELCA® in several places to make it look as if the cheek guards have rivet heads (they will be painted grey/silver later).

32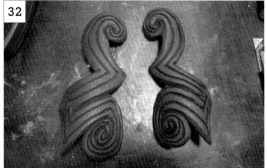

Heat using a heat gun and it's ready.

FINISHED!!

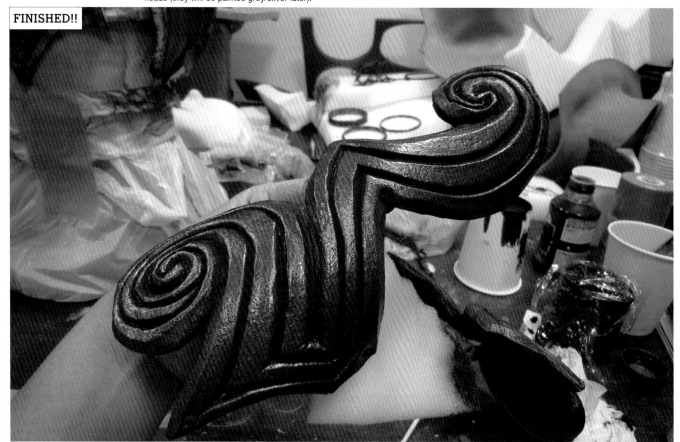

Paint the cheek guards copper and give weathering effects to complete.

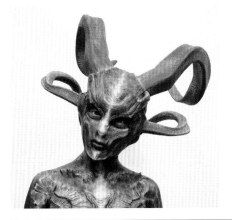

How to Make
Mythical Horns

Using SUNPELCA®, produce thick and twisted horns like the ones that mythical demons possess. Since an aluminum wire forms the core of the horns their shape can be changed to suit your needs.

by Kakusei Fujiwara

[Materials]
SUNPELCA® (polyethylene foam), Aluminum wire, Latex, Lacquer spray, FRP (fiber-reinforced plastic), Dental acrylic, Piano wire, Fabric, G Bond, G Bond thinner, Water-based dye
[Tools]
Airbrush, Soldering iron, Utility knife

01

Prepare two different thicknesses of SUNPELCA® for the horn material.

02

An aluminum wire being a core, Sandwich the aluminum wire core in between the SUNPELCA®. Shave the SUNPELCA® to form the desired shape and then add detailed designs using a soldering iron.

03

Adjust your detailed designs with the soldering iron. Be sure to use proper ventilation and be aware of the fire hazard!

04

Apply G Bond that has been thinned with G Bond thinner over the entire horn. Dye some latex using a water-based dye and then apply over the horn.

05

After applying either bonding wax or Vaseline® as a releasing agent on the head lifecast cover the "cap" of the head with FRP. Then, add fiberglass matting by dabbing with more FRP. Allow to cure. This makes a skull cap.

06

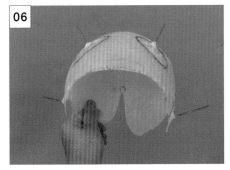

Secure heavy gauge piano wire on the skull cap where you want to attach each horn.

07

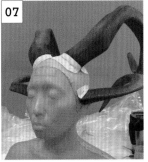

Attach the horns and secure them using dental acrylic.

FINISHED!!

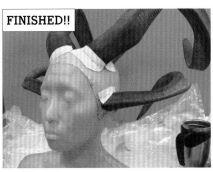

Since the horns are meant to bend you will need to reinforce the base where force will be applied when bending. Do so by adding pieces of fabric that have been coated with bonding agent to the base of each horn.

How to Make a Hard Skin Prosthetic Using Foam Latex

Produce a prosthetic with hard textured, matte skin that resembles a reptile's skin by using latex coated foam latex.
In order for the mouth to move freely the prosthetic breaks down into the head pieces and the cheek & mouth piece.

by Kakusei Fujiwara

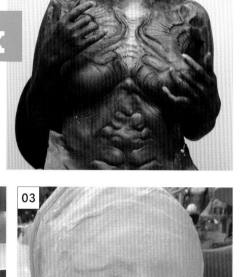

[Materials]
Bald cap, Vaseline®, Self-skinning urethane, Urethane toner, Alginate, Bandages, Dental acrylic separator, Plaster (FX Stone), Clear lacquer spray, Silicone (KE-12), Curing agent, NSP clay, Oil-based clay, Water-based paint, Latex, Foaming agent, Curing agent, Gelling agent

[Tools]
Pail, Engraving tools, Hand mixer, Injector, Hake brush, Dryer

Model: Akari, a Japanese idol

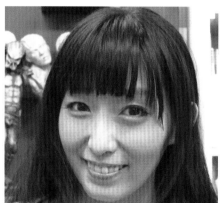

01

Cover the models head with a bald cap. Apply Vaseline® over the bald cap so the alginate comes off without locking.

02

Apply alginate.

03

Reinforce with bandages over the alginate. Take the cast off once the bandages have set up. Pour plaster into the negative space to make a lifecast.

04

Make a mold out of the lifecast using silicone. Pour plaster into the silicone mold to make two frontal face molds (since the face will be broken down into two parts).

05

Apply either dental acrylic separator or hair conditioner on areas where you intend to breakdown the clay sculpture (this helps with the breakdown).

06

Start to sculpt your prosthetic out of NSP clay.

07

Once the overall shape is fixed, make a cut line where you intend to breakdown the clay sculpture. Pay attention to the angle of the cut plane.

08

Submerge the clay sculpture in a container filled with water for a couple of hours.

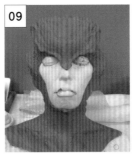

09

The photo above shows the face after the cheek & mouth part has been removed.

10

Finish detailing.

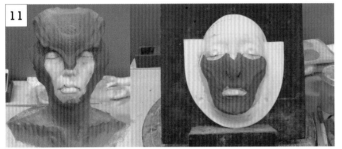

11

Shown above are the two broken down parts of the clay sculpture.

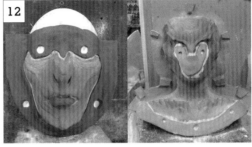

12

Put oil-based clay around the clay sculptures, carve out some keys, and build flashing.

13

Apply clear lacquer spray as a releasing agent and then make a mold using plaster. The plaster used in this fabrication is a brand new product called FX Stone.

14

Apply latex dyed with water-based paint on areas that do not influence the expression of the prosthetic.

15

The reasons for applying the latex are: to prevent air pockets, and to reinforce the surface because of the weight of the head.

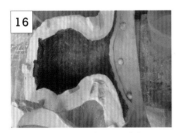

16

Before pouring in the foam apply latex again.

17

Use an electric hand mixer to mix foam latex, foaming agent, and curing agent in a 10 : 2 : 1 ratio.

POINT

Mixing of Foam Latex
At first, mix at a slow speed for 1 min. Next, mix at the highest speed for 3 mins. Once it begins to foam, mix at medium speed for 4 min. Then, mix at the same slow speed as you did before for 3 min. Keep mixing with an electric mixer while dropping in a small amount of gelling agent over 30 sec. Mix together completely until the gelling agent is fully incorporated.

18

At first, apply foam latex using a hake brush. Next, force the foam latex in using an injector and then let it dry in a dryer.

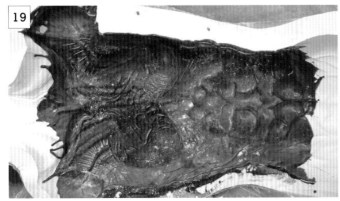

19

Lightly swish self-skinning urethane on the lifecast bust.

FINISHED!!

Fill in the negative space with urethane toner to complete.

How to Make a Fish Man Prosthetic

This is a silicone prosthetic where the skin looks like that of a slimy fish. When the prosthetic is made entirely using silicone, it becomes heavy and the weight causes the bulging portions to warp. Therefore, this section introduces a method for making the inside of the prosthetic hollow using FRP (fiber-reinforced plastic).

by Tomo Hyakutake

[Materials]
Full head lifecast, Water-based clay, Lacquer spray, Plaster bandages, Bonding wax, FRP (fiber-reinforced plastic), NSP clay, Thinner, Oil-based clay, Plaster, Wood clay, Ecoflex® 00-10 (by Smooth-On Inc.), Mold releasing agent, Shark teeth, Dental acrylic, Plastic model paint (Clear Red), Transparent polyvinyl chloride dome, Acrylic paint, Skin Tite® (by Smooth-On Inc.), Soapy water

[Tools]
Engraving tools, Brushes, Hake brush, Paper cups, Disposable chopsticks, Oven

02 Create an original model using water-based clay (as seen above). This will become the FRP-base.

01

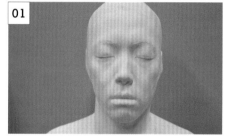

Make a full head lifecast of your model.

03

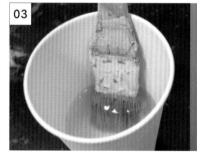

Smooth out the clay surface with water.

04

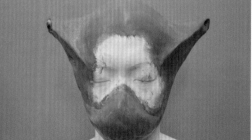

Once the clay sculpture is done, apply lacquer spray.

05

Fold plaster bandages in half and then cut to a length of 40 cm / 15.75 in. Soak in water and squeeze out the excess.

06

Cover the clay sculpture with the plaster bandages.

07 Once the backside of the clay sculpture is covered, apply soapy water alongside the plaster bandages, where they touch the clay. Similarly, cover the front with the plaster bandages.

08 Apply bonding wax as a releasing agent inside the plaster cast and then apply FRP over that.

09 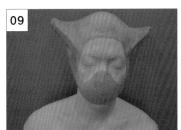 Above we see the model after the FRP has dried and the FRP mold has been removed from the plaster cast and placed on the lifecast.

10 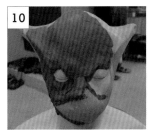 Once the FRP mask is on the lifecast, sculpt your prosthetic over the mask using NSP clay.

11 In a glass container, mix NSP clay and thinner in a 1:1 ratio. Then, apply that mixture to the clay sculpture while creating a bumpy texture. This will add details to the surface.

13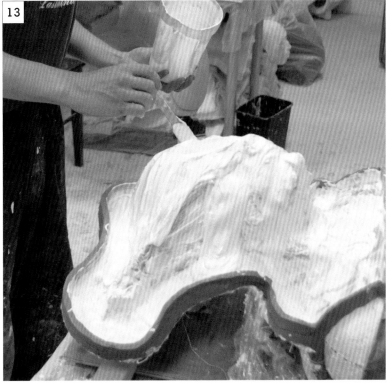

12 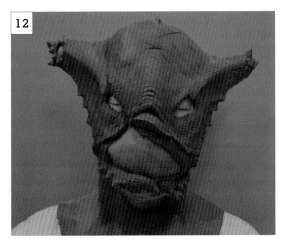 The finished clay sculpture is shown above.

Build flashing out of oil-based clay and then make a mold with plaster.

14 Fill in the gaps between the FRP mask and plaster with wood clay and put the mold in an oven.

15 Take a small amount of blue pigment (using the tip of a disposable chopstick) and then add that to the B solution of Ecoflex® 00-10 (silicone) from Smooth-On Inc. and mix

16 Next, take a small amount of white pigment (using the tip of a disposable chopstick) and mix it in the B solution as well.

17 Mix the A and B solutions (Ecoflex® 00-10) together in a 1:1 ratio.

Spray a mold releasing agent on the plaster mold after applying lacquer spray.

After brushing Ecoflex® all over using a hake brush, put both sides of the mold together and then slowly fill the mold with the remaining Ecoflex® from the backside.

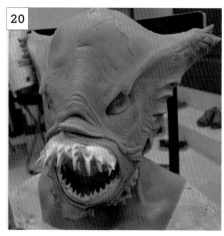

Above we see the cured Ecoflex®. Attach shark teeth.

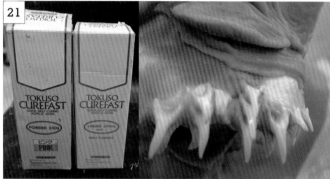

Apply dental acrylic on the gums and then paint using clear red plastic model paint (see photo on right).

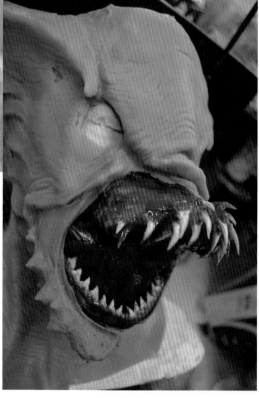

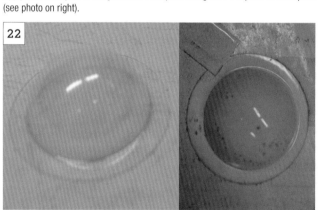

For the eyes, prepare four transparent polyvinyl chloride domes. Paint two of them using acrylic paint.

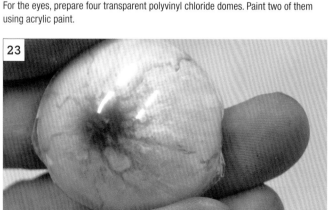

Lay one transparent polyvinyl chloride dome over the painted eyeball polyvinyl chloride dome.

FINISHED!!

Put the eyes in the eye socket of the prosthetic and glue them on using Skin Tite® from Smooth-On Inc.

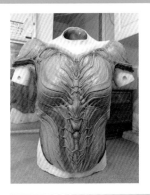

How to Make a Foam Latex Torso Prosthetic

Produce a bare skin like textured prosthetic out of foam latex using a spandex covered torso lifecast.

by AKIHITO

[Materials]
NSP clay, Syntactic foam, Clear spray, FRP (fiber-reinforced plastic), A kit of foam latex (Latex base, Foaming agent, Gelling agent), Pros-Aide, Acrylic paint, Bonding spray (Super 77®), Latex, Spandex (Polyurethane fiber), Cloth (fiberglass mat), PAX

[Tools]
Brushes, Hake brush, Airbrush, Sunbeam mixer, Oven, Scale

POINT

Syntactic Foam
Syntactic foam is a lightweight, high-strength composite material that has even been used for deep-sea submarine parts, etc. It is hard but surprisingly lightweight and syntactic foam can produce molds that can be used semi-permanently. A mold made out of syntactic foam increases production efficiency, when compared to using heavy molds. In addition, a syntactic foam mold has less shrinkage and distortion compared to an FRP (fiber-reinforced plastic) mold. Thus, the majority of mold-making performed in Hollywood is now done with syntactic mold. The syntactic mold can be utilized for all silicones, gelatins, and foams. Of note, you can produce extremely smooth and soft prosthetics using foam syntactic molds. The drawbacks are that it is an expensive material and it takes time to make the mold. The syntactic foam that AKIHITO used in this production is the least expensive product among many. The product is called "ADTECH" and it is manufactured by CACC. It is sold at "RevChem" (http://www.revchem.com/) in Los Angeles.

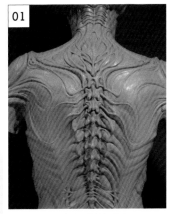

Shown above is the finished clay sculpture for the head and the torso. Chris Bear was in charge of mold-making for these sculptures.

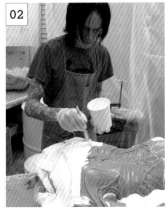

Syntactic mold making: Apply clear spray on the finished clay sculpture as a releasing agent. The above photo shows someone brushing in the first layer of syntactic foam (white liquid).

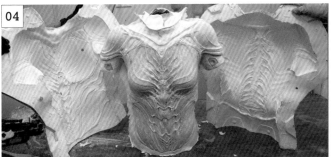

Above we see the complete torso prosthetic.

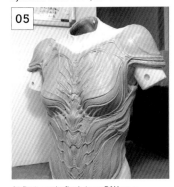

Mix foam latex using a Sunbeam mixer and then pour it in the syntactic mold. Then, bake in an oven for five hours.

At first, apply flesh tone PAX as a basecoat. Next, airbrush on thinned acrylic paint. Then, apply Pros-Aide using a hake brush. Lay down several layers of color while sanding between applications.

Now layer on some brown and black with the airbrush.

[How to Reinforce a Torso Cast]

The material used here is latex and the bonding spray Super 77®. Use the bonding spray to secure spandex on the torso lifecast.

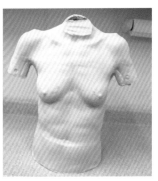

A torso lifecast covered with spandex is shown above.

How to Make Zombie Makeup Prosthetic Appliances

Postmortem. Produce zombie prosthetic appliances, where the skin is decayed and dried-up due to the passing of time, using foam latex.

by Akiteru Nakada

[Materials]
Bald cap, Vaseline®, Alginate, Plaster bandage, Plaster, Oil-based clay, Silicone, Foam latex

[Tools]
Brushes, Hake brush, Engraving tools, Electric hand mixer, Oven

The model is one of our M.E.U. staff members, Toru Kushibuchi. Since the theme here is zombie makeup, I chose a model with a slim figure.

Cover the model's head with a latex bald cap to prevent alginate from sticking to the hair.

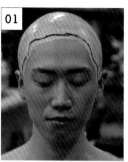

Apply alginate on the model's face. Once set, reinforce with plaster bandages.

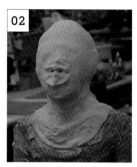

Once both materials have cured, remove from the model's face. This becomes the negative mold. Pour in some plaster.

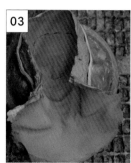

Make a silicone mold of the finished plaster lifecast. For sectioning purposes, make molds of the face and the neck separately using plaster. This is the preparation for an original sculpting model for zombie makeup appliances.

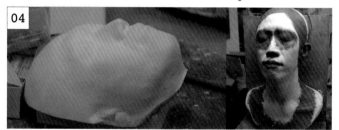

Sculpt your prosthetics out of oil-based clay, based on your design sketches. At this point, it is important to imagine the human bone structure, muscles, skin texture, wounds, etc., based on various resources and knowledge.

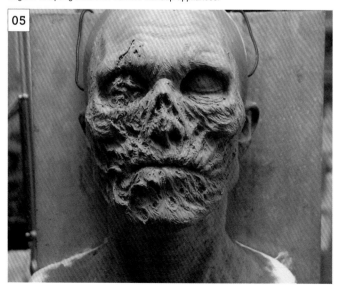

Break down the sculpture of the face and the neck. Doing so increases efficiency when applying the prosthetic and prevents the mold from becoming too large.

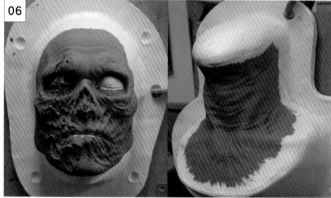

Make plaster molds of the original models. Then, pour foam latex in the molds and bake them in an oven. The prosthetics are ready.

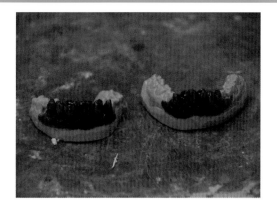

How to Make Zombie Teeth

Teeth are an important element of a zombie's features. The roots of the teeth are exposed because the gums are thin and decaying. Capture the look and feel of teeth that are chipped and filthy from eating human flesh.

by Akiteru Nakada

[Materials]
Dental plaster, Alginate, Polyvinyl chloride sheet, Oil-based clay, Silicone, Dental acrylic, Epoxy adhesive

[Tools]
Engraving tools, Dental tray, Vacuum form

01 Prepare a pair of dental trays, alginate, and dental plaster.

02 Fill the dental tray with alginate and insert it inside of the model's mouth to take an impression. Take impressions of both the upper and lower teeth.

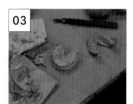

03 Fill the impressions with dental plaster. Once set, the dental cast is ready.

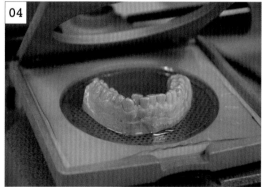

04 Place the dental cast in a vacuum former in order to make a polyvinyl chloride cap of the dental cast. Doing so allows you to make a denture that fits the model's teeth securely.

05 Make a silicone mold of the dental cast. Pour plaster into the silicone mold.

06 Sculpt an original model of your zombie teeth out of oil-based clay. Then, make a silicone mold of the sculpture.

07 Pour dental acrylic resin into the silicone mold to make the false teeth.

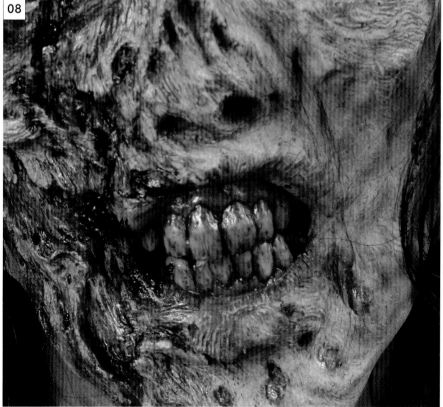

08 Assemble the dental acrylic false teeth and polyvinyl chloride cap using epoxy adhesive. Paint to complete.

Special Make-up Artist Zombie

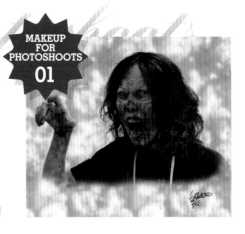

by Akiteru Nakada

The basic idea behind this photoshoot was a special effects make-up artist has been eaten by a zombie! The mysterious corpse was found in a studio... The photoshoot for the gallery pages occurred like this: I approached the corpse, then suddenly it rolled off its chair, stood up, and then I was being chased and attacked! The makeup was applied over foam latex appliances. The dental acrylic denture was produced for a zombie that has been dead for three months and has begun to dry up.

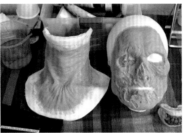

[Materials]
Foam latex pieces, Gelatin pieces, Astringent, Skin barrier cream, Pros-Aide, PAX (A mixture of Pros-Aide and Liquitex), Ink for painting (TEMPTU DURA: Brown, Purple), Liquitex, Polymer medium gloss (Liquitex gloss medium), Black Tooth Color, Fake blood, Aerosil®, Zombie contact lenses, Dental acrylic denture, Greasepaint, Set Powder

[Tools]
Sponge, Airbrush, Brushes, Kleenex, Spray bottle

Model: Tetsuya Kushibuchi (M.E.U. staff)

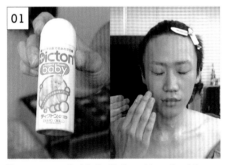

01 Remove excess facial oil with the astringent and then apply baby cream carefully.

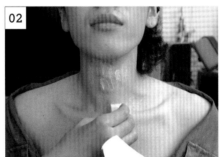

02 Lightly apply Pros-Aide on the neck.

03 Decide on the centerline of the Adam's apple and then glue the prosthetic to the neck. Next, glue down the appliance below the chin while moving the neck to keep it tight.

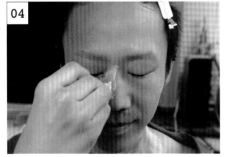

04 Apply Pros-Aide starting from center of the face.

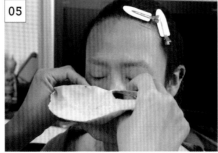

05 Place the bottom of the face appliance under the chin and then glue it down by moving upwards.

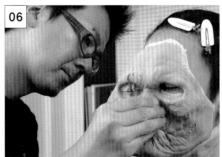

06 While holding the middle of the forehead on the prosthetic, adjust it so it aligns with center of the model's face.

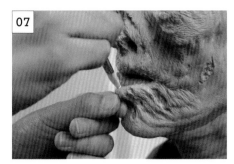

Glue down the edges of the lips.

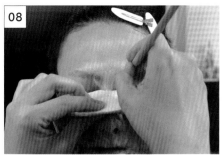

Glue the prosthetic down from the eyelids up to the forehead. The right eye (the side that is crushed) has a small hole so the model can see.

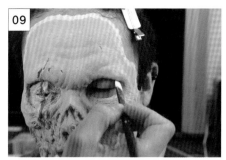

Carefully glue around the eye so that the blended edge hides under the crease line.

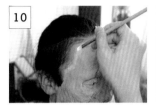

Glue down the forehead area and then refine the edges using Pros-Aide.

Take PAX (a mixture of Pros-Aide and Liquitex) on a sponge and apply it over the prosthetic. Since this is a zombie, the PAX is made to have stronger blue and yellow colors compared to normal human flesh tone. Use a brush to apply PAX on the earlobes and the lips.

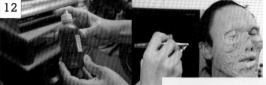
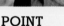

Fill the airbrush with TEMPTU DUAR brown and adjust the pressure so it splatters. Then, airbrush the prosthetic.

POINT

When the air pressure is reduced and the needle cap is opened, the paint is sprayed in coarse drops instead of a mist. You can use this setting to paint the skin's fine texture.

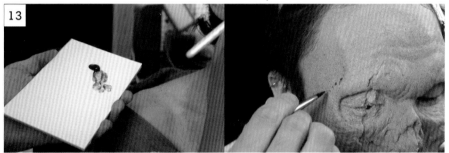

Add Liquitex purple on the wounds and in the shadows. When purple is used, it depicts a type of "decayed red." Paint the deepest spots black and paint the edge of the wounds black.

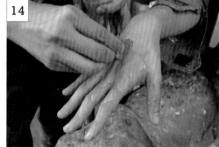

Apply PAX on the hands.

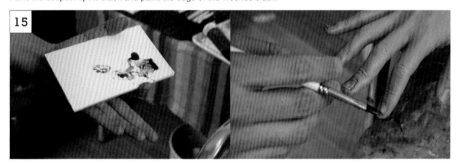

Mix some brown and purple and then brush it on the nails. Mix black and brown and paint that on the joints of the fingers and between the fingers to make them look filthy.

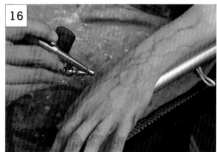

Fill the airbrush with TEMPTU DURA purple and then airbrush the veins on the arms. To be effective, do not make the veins too "cluttered." Using the same airbrush, paint the finger joints.

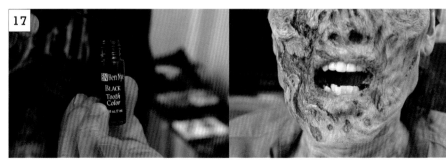

Wipe moisture off the model's teeth using a piece of Kleenex, then apply Black Tooth Color.

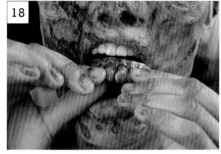

Put the dentures in.

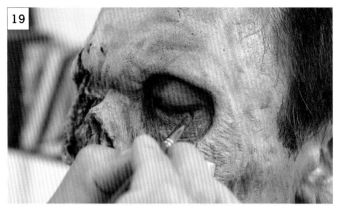

19

Mix red purple, blue purple, and brown. Apply from the lower eyelid to the crease in the same manner as applying eye shadow. Then blend it out.

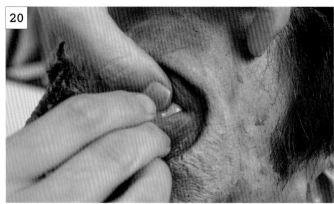

20

Put in zombie contact lenses.

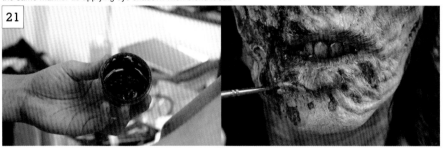

21

Pat polymer medium gloss (Liquitex gloss medium) in areas with severe wounds.

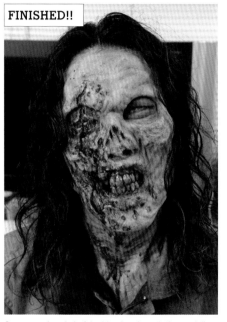

FINISHED!!

22

Wet the hair using a spray bottle. Drip fake blood on the clothes.

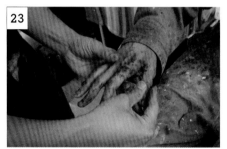

23

Coagulate fake blood using Aerosil® and put blood clots on the hands and the throat.

Cover your hands in fake blood and touch the model's hands and clothes in order to add traces of blood. Then, it's done!

Once again, the zombie has struck!
Zombie Victim Wound Makeup

The next victim is Akiteru Nakada, an FX make-up artist!
In this section we will create skin that has been torn up in a zombie attack.

01

Apply Pros-Aide where the wound is located.

02

Glue on gelatin pieces.

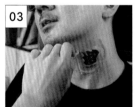

03

Refine the edges of the gelatin by melting with skin toner.

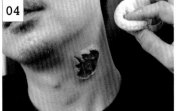

04

Dab the edge with powder.

05

Paint the inside of the wound with brown and red greasepaints.

FINISHED!!

Apply a medium gloss. Then, it's done!

Jean Yu-bin Dyske

MAKEUP FOR PHOTOSHOOTS 02

by Soichi Umezawa

Jean Yu-bin Dyske is a person whose fingers have started to grow from his head and face. In the end he has to live with that because there is nothing he can do. It has been a while since the fingers started to grow, so he has reluctantly begun to experiment with putting decorations on the nails. The fingers grow one after another and lately his head has begun to hurt… Reproduce the textures of human flesh with realistic silicone appliances.

[Materials]
Silicone finger appliances (divided into four sections), Finger-shaped earring, Telesis, Telesis thinner, Pros-Aide, Pros-Aide Cabosil, Acetone, Ethanol, Face powder, Skin Illustrator, Greasepaint, Adhesive, Color contact lenses (Black, White), Hair gel

[Tools]
Brushes, Airbrush, Dryer, Mixing palette

Model: Former actor, Daisuke Yanagisawa, currently works as a prop-master for film productions.

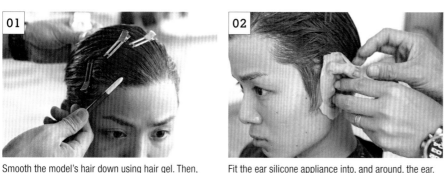

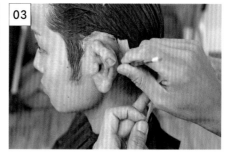

01

Smooth the model's hair down using hair gel. Then, apply Pros-Aide along the hairline to settle the hair down. Wipe excess facial oil off using a face cleansing towelette, etc.

02

Fit the ear silicone appliance into, and around, the ear.

03

Glue down the ear silicone appliance using thinned Telesis. Melt the blending edges away with acetone to refine the edges.

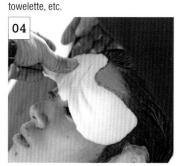

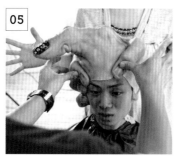

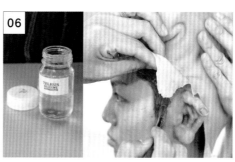

04

When applying the silicone appliance, have the model lay down to prevent deforming the application through sagging.

05

Fit the hollowed out silicone appliance onto the model's head.

06

Glue down the silicone appliance using Telesis.

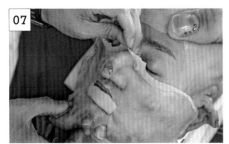

07 Apply the silicone appliance that covers the model's nose, chin, and cheeks. Begin gluing from center of the nose.

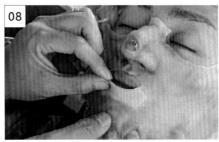

08 Align the silicone appliance's lip line at the very edge of the model's lip line.

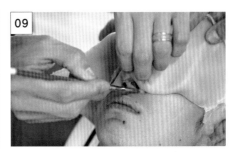

09 Apply Telesis around the nostrils and glue down the silicone appliance.

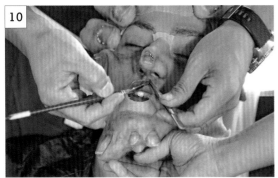

10 For the base of the nose, lift up the edge of the silicone appliance using tweezers and then carefully glue it down.

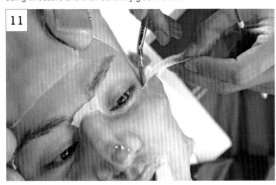

11 For the eye area, glue down the silicone appliance by aligning with the edge of the model's eye.

12 Since the model is laying down, work while squatting or sitting with one knee up for stability.

13 Glue down the area between the brows. Extend the cheek silicone appliance over this.

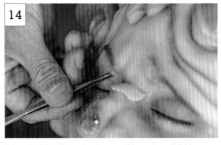

14 Bring the blending edge to a position where it hides under the crease line.

15 Smooth out the blending edges with Pros-Aide Cabosil.

16 Dry the Pros-Aide Cabosil you applied using a dryer. Thin out some Skin Illustrator with ethanol and airbrush shadows and highlights onto the silicone appliances.

17 Prepare acrylic nails. Glue the stick-on nails onto the model's nails.

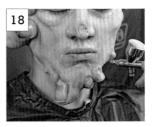

18 To paint the silicone appliances, use an airbrush.

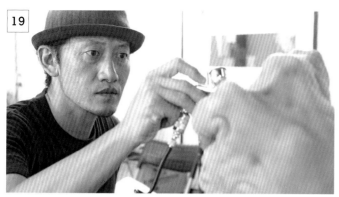

Make a darker shade of flesh tone and then airbrush it onto the fingers to add shading.

Spackle red coloring (made from red purple, brownish red and red) on the silicone appliance by flicking the brush tip against the edge of the mixing palette and onto the face. Spackle the T-zone and bulged areas like the cheeks, boney protrusions, in between the brows, nose, etc.

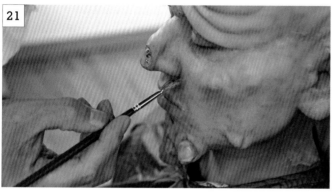

Add red to the nose-wings.

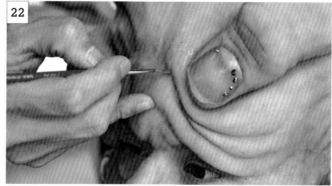

Add shading in the wrinkles. Based on the history of this character we know that he is in his late twenties, so it is not necessary to add many brown spots.

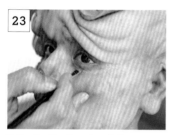

Refine the blending edges in the eye area using Pros-Aide Cabosil.

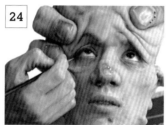

Create shading around the eyes using dark eye shadow.

Apply eyeliner along the upper lashline.

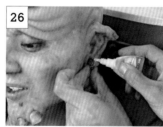

Glue on a finger shape earring made of epoxy.

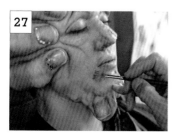

Refine all the blending edges once and for all.

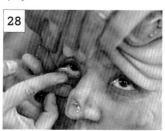

Put in swirly black and white colored contact lens. It's done!

FINISHED!!

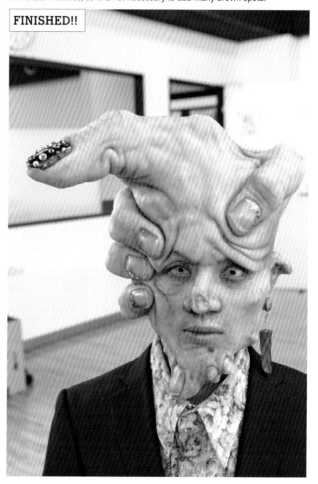

The Rabbit Seargent

by Yuya Takahashi

The Rabbit Sargeant is a rabbit soldier from a fantasy world. Given the clock face attached to his chest, it is easy to see similarities to *Alice in Wonderland*. This appliance is made using a foam latex face appliance and headgear made from SUNPELCA® (polyethylene foam).

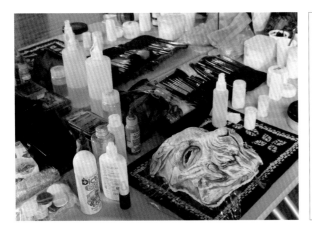

[Materials]
Foam latex appliance, PAX (Pros-Aide mixed with Liquitex), Derma Shield, Bald cap, Surgical tape, Black sclera contact lenses, Pros-Aide, Oil-based foundation, G Bond, Pros-Aide Cabosil, Set Powder, Castor oil, Skin Illustrator, Ethanol

[Tools]
Airbrush, Brushes, Spatula, Spray bottle

Model: Kai Sasaki, a toy model maker apprentice.

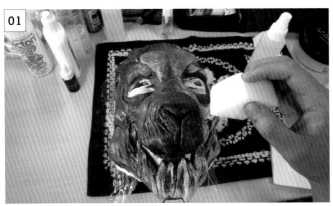

01 Apply brown PAX (Pros-Aide mixed with Liquitex) everywhere on the foam latex appliance so that the PAX penetrates every groove. Rub white PAX over the surface, but leave the brown in the grooves.

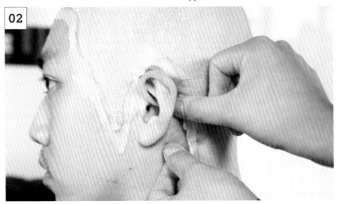

02 Apply Derma Shield to protect the model's skin and put a bald cap on the model's head. Reinforce the bald cap behind the ear with surgical tape.

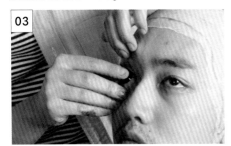

03 Put in black sclera contact lenses.

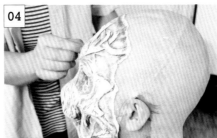

04 Hold the foam latex appliance against the face. Then, apply Pros-Aide inside of the foam latex appliance.

05 Apply Pros-Aide also on the model's skin and then begin to glue it down from the center (the nose) outward.

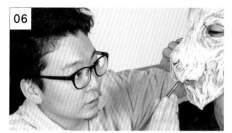

06 The model's mouth aligns with the muzzle of the foam latex appliance.

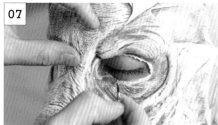

07 Use Pros-Aide to glue down detailed spots in the eye area that easily fail. Then, dab with Set Powder. This concludes the gluing process.

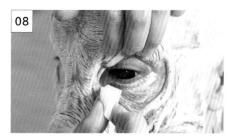

08 Apply Pros-Aide Cabosil to edges that might attract attention, then dab PAX on the blending edge with a sponge to blend with the model's skin.

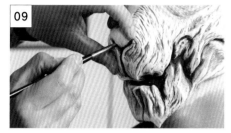

09 Let the PAX completely dry and then dab with Set Powder. Paint the nostrils, etc., using black oil-based foundation that was mixed with a small amount of brown.

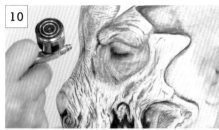

10 Airbrush in some black to add shadows. Begin by adding shadows to the deeper creases and move on to shallower creases.

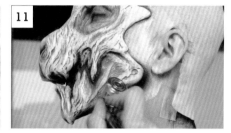

11 Airbrush brown and blend it in with the white PAX that was applied prior. Next, add various tones using red, purple, and pink.

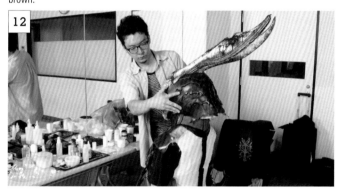

12 Apply the body appliance and put the foam latex ear appliance on to check positioning.

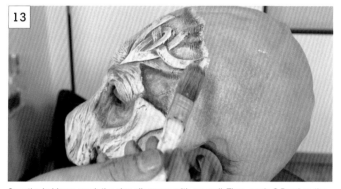

13 Over the bald cap, mark the glue allowance with a pencil. Then, apply G Bond on the bald cap accordingly.

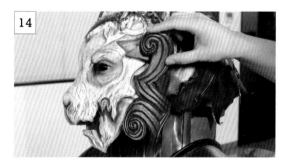

14 Glue the head gear on. Glue the design piece on the cheek using G Bond as well.

15 Use black colored foundation to add final shading and aging.

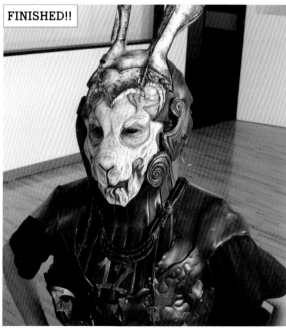

FINISHED!! The finished application is shown above. Add a coat for photoshoots.

Creation and Destruction

by Tomonobu Iwakura

Cracked flesh shines through! This character was produced by imagining the body of an individual who is slowly being destroyed. Apply silicone appliances all over the body and insert holographic film into the open wounds. This is an interesting and astonishing makeup application that took four hours.

[Materials]
Silicone (GEL10) and latex appliances, Astringent, Ethanol, Telesis, Acetone, Face powder, Bald cap, Skin Illustrator (Red, Black, Flesh tone orange), PAX, Acrylic paint, Foundation (Make Up Forever), Vaseline®, Pros-Aide Cabosil, Pros-Aide, Color Lining, Holographic film, Leather cord

[Tools]
Brushes, Cotton swabs, Hair spray, Urethane sponge, Airbrush, Hair dryer, Paper cup, Scissors

Model: Hiroaki Murakami, my best friend.

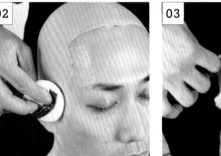

01
Wipe excess facial oil off using the astringent. Smooth the model's hair down using hair spray and then put on a bald cap. Then, apply Telesis along the hairline to settle the hair.

02
Smooth the edge and then dab on some powder.

03
The head piece is made of latex, while the ears, neck, etc. are made of GEL10. If everything is made of latex, unexpected wrinkles will appear. So this time we used silicone for the appliances that were intended to have a soft finish.

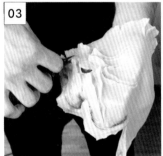

04
Put the latex and silicone appliances on the model's head.

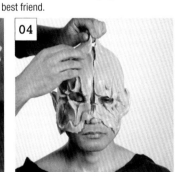

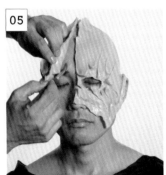

05
Glue down the appliances using Telesis.

06
Apply Telesis on the edges of the neck and the forehead and glue down the appliance tightly to prevent wrinkles.

07
Apply acetone to peel off the edge excess.

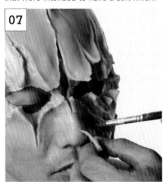

08
Glue down the ear silicone appliance. Use Pros-Aide Cabosil to refine the edges at the base of the ear (latex blending edge).

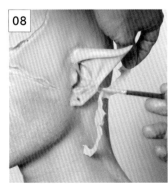

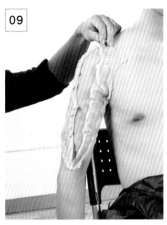

09

Glue down the silicone appliance from the shoulder to the arm.

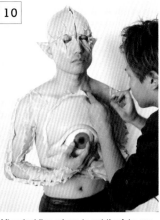

10

After deciding where to put the fake eye on the chest, glue it down using Telesis.

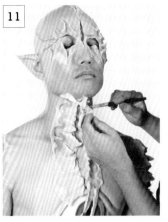

11

Glue down the fake eye on the chest beginning at the throat and moving downward. Glue the open wound prosthetic on the stomach.

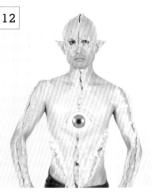

12

The photo above shows all of the appliances glued down. Apply Pros-Aide Cabosil and dry using a hair dryer. Put PAX on a urethane sponge, apply it to blend the edges of the appliances. Apply PAX thickly on the hairline, especially around the ears, as the silicone easily peeks through.

Put Skin Illustrator red on a brush and then paint along the edge of the fake eye. Airbrush red and black on the open wounds and the fake eye on the chest. Fill the cracks on the head, and into the depths of the well, with black acrylic. With this, the painting is concluded.

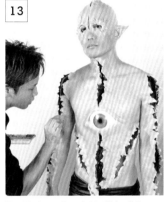

13

Use black acrylic paint to fill in all the cracked areas. Dab Skin Illustrator flesh tone orange on the center of the chest with an ethanol soaked sponge to create uneven coloring.

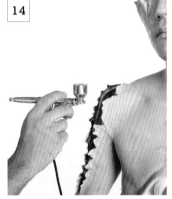

14

Airbrush Skin Illustrator white all over the body.

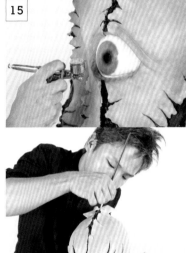

15

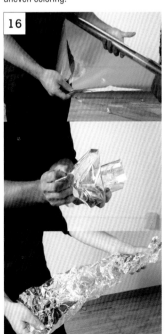

16

Cut off a piece of holographic film and crumple it up your with hands.

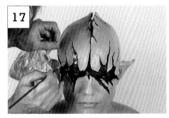

17

Apply Telesis on the open wounds and then glue holographic film on all of the open wounds. Paint the eye area in black and glue on some holographic film.

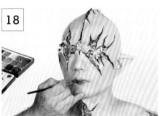

18

In order to give impact to the lips, fill them in using Bordeaux color, starting from slightly outside the lip line.

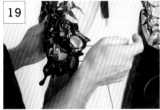

19

Use cotton swabs to remove smudges on various parts of the body, such as the head, face, and arms. Then, dab on some foundation to adjust the color. Glue the nail prosthetics on using double-sided tape and Telesis. Put the black flame props on by tying them down with leather cords.

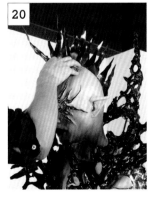

20

Put on the costume and Mohican head piece. Double-sided tape is attached to the backside of the Mohican head piece, so just insert it in the cracks that already have Telesis brushed into them.

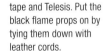

FINISHED!!

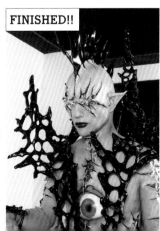

MOTHER HYDRA

by Kakusei Fujiwara

This character is a demon-bride inspired by Hydra from the Cthulhu Mythos. The detailed makeup is applied while using rigid textured foam latex appliances and large horns attached to a bald cap.

[Materials]
FRP (fiber-reinforced plastic) bald cap, Surgical tape, Foam appliances, Pros-Aide, Telesis, Self-skinning urethane appliance, Transpore clear tape, Set powder, TEMPTU DURA (Black, Red), Pros-Aide Cabosil, Ethanol, Orange stipple sponge, Skin Illustrator, Dental acrylic made fangs, Acrylic nails, White sclera contact lenses, Black sesame paste, Color lining

[Tools]
Hake brush, Airbrush, Drybrushing brush, Brushes, Cotton swabs, Sponge

Model: Akari, a writer who also works in the entertainment industry. In 2002, she started her career as a pin-up model then went into freelance in 2006. Since then, she has actively been involved in writing for magazines and online publications such as BUBKA, Saizo, Arm's Magazine, etc.
Japanese blog: http://yaplog.jp/benijake148/

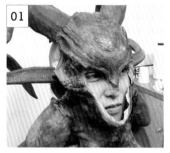

01 Tack the model's hair down. Put the horns, attached to an FRP bald cap, on the models head. Secure using surgical tape and then put the foam appliance on the cap.

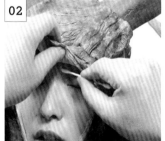

02 Apply Telesis to the edges at the neck, forehead, etc., to secure the appliance tightly while preventing the edges from wrinkling.

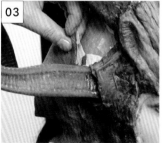

03 Glue down the appliance while hiding the seams of the horns. Use Telesis where Pros-Aide doesn't quite hold the appliance down well enough.

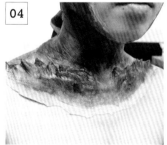

04 Glue along the collarbone.

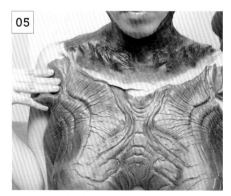

05 Hold the self-skinning urethane appliance against the model's chest.

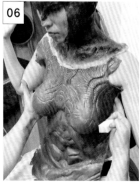

06 Glue down the appliance using Telesis and secure the sides using transpore clear tape.

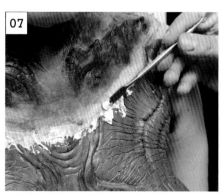

07 Apply Pros-Aide along the seam where the head and the chest appliance meet.

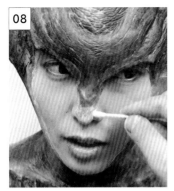

08 Put the face appliance against the model's face and then apply powder.

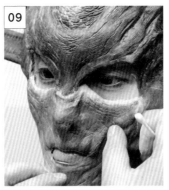

09 Using Pros-Aide, glue down the foam face appliance.

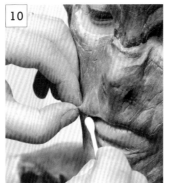

10 Apply Pros-Aide along the edges of the lip to glue down.

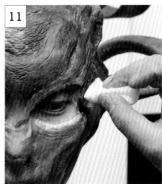

11 Dab with powder and then smooth the edges using Pros-Aide Cabosil.

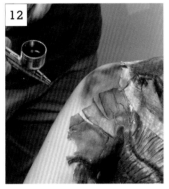

12 Airbrush TEMPTU DURA black on the bare skin and the prosthetic.

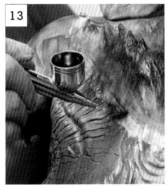

13 For shaded parts, airbrush the black a little darker. This gives the grooves depth.

14 Airbrush patterns on the arm.

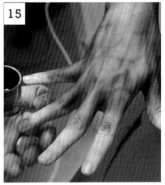

15 Airbrush black in between the fingers.

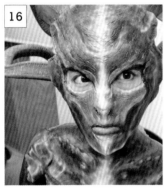

16 Apply black over everything and then put highlights down the center.

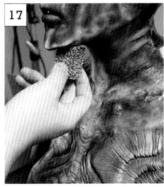

17 Dab TEMPTU DUAR red on the edges. Mix ethanol and brown and spackle it on using a hake brush. Use a drybrushing brush to rub on some brown.

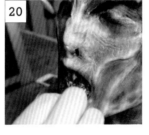

20 Paint the nostrils black. Using Skin Illustrator black, paint the lips black as well. Put in the dental acrylic made fangs.

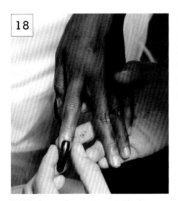

18 Add texture using an orange stipple sponge. Glue the acrylic nails on using thinned Telesis.

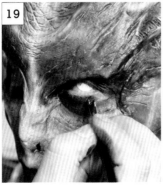

19 Apply black colored liner around the eyes.

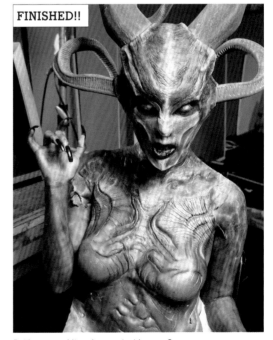

FINISHED!!

Put in some white sclera contact lenses. Smear black sesame paste on the lips to complete.

Law and Punishment

by Tomo Hyakutake

The word "dharma" in the dharma doll includes the ideas of truth, justice, and the law of morality. This character was created with the idea that when a dharma doll reads a sacred scripture aloud, it frees the Shark Man who is chained up. Then the Shark Man comes to seek revenge. Under the dharma mask, there is a girl with a thorny head.

MAKEUP FOR PHOTOSHOOTS 06

[Materials]
Silicone appliance (made of Ecoflex® 00-10 by Smooth-On Inc.), Gelatin prosthetic, Thorn prosthetic, Nails made out of paper, Thorns of a rose, Boots, Leather skirt, Skin Tite®, Red acrylic paint, Skin Illustrator, Eye shadow, Translucent polymer clay, Airbrush, TEMPTU DURA blue, White greasepaint, Color contact lenses (Black sclera), Pros-Aide, Latex, Pros-Aide Cabosil, Fake blood, Instant glue, Face powder

[Tools]
Sponge, Brushes, G Bond, Rubber, Hair dryer, Airbrush, Scissors, Surgical tape, Cotton swabs, Toothpicks

Model: Nanae, a special effects makeup artist and actress.

[Female Makeup]

01 Put a bald cap on the model's head and put in some black sclera contact lenses.

02 On top of the bald cap, put on another bald cap with thorns attached. Glue this down using Pros-Aide. Dab Pros-Aide Cabosil with a sponge along the hairline and blend in the edges.

03 Apply Pros-Aide along the hairline to glue the gelatin prosthetics to the forehead and brows.

04 Glue down the silicone appliance (made of Ecoflex® 00-10 by Smooth-On Inc.). Apply Skin Tite® from the edge of the jaw to the back of the neck and glue the silicone appliance to the nape of the neck.

05 Uniformly apply white greasepaint on the feet and legs.

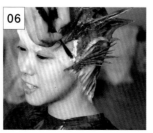

06 Make a film by applying 5 to 6 layers of latex. Then, glue toothpicks on the film using instant glue. Using Pros-Aide, glue the red painted thorn prosthetic over the ears.

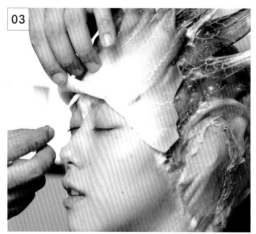

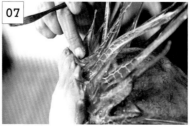

07 Fill gaps between the thorns on the head, around the ears, and the back of the neck, with translucent polymer clay. Then, airbrush TEMPTU DURA blue.

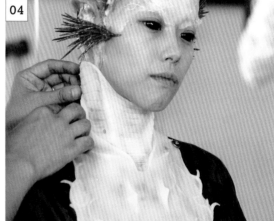

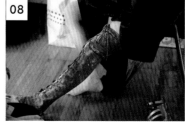

08 Put on the boots.

09

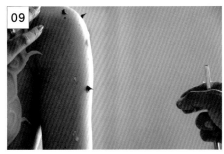

Glue rose thorns, painted red, on the bare skin using Pros-Aide.

10

Glue the silicone appliance on the chest using Skin Tite®.

11

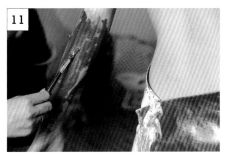

Paint the arms with acrylic red paint.

12

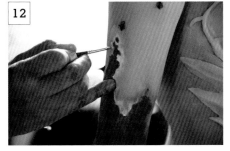

Apply white greasepaint all over the body. For the borderline between red and white, apply white greasepaint with a fine-tipped brush to make the skin look like it has peeled off.

13

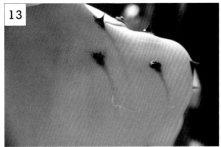

Paint sepia-colored Aeroflash around the base of the thorns on the back.

14

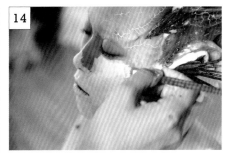

Apply white greasepaint on the face and dab with powder.

15

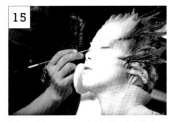

Paint white greasepaint in the detailed areas using a fine-tipped brush, while being careful to make the application uniform.

16

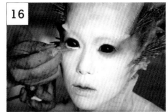

Apply eye shadow to the outer corner of the eye. Then, add red to the "tail" of the eye.

17

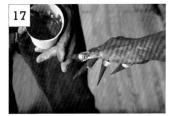

Place nails made of wrapping papers on the fingers and secure using surgical tape. Apply red acrylic paint to blend them in.

FINISHED!!

Cut the hem off the skirt with scissors. Rub red acrylic paint on the skirt to make it appear dirty. Pour fake blood on both hands/forearms to complete.

Quick transformation to a Dharma Doll

This photoshoots was planned with two different patterns in mind for the female model: a girl and a dharma doll. Therefore, after we finished shooting the girl version, we removed some prosthetic makeup and put the dharma mask on.

01

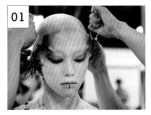

Remove the thorns attached to the bald cap.

02

Put on the dharma mask. Cut the bald cap, with the thorns attached, and glue it on at the back of the dharma mask.

FINISHED!!

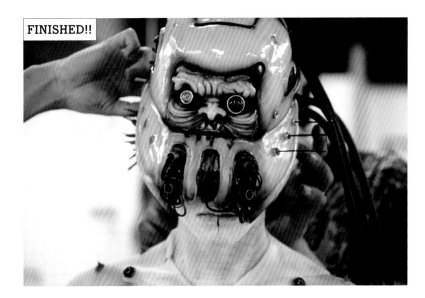

[Shark Man Makeup (Hammerhead Shark)]

Model: Pai Nara So, a student from Mongolia who is currently an acting major at Tokyo Film Center School of Arts.

[Materials]
Bald cap, Silicone (Sculpt Gel), Skin Illustrator, Greasepaint, Color contact lenses (Red), PAX, Skin Tite®, Rubber

[Tools]
Sponge, Brushes, G Bond, Hair dryer, Airbrush, Scissors, Shurtape (Permacel), Cotton swabs, Toothbrush

01

Put the costume and bald cap on. Paint wounds on the arm using Skin Illustrator.

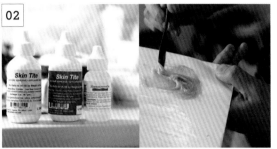

02

Mix silicone (Sculpt Gel by Smooth-On Inc.) A, B, C, in a 1:1:1 ratio.

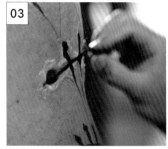

03

Apply the silicone around the wound to make it bulge and then dab with a sponge.

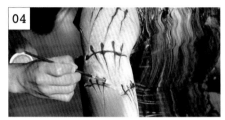

04

Apply white greasepaint inside the arm and then apply blue-gray greasepaint using a brush to the outside of the arm. After applying the greasepaints, blend them in by dabbing with a sponge. Similarly, apply white greasepaint on the legs.

05

Wrap rubber over the gloves crosswise and secure using G Bond.

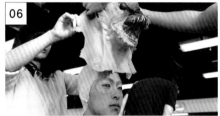

06

Put in red color contact lenses. Apply blue-gray PAX on the brows and around the eyes and dry using a hair dryer. Brush powder over the applied PAX. Remove any powder stuck to the eyelashes using cotton swabs.

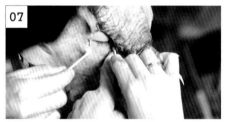

07

Apply Skin Tite® around the eyes, inside the prosthetic, the chin, and around the neck. Then, glue down the prosthetic carefully. Tightly secure the prosthetic by applying Skin Tite® where the appliance doesn't touch the skin.

08

Put light-gray Skin Illustrator on a sponge and dab to blend the colors.

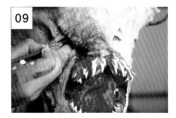

09

Cut the edge excess off the prosthetic. Adjust any uneven coloring and add red to the legs and "tail" of the eyes using a brush.

10

Final color adjustments. Add textures by spackling on some red paint using a toothbrush.

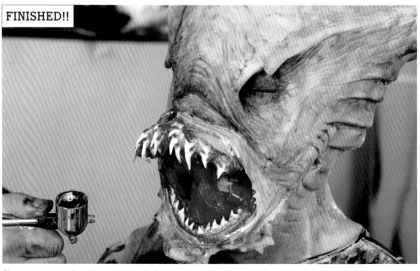

FINISHED!!

Glue on some acrylic nails and airbrush them black. Add red to the teeth to complete.

—Thistle—<2012>

by Manabu Namikawa

The concept is to fuse a machine and an exoskeleton. Based on the "flower language" of thistles, which this mask is named after, create a mask that appears untouchable and will hurt anyone who tries to touch it.

[Materials]
Epoxy putty, Wood putty, Paper clay, Primer, Vaseline®, Plastic modeling parts, Metal parts, Etching parts, Vacuum tubes, Acrylic paint, Plastic model paint, Silicone, Enamel paint, Aeroflash, Lacquer spray, Glass items, Leather cord, Resin cast, Instant glue

[Tools]
Brushes, Toothbrush, Utility knife, Scissors, Pliers, Wire cutters, Small scissors, Tweezers, Paper cups, Spatula, Engraving tools, Pencil, Vinyl, Masking tape

[Ornamental Pieces]
Crab shells, Sea shells, Swimming goggles, an item made previously

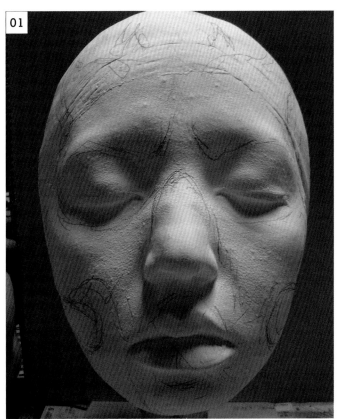

Pencil in the position of the mask on the lifecast. Apply Vaseline® on the lifecast for easy putty removal.

On the lifecast, place a crab shell on the forehead, swimming goggles on the eyes, a vacuum tube on the nose and temporarily glue them on using instant glue.

After temporarily securing a speaker-like metal item over the mouth, and crab legs around the mouth, using instant glue, apply paper clay to the gaps around each item and begin to sculpt.

In order for the epoxy putty to stick, first put some instant glue on the paper clay base.

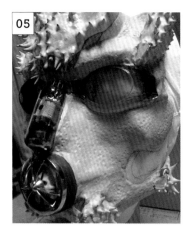

05

Apply epoxy putty and start to sculpt the mask. At this point you will not sculpt the fine details, so apply epoxy putty thinly over everything.

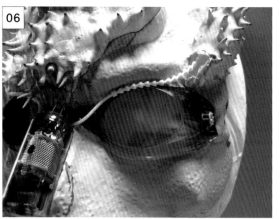

06

Attach the fine decorative items. For example, attach some small tubing over the goggles (see photo).

07

Attach decorative items that were made and lightly painted previously.

08

Make horns out of crab legs, nails, and plastic model items.

09

Make a small pelvis shape out of clay and then make a silicone mold.

10

Cast the silicone mold to make several replicas. Paint them with plastic model paint. Connect them by tying with a leather cord and secure them on the cheeks.

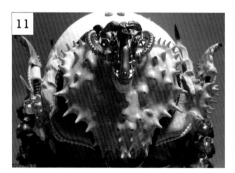

11

Decorate the crab shell on the forehead with decorative items and putty.

12

Fill gaps in between the parts with putty. Sculpt the clay, while adding bone-like textures.

13

Sculpt bulges under the eyes, on the sides of the nose, and around the mouth, using putty.

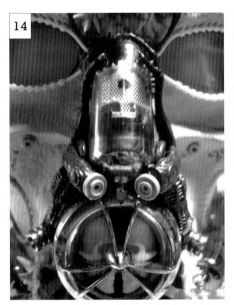

Decorate around the nose with decorative items and plastic model parts.

Sculpt a line connecting to the cheekbone with bone-like textures.

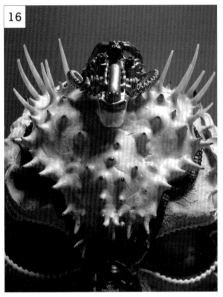

Add seashells to extend the thorns of the crab shell that was attached to the forehead.

Touch up the sculpture on the sides of the nose and around the mouth.

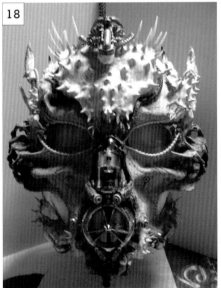

Add a base coat using flesh toned enamel paint.

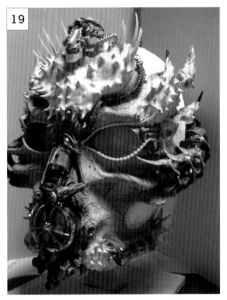

Apply the base color in a way that brings uniformity to the mechanical items, sculpted bones, and items painted previously.

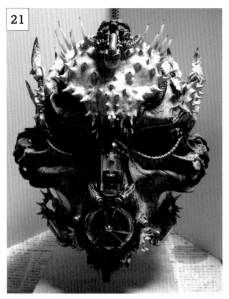

Remove mask from base and cure the inside by applying plastic and masking tape (the plastic keeps in moisture and stops cracking). Spray clear red inside of the goggles. It looks purple when overlaying the red on the blue color of the goggles.

Fill in the grooves using black acrylic paint

Giver further details to the items on the forehead and then lay color over them.

Decorate with etching items.

Fill the space beside the goggles using small accessory parts.

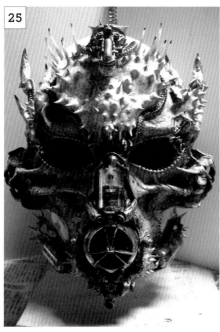

25

Dilute burnt sienna and sepia Aeroflash with water and then spackle it on.

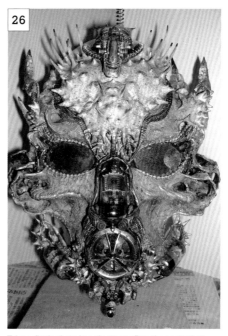

26

Take a flash photo in order to confirm the spots that need more shading. Lightly add shading using black paint. Where necessary add dark iron colored enamel paint.

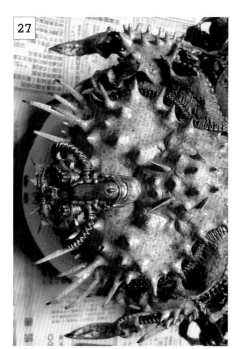

27

Spray on crystal pearl for the horns, forehead, and thorns.

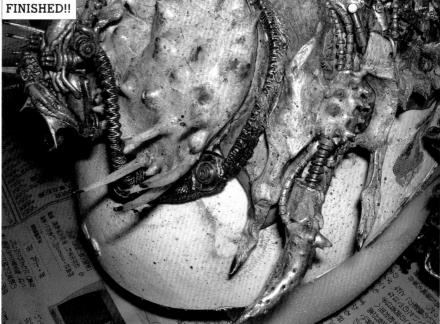

FINISHED!!

Once the pearl color dries, it's done!

Bio-Veronica

by Akihito

With the theme of this book being "dark fantasy," I designed this character with a female version of an alien in mind. The makeup application was done using silicone, foam, Pros-Aide, and prosthetics.

MAKEUP
FOR
PHOTOSHOOTS
07

[Materials]
Latex bald cap, Silicone appliances, Pros-Aide skin, Telesis, Acrylic paint

[Tools]
Makeup tools, Airbrush, Cotton swabs, Sponge

[Test Makeup]

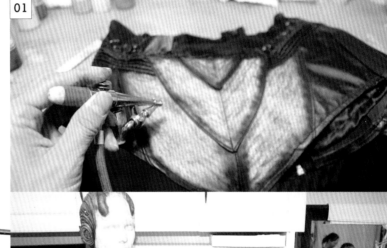

Paint the patterns using acrylic paint and add weathering so all the appliances have a uniform image and texture.

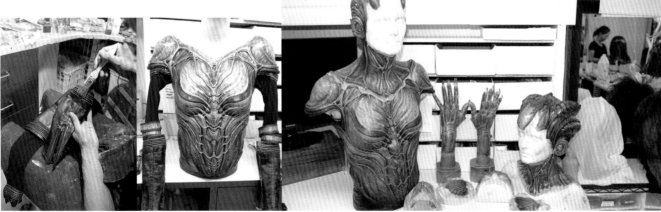

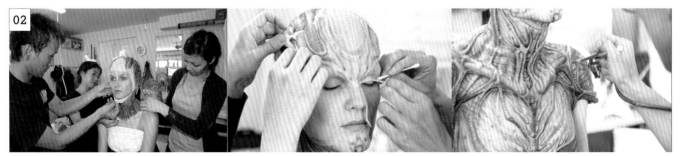

In order to improve the quality of your photoshoot, a makeup test shoot is crucial. We found issues, after examining the makeup for the eye area, as a result of doing a test shoot. Finish the remainder of the painting and prepare for the photoshoot.

[Photoshoot]

~ Prologue ~

Leading up to this photoshoot, unfortunate accidents kept happening. Two days before the photoshoot, the studio we booked called to cancel. So, I rescheduled the shoot, instead using my atelier in my house. However, the night before the rescheduled shoot, the model called and said that she had injured her face in an unlucky accident – so the shoot was postponed again and I had to find another model. Somehow, I managed to find a substitute model, Valentina Ivanconce, and began the shoot with only a week's delay.

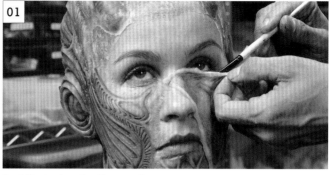
01
Carefully glue down the silicone appliance.

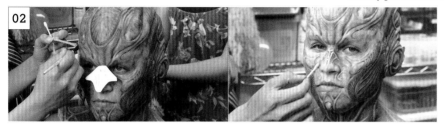
02
As a result of the makeup test, we noticed that the nose and upper lip appeared too human-like and they were not blended with the other facial prosthetics. Therefore, after the makeup test, I speedily redid the prosthetics for the nose and upper lip using Pros-Aide.

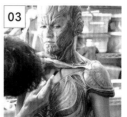
03
Since the size of the neck area is considerably different from the original model, it had to be glued down very carefully.

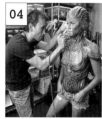
04
Airbrush thoroughly with Skin Illustrator brown and black.

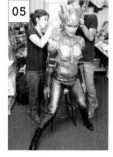
05
After the head and body makeup are finished, put on the costume (pants, sleeves, shoes, gloves). Put the helmet on then the makeup is done. Inside the helmet, a small-sized flashlight is embedded so it glows inside.

06
During makeup preparations, the photographer uses a stand-in who has about the same height of the model. This phtoshoot was difficult as we had to make the head glow by properly lighting behind the model.

07
The makeup is finished. Here I explain my vision to the model by showing her some photos and then I direct the model's movements.

FINISHED!!

The actual photoshoot is shown above.

[staff]
Special Thanks
Amalgamated Dynamic,Inc.
BJGuyer

Art director / AKIHITO
Photographer / Yasunari Akita
Model / Valentina Ivanconce, Julia Senecal
Costume Designer / Kathy Sully
Mold maker / Chris Bear
Prostheic Technician / Matthew Gerard Mastrella
Assistant / Miyo Nakamura, Ayumi Saito,
Yuko Kamada, Jon K Miller, Daiki Suzukawa
2nd Assistant / Hiroshi Furusho,
Mayumi Okamoto

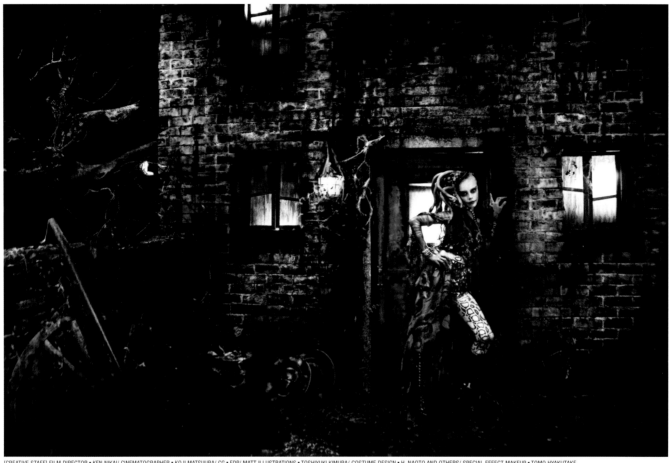

[CREATIVE STAFF] FILM DIRECTOR • KEN NIKAI/ CINEMATOGRAPHER • KOJI MATSUURA/ CG • EDP/ MATT ILLUSTRATIONS • TOSHIYUKI KIMURA/ COSTUME DESIGN • H. NAOTO AND OTHERS/ SPECIAL EFFECT MAKEUP • TOMO HYAKUTAKE

HALLOWEEN PARTY

At HALLOWEEN PARTY 2011 (the largest Halloween live music event around) the Halloween song HALLOWEEN PARTY was created. Now the song is being released on CD as a Halloween special edition by a unique band, HALLOWEEN JUNKY ORCHESTRA. The splendid members of the band are: HYDE (VAMPS), Acid Black Cheery, DAIGO (BREAKERZ), kyo (D'ERLANGER), Tommy february6, Tatsuro (MUCC), Anna Tsuchiya, Ryuji Aoki, K.A.Z. (VAMPS), Hitsugi (Night Mear), Aki (SID), RINA (SCANDAL), and Kanon Wakeshima. Character design was performed for each member and their special effects makeup and costumes were tailored to fit the Halloween style. The CD cover is filled with picture book-like art direction, prosthetic makeup, masks, and more - A must see!

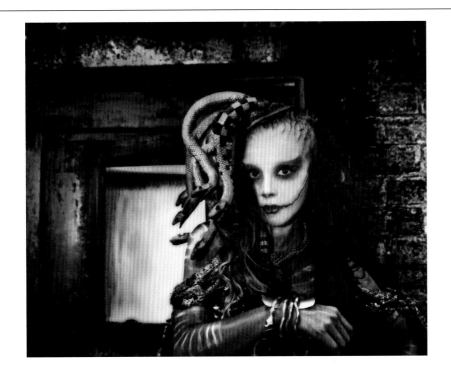

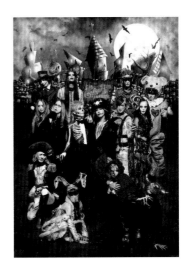

Comments from Tomo Hyakutake, Special Effect Makeup Artist

HYDE asked me to make a Gorgon, so I designed a Mohican Gorgon. A clock is attached to each snake face. My vision for this character (pictured above) is that Tsuchiya (the target model) and a single snake, wearing the crown, are partners and the rest of the snakes are their servants. The snakes are made of latex and the prosthetics are made of gelatin. The makeup application and photoshoot took a long time, although I think it turned out beautifully and we produced a Gorgon that only Tsuchiya can pull off. Namikawa, a member of my staff, and I produced the fangs and mouth wound makeup for HYDE, wound makeup for K.A.Z. Kyo, from D'ERLANGER, produced head gear and wound makeup for Tatsuro from MUCC, wolf makeup and a mask for Kanon Wakeshima and other boogiemen and clown masks. The amazing set design, by art director Hashimoto, the out of this world music performance by the band, and the various clashing concepts, all intermingled like a potion in a witch's cauldron – this is the supreme vision that HYDE, and the director Nikai, created.

[Version]
First Edition
Price ¥1,890 (incl. tax)
*Includes a first edition limited booklet

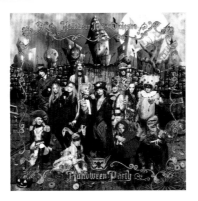

Regular Edition
Price ¥1,200 (incl. tax)

HALLOWEEN PARTY
2012.10.17 ON SALE

[CD Content]
(Lyric, Music: HYDE)
(Music: HYDE)
[DVD Content]

A top-notch creator
Special Lecture by Kazuhiro Tsuji

Kazuhiro Tsuji is a genius special effects makeup artist, known globally for his ability to produce extremely realistic makeup. With his top-class Hollywood techniques and artistic sense, Tsuji was involved in numerous masterpiece films and he was nominated twice consecutively for Best Makeup Academy Awards for his work on Click, and Norbit. His work in Salt drew people's attention by transforming Angelina Jolie into a man. In cooperation with Tsuji, AMAZING SCHOOL JUR – a special effects makeup school in Japan – provides study abroad opportunities for learning Tsuji's remarkable skills. Besides being in charge, as special lecturer of the Hollywood study abroad program, Tsuji undertakes special demonstration lectures at JUR annually.

"I am always surprised by the finished quality of JUR students' work. The manner in which instructors and students at JUR relate to each other is well reflected in students' work. Given that JUR is a school that teaches students to become artists, it is a school that uses methods of teaching that bring students' talents to the fore while valuing self-expression. It also freely teaches in a way that suits each individual. Every year, when I visit to give my special lecture, I can see the significance of these concepts. All of the staff at JUR are wonderful individuals and I look forward to seeing them always." Kazuhito Tsuji

KAZUHIRO TSUJI PROFILE

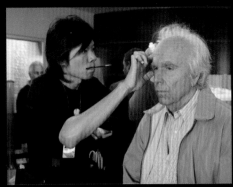

Kazuhiro Tsuji was born in Kyoto, Japan. Since Tsuji was little, he has been interested in painting, film, science, and technology. He taught himself special effects makeup when he was in high school. Tsuji contacted master special effects make-up artist, Dick Smith (*Amadeus*, *The Exorcist*, *The Godfather*, et al.). After Tsuji graduated from high school he was invited by Smith, who was supervising the Japanese horror film *Sweet Home* (1998) – with Nobuko Miyamoto in the lead role – to be part of the production staff. Since then, Tsuji has been involved in the production of numerous Japanese films, including *Rhapsody in August* (1991) directed by Akira Kurosawa. He has also taught special effects makeup at Yoyogi Animation Institute. In 1996, Tsuji was invited by Rick Baker (*Star Wars*, *An American Werewolf in London*, *Thriller* by Michael Jackson, et al.) to go to the United States. Tsuji worked on the film, *Men in Black* (1997). Since that film, Tsuji and Baker have collaborated for over a decade, working on numerous Hollywood blockbuster films. Credits for work in which Tsuji teamed up with Baker include: *Nutty Professor* (1996), *Batman and Robin* (1997), *The Devil's Advocate* (1997), *Wild Wild West* (1999), *How The Grinch Stole Christmas* (2000), *Planet of The Apes* (2001), *Men in Black 2* (2002), *The Ring* (2002), *The Haunted Mansion* (2003), *Hellboy* (2004), *The Ring 2* (2005), *Click* (2006), *Norbit* (2007), and more.

Tsuji received a BAFTA Award for his work on *How The Grinch Stole Christmas* and *Planet of The Apes*. Tsuji also received two consecutive nominations for Best Makeup Academy Awards for his work on *Click* and *Norbit*. In 2007, Tsuji established KTS Effects Inc.

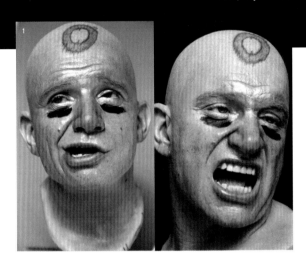

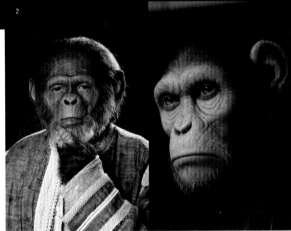

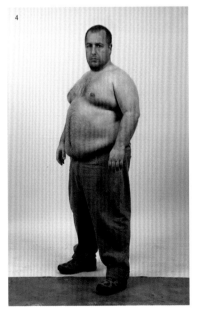

1. Batman & Robin (1997). Surprisingly, for this film Mr. Freeze is a dummy made out of clear resin. This work instantaneously made Tsuji famous in Hollywood.

2. Planet of The Apes (2001). Tim Burton's remake of the original masterpiece. Foam latex appliance makeup was applied to over twenty apes each time. The photo on the left is Tsuji himself.

3. A bust of the highly regarded Dick Smith, father of special effects makeup and one of the reasons why Tsuji moved to Hollywood. The surprisingly realistic double scale bust was given to Smith on his eightieth birthday.

4. Click (2006). Tsuji received a nomination for Best Makeup at the 78th Academy Awards for this film. Adam Sandler's face had "fat makeup" applied and then a "head replacement" was filmed with CG using the body of a different actor.

Top-notch Level
Special Effects Makeup Lecture at JUR

Prior to his demonstration-style special lectures, which started in 2012 at JUR, Tsuji was invited to give a preview class in November 2011. After his lecture explaining materials and molding methods, Tsuji manipulated a clay original model of a young man's face and instantaneously transformed it into an old man, right in front of the students. This practical class, given by a world-class creator, enables you to acquire more than a year's worth of learning than could be acquired in Japan.

The class was filled with an audience that learned all about the class. Enthusiasm filled the room and some audience members had to stand as there were not enough seats.

Primarily, a biological lecture was conducted to explain how each part of the body changed.

Demonstration of Clay Sculpting

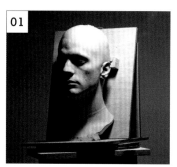

01

First, in the area where he will sculpt, Tsuji begins to create the same lighting as that of the model's photoshoot. If the lighting doesn't come from the same angle and the same position as in the photoshoot, the sculpting will be negatively influenced by shadows and lead to a different appearance.

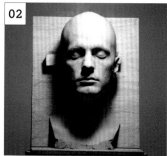

02

Original model of a young man before sculpting.

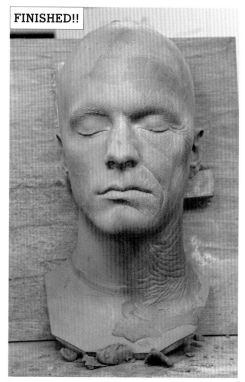

FINISHED!!

In about an hour the clay original model is finished. In the photo above, the right side (from the model's perspective) is not aged, while the left side is aged to the face of an elderly man who is about sixty.

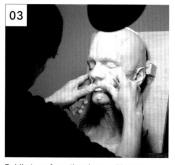

03

Boldly transform the shape with your fingers.

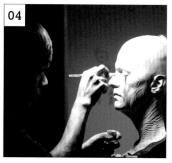

04

Sculpt the details using an engraving tool.

The silicone that Tsuji uses is GEL10. Cover GEL10 with a thin film called Baldiez and then glue down the silicone appliance to the skin. The appliance made by Tsuji is skillfully thin and realistic.

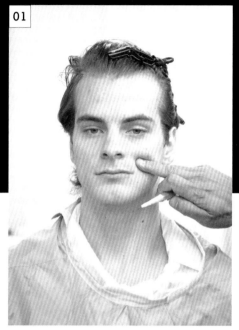

Apply protective cream on the model's face.

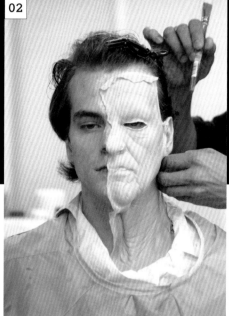

Since a half the face is aged, glue the silicone appliance on left half of the face using TELESYS thinner.

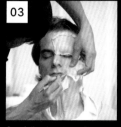

Carefully glue down the detailed areas.

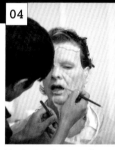

Neatly glue down any fine edges, such as the edges of the lips and around the eyes.

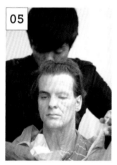

Shown above is the finished silicone appliance application.

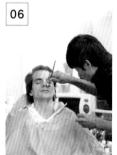

Paint using an airbrush and brushes. Do not exaggerate! Apply aging makeup while creating uniformity with the right half, which does not have any aging makeup on it.

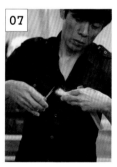

Cut a fake beard and glue it down.

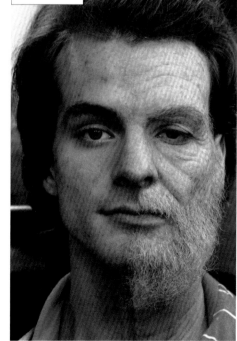

FINISHED!!

It is complete. At first glance, it does not look overly discomforting. Try to look at it by alternatively hiding the left and the right side. The model should appear to have a totally different age.

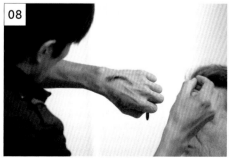

Tsuji cuts out a fake eyebrow and glues it down quickly. It's like watching a magic show.

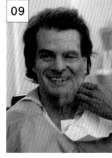

Give it a final layer of paint and it's done!

The Society of Conceptual Special Effects Makeup
Author Profiles

©legacy effects studio

AKIHITO

Born in Fukuoka prefecture, Akihito is CEO of "Shiniseya" Fine Arts Studio. He is three-time consecutive champion of the special effects makeup episodes for the Japanese television program "TV Champion." He is the only Japanese artist to win the prestigious IMATS Avant-Garde makeup competition, where top notch make-up artists gather from around the world. Akihito moved to the United States in 2002 and is currently working at a special effects makeup studio in Los Angeles as the key-artist. He has also shown us his particular point of view in the fine arts field and was named recipient of the silver award for his work *Heart of Art* in the notoriously difficult FineArt Book SPECTRUM 15 3D section. Similarly, in SPECTRUM 16, his work "Elegant medusa" received the gold award. His film credits include: *Alien vs Predator, The Chronicles of Narnia, Alice in Wonderland, Iron Man 2, The Revenant, Terminator Salvation, Terminator Genisys, Guardians of the Galaxy Vol.2* and more.

Akiteru Nakada

Nakada was born in Saitama prefecture. He received a real shock watching things like *Jaws* and *Dawn of The Dead* as Nakada has always found intrigue in the terrifying. Watching the music video *Making Michael Jackson's Thriller* and the documentary film about Tom Savini, *Master of Horror Effects* (produced by *Fangoria* magazine), Nakada was greatly influenced in his decision to pursue special effects makeup as a profession. He met his mentor, Kazuhiro Tsuji, at Yoyogi Animation Gakuin in the SFX Special Visual Effects program. After a stint as Tsuji's assistant, Nakada went independent. After working on various projects in 2012, Nakada started ZOMBIE STOCK Inc. His list of credits include: *Sekigahara* (film), *Too Young to Die! Wakakushite Shinu* (film), *Close-Knit* (*Karera ga honki de amu toki wa*) (film), *Garo* (TV series), *figma Flyboy Zombie* (model figurine), and many others. He also undertakes theater/advertisement art productions such as the Gekidan ☆ Shinkansen theater program and theater programs directed by Yukio Ninagawa.

Kakusei Fujiwara

Fujiwara was born in Kyoto prefecture. He was very much influenced by an array of genre-redefining films. Shaped by Smith, Baker, Borden, and Savini, in their prime, Fujiwara decided to pursue the world of special effects makeup. Fujiwara is self-taught, aside from drawing rough sketches, and he has truly mastered the techniques of special effects makeup and sculpting. After working at representative studios in Japan (Egawa, Wakasa, Haraguchi), he became independent and founded "Special Effects Makeup Design Dummy Head." With special effects makeup/dummy making as the basis of his studio, he is actively involved in various media such as films and commercials, while undertaking character design, maquette making, costume making, animatronics, and producing real mannequins. His favorite special effects make-up artist is Giannetto De Rossi from Italy. His films credits include, *Zatoichi, SPL Ookami yo Shizukani Shine* (Hong Kong), *K-20 Kaijin Nijumenso-den, Eien no Zero, KILLERS*, and more.

Manabu Namikawa

Namikawa was born in Kyoto prefecture. He is chief of staff at Hyakutake Studio Inc. He studied special effects makeup at Yoyogi Animation Gakuin in the Special Makeup Artist division. Artists of influence are: H.R. Giger, Gerard Di-Maccio, Joel-Peter Witkin, Salvador Dalí, and René Lalique. Works that influenced him in film are: *Alien* and *Hellraiser*, and other artistic mediums such as painting, sculpture, photography, decoration, etc. His list of film credits includes: *CASSHERN, The Great Yokai War* (*Yōkai Daisensō*), *Dororo, Shin Godzilla, Smuggler, Lychee Light Club, Museum, Innocent Curse* (*Kodomo tsukai*), *Memories of a Murderer* (*Nijū ninen me no kokuhaku*), *Tokyo Ghoul, Fullmetal Alchemist* (*Dō no renkinjutu-shi*), *Aa kōya*, etc.

Soichi Umezawa

Umezawa was born in Kanagawa prefecture. He became interested in film and special effects makeup after watching *The Fury, The Howling*, and *Scanners* when he was in junior high. At age sixteen he decided to pursue the world of special effects makeup in earnest so after graduating high school – through a recommendation from Rick Baker, with whom Umezawa was in contact at the time – he began freelance work at a studio in Japan. He became independent in 1997. Currently, he is CEO of Soichium Inc. His credited films include: *Tenshu Monogatari, Koko no Mesu, CUT, Yokai Ningen Bemu, Kirishima bukatsu yamerutteyo* etc. In 2014, Umezawa made his directorial debut in an American short film called *Y is for Youth*, which is part of *ABCs of Death 2*. He has subsequently released other short films. In 2017, he released his first feature film *Vampire Clay* and undertook the direction, screenplay writing, editing, and special effects makeup.